Secondo moto.
+ Prima figura

ARCHITECTURE OF LIFE

LAWRENCE RINDER

WITH ESSAYS BY SABRINA DALLA VALLE PADMA D. MAITLAND
SPYROS PAPAPETROS LISA ROBERTSON REBECCA SOLNIT

UNIVERSITY OF CALIFORNIA, BERKELEY ART MUSEUM & PACIFIC FILM ARCHIVE

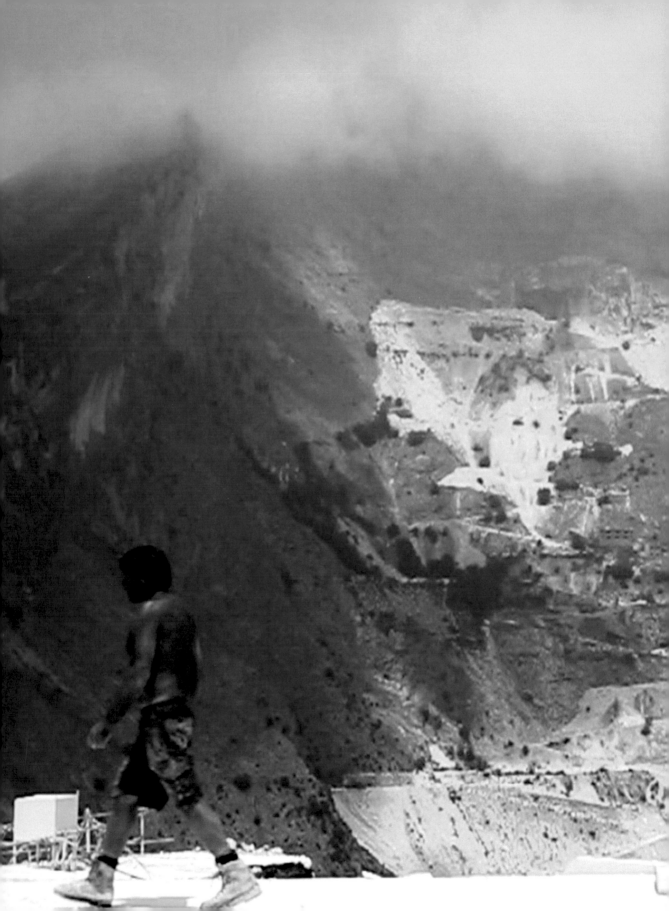

Architecture of Life is supported in part by major funding from an anonymous donor, Ann Hatch and Paul Discoe, Frances Hellman and Warren Breslau, Dr. Rosalyn M. Laudati and Dr. James Pick, Alexandra Bowes and Stephen Williamson, Nion McEvoy and Leslie Berriman, an anonymous donor, the Blitt Family, The John and Natasha Boas Art Fund, Agnes Bourne, Rena Bransten, Richard Buxbaum and Catherine Hartshorn, Graham Foundation for Advanced Studies in the Fine Arts, Marian Lever and Arthur S. Berliner, Ama Torrance and C. J. David Davies, and the BAMPFA Board of Trustees.

Section 1 of "Preludio" from *7 Days and Nights in the Desert (Tracing the Origin)* by Sabrina Dalla Valle.
© 2013 Kelsey Street Press and Sabrina Dalla Valle

"Rubus Armeniacus" from *Occasional Works and Seven Walks from The Office for Soft Architecture* by Lisa Robertson.
© 2006 Coach House Books and Lisa Robertson

Published by the University of California, Berkeley Art Museum and Pacific Film Archive, Berkeley, California bampfa.org

Available through D.A.P. / Distributed Art Publishers
155 Sixth Avenue, Second Floor, New York, NY 10013
(212) 627-1999 artbook.com

The University of California, Berkeley Art Museum and Pacific Film Archive has made every effort to obtain copyrights for images reproduced herein. Should there be any omission, please contact us in writing.

Library of Congress Cataloging-in-Publication Data

Architecture of life / Lawrence Rinder ; With essays by Sabrina Dalla Valle, Padma D. Maitland, Spyros Papapetros, Lisa Robertson, Rebecca Solnit.

 pages cm

 "Published on the occasion of Architecture of Life, the inaugural exhibition in the University of California, Berkeley Art Museum and Pacific Film Archive's new building, designed by Diller Scofidio + Renfro. Curated by BAMPFA Director Lawrence Rinder, the exhibition is on view from January 31 to May 29, 2016."

 Includes bibliographical references.

 ISBN 978-0-9838813-1-5

 1. Architecture--Human factors--Exhibitions. I. Rinder, Lawrence. Architecture of life. II. Valle, Sabrina Dalla. Hearing the metron. III. Maitland, Padma Dorje. Mandalas. IV. Papapetros, Spyros. Architecture and life. V. Robertson, Lisa, 1961- Rubus armeniacus. VI. Solnit, Rebecca. Private in public. VII. Berkeley Art Museum and Pacific Film Archive, organizer, host institution.

 NA2542.4.A737 2016

 720.74'79467--dc23

Cover: Based on Santiago Ramón y Cajal, *Purkinje cell of the human cerebellum*, 1899

Frontispiece: Carlo Urbino, "Secondo moto. Prima figura," from *Codex Huygens* (Urbino codex), fol. 21, 16th century

Pages 4–5: Yuri Ancarani, *Il capo*, from the trilogy *La malattia del ferro (The Malady of Iron)*, 2010 (still)

Page 12: Vance Williams, Nematic liquid crystal droplets, 2015

Page 346: Tomás Saraceno, *Solitary, semi-social mapping of ESO-510 613 connected with intergalactic dust by one Nephila clavipes—one week—and three Cyrtophora citricola—three weeks*, 2015 (detail)

Page 350: Lace: Coraline fragment, 16th century

Page 352: Carlo Urbino, "Quinta figura et principio di moto et ultima del primo libro," from *Codex Huygens* (Urbino codex), fol. 7, 16th century

Book Design: Mary Kate Murphy
Editors: Juliet Clark and Nina Lewallen Hufford
Print Management: Perry-Granger & Associates
Printed in China

Contents

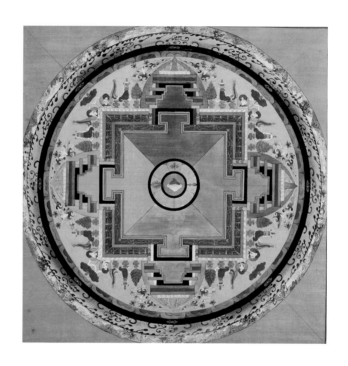

Tibet, *Mandala of Mahamaya*, 19th–20th century (pl. 232)

Foreword

Over the past few decades, university art museums have become more deeply engaged across the many disciplines that constitute a liberal arts education. Experiences with visual art are now understood to significantly benefit students' quality of life as well as positively impact academic performance. Museums have gone from being ancillary to the mission of higher education to being central—even foundational—to it. At its new location directly across from the main entrance to UC Berkeley and in the heart of downtown Berkeley, BAMPFA is well positioned to be a point of extraordinary intersection, making the material and intellectual richness of the University available to diverse publics as well as inviting the community to join in conversation with our students and faculty.

Even as they are becoming steadily more integrated into the diverse curricula and academic strategies of colleges and universities, art museums are simultaneously reaching out to broader publics and striving for forms of engagement that go well beyond passive enjoyment and contemplation (however valuable such experiences may be). Art museums are among the few public sites where we are willing to let down our collective guard, and to consider—and perhaps even adopt— a perspective, emotion, or ideology different from our own. They are spaces of vulnerability, openness, and expansiveness. The value of such socially dynamic spaces—for both students and the general public— cannot be overestimated.

University art museums should be no less diligent in their methods, original in their thinking, and groundbreaking in their outcomes than any of our cutting-edge academic disciplines. Our art museums—like the works of art they showcase—should exemplify innovation, provocation, and revelation. So I am thrilled that BAMPFA is inaugurating its new downtown Berkeley home with an exhibition that breaks down boundaries, challenges definitions, and inspires fresh thinking on matters of great importance to us individually and as a society. Indeed, I would go so far as to say that *Architecture of Life* is truly a "Berkeley" exhibition, exemplifying the generative, interdisciplinary, and independent spirit of both Cal and the remarkable city in which we reside.

Nicholas B. Dirks, Chancellor, University of California, Berkeley

Acknowledgments

Architecture of Life—the exhibition, catalog, and programs—could not have been accomplished without the enthusiastic assistance and participation of many people throughout the world. I am tremendously indebted to all of those who went out of their way to offer guidance, support, and funding for this unusual and ambitious project.

The exhibition is inspired by our new building, which was so masterfully and innovatively designed by Diller Scofidio + Renfro. I'm especially grateful to Charles Renfro, with whom we worked very closely from start to finish. As executive architect, the San Francisco–based firm EHDD brought its considerable design insight to the project, and UC Berkeley's Capital Projects team, especially Brian Main and Shannon Holloway, devoted exceptional focus and skills over many months. Our gratitude goes, as well, to general contractor Plant Construction, and to all of the many consultants, subcontractors, and laborers whose diligence and talent made the new building come to life.

An exhibition of this scope is virtually impossible to document fully or explain comprehensively; hence, for this catalog, I invited a diverse range of writers to reflect on *Architecture of Life* from their unique perspectives. Experimental writer Sabrina Dalla Valle explores the omnipresence of tempo and rhythm in lived experience and the relation of time to form in art, music, and architecture. Spyros Papapetros, Associate Professor of History and Theory of Architecture at Princeton University, draws connections among various works in the exhibition to explore the ambiguous distinction between living and nonliving forms as well as noting some intriguing precedents for the exhibition itself. UC Berkeley graduate student Padma D. Maitland has written about the mandala as a form that signifies the architecture of the mind, spirit, and cosmos across eras and cultures. Lisa Robertson's text, a reprinted classic, considers architecture in relation to the rambling and draping forms of the Himalayan blackberry. Essayist Rebecca Solnit approaches the subject of architecture obliquely, through the lens of homelessness in contemporary society, particularly in the San Francisco Bay Area. I am grateful to the authors for their insight and generous engagement with the theme.

BAMPFA's staff members have brought to this project the very best of their expertise and dedication. I am deeply indebted to each and every one of them. I would like to thank above all Lauren R. O'Connell, Curatorial Associate, who bore an undue share of the burden such a complex project entails. Her attention to detail, combined with a passion for the works, was critical to making this project a success. The registration team led by Lisa Calden was exceptionally accommodating in their willingness to take on a host of unusual challenges. Chief Preparator Kelly Bennett and the entire installation team provided great creativity and care in handling and presenting many rare treasures we received from around the world. Mary Kate Murphy, Director of Design, brought her wonderfully inventive vision to the design of this catalog and other graphic material. Managing Editor Nina Lewallen Hufford kept the publication on track and, with Juliet Clark, provided invaluable editorial support. The gorgeous illustrations in this book are thanks largely to the masterful photography of Sibila Savage. Peter Cavagnaro, Media Relations Manager—along with our special communications consultants, Fitz & Co.—kept the press informed and our social media networks engaged. An exhibition of this scale requires a larger than usual amount of financial support, and I am grateful to Development Director Louise Gregory, Grants Officer Frances Pomperada, and Major Gifts Officer Alison Bernet for all they did to make the exhibition and catalog possible. The many technical issues involved in the exhibition were resolved with the help of Mona Nagai, Film Collection Curator; Nancy Goldman, Head, Film Library and Study Center; and Dave Taylor, Digital Content Producer. Kathy Geritz, Film Curator; Steve Seid, former Video Curator; Julia White, Senior Curator for Asian Art; Max Goldberg, former Conceptual Art Study Center Cataloger; and Jon Shibata, Assistant Film Archivist, offered suggestions that helped to shape the content of the exhibition. Thanks to Academic Liaison Lynne Kimura, the exhibition will be accompanied by a host of UC Berkeley faculty presentations and class visits. The public programs have been developed for our many audiences through the inspired work of Director of Education Sherry Goodman, Sharon and Barclay Simpson Associate Curator of Education Karen Bennett, Engagement Programmer David Wilson, and Guest Programmer Sarah Cahill. Former Executive Assistant Morgan Wadsworth-Boyle helped to get the project off the ground. Curatorial Intern Greta Schluenz was also involved in the early research and

with logistical help throughout the project. Thanks most especially to Rachael Dickson, Executive Assistant, who kept me focused, organized, and optimistic.

Several members of the UC Berkeley faculty have been exceptionally supportive. I'd like to thank, in particular, Shannon Jackson, Associate Vice Chancellor of Arts and Design; Nicholas de Monchaux, Associate Professor of Architecture and Urban Design; Martin Jay, Sidney Hellman Ehrman Professor of History; and Lucia Jacobs, Professor of Psychology. Alan Tansman, Director of the Doreen B. Townsend Center for the Humanities, has also been a wonderfully supportive colleague.

Numerous people throughout the world have helped to make this exhibition and catalog possible. I am grateful to Joan Banach, Leandra Burnett at the Estate of Lebbeus Woods, Brian Butler at Anger Management LLC, Kay Coates, Pablo Colapinto, Shawna Cooper, Johan Creten, Jacqueline Crist at James Castle Collection and Archive, Aiko and Laurence Cuneo, John Ferry at The Estate of R. Buckminster Fuller, Nicole Gallo, Rowan Geiger, Terri Green, Jerry Gorovoy, Kathrin Haaßengier at Dieter Roth Foundation, Hank Hine, Jenny Hurth, Colter Jacobsen, Tulika Kedia, Addie Lanier, Graham McNamara, Claire Pauley McPherson, Anita Mehta, Victoria Newhouse, Yuma Ota at Toyo Ito & Associates, Lisa Pisano at James Castle Collection and Archive, Ingrid and Joerg Schauberger, Alix Schwartz, Pejman Shojaei at The Estate of Robert Overby, Ethan Sklar, Craig Starr, Jennifer Tonkovich, Regis Trigano at Kimsooja Studio, Anna Wall, Aleksandra Wagner, Gentle Wagner, John Whitney Jr., Vance Williams, Wendy Williams at Louise Bourgeois Trust, Sally Woodbridge, Jiaqi Wu, and Mâkhi Xenakis.

Thanks to the many individuals at galleries, museums, and archives who have made invaluable contributions to the project. We are indebted to Reena Lath, Akar Prakar Art; Claudia Altman-Siegel and Josh Minkus, Altman-Siegel Gallery; Andrew Edlin and Rebecca Hoffman, Andrew Edlin Gallery; Amber Noland, Art Collection Management; Dr. Dieter Bogner and Gerd Zillner, Austrian Frederick and Lillian Kiesler Private Foundation; Dr. Juan A. de Carlos, Cajal Institute, CSIC; John Cheim, Cheim & Read; Lial Jones, John Caswell, and Scott A. Shields, Crocker Art Museum; Sasha Baguskas, Crown Point Press; James Danziger, Danziger Gallery; Greg Lulay, Lauren Knighton, and Maria Filingeri, David Zwirner; Dr. Thomas Bach, Ernst Haeckel Haus; Alberto Zenere, ZERO . . . ; Gregory Lind, Gregory Lind Gallery; Anne Ellegood, Hammer Museum; Karin Seinsoth, Hauser & Wirth; Dr. Klaus Nippert and Elke Leinenweber, Karlsruhe Institute of Technology, KIT Archives; Kate MacGarry and Lizzy McGregor, Kate MacGarry Gallery; Jules Kliot and Erin Algeo, Lacis Museum of Lace and Textiles; Sarah Hymes, Lora Reynolds Gallery; Catherine Belloy, Marian Goodman Gallery; Josef Helfenstein, Menil Collection; Michael Rosenfeld, Halley K. Harrisburg, and Marjorie Van Cura, Michael Rosenfeld Gallery; Kaywin Feldman, Minneapolis Institute of Arts; Glenn D. Lowry, The Museum of Modern Art; Lori Fogarty, Carin Adams, Joy Tahan, and Meredith Patute, Oakland Museum of California; Ira Jacknis, Victoria Bradshaw, and Linda Waterfield, Phoebe A. Hearst Museum of Anthropology; Karen Sinsheimer and Delphine Sims, Santa Barbara Museum of Art; Annalisa Palmieri Briscoe and Sarah Q. Barnett, Sicardi Gallery; Robert G. Trujillo, Tim Noakes, and Mattie Taormina, Department of Special Collections, Stanford University; Tanya Bonakdar, Joel Draper, and Annie Rochfort, Tanya Bonakdar Gallery; Suzanne Modica, Thea Westreich Art Advisory; and Adam Weinberg, Dana Miller, Barbi Spieler, and Anita Duquette, Whitney Museum of American Art.

I want to thank all of the artists, architects, scientists, and musicians whose work has made this show such an inspiration to me and, I hope, to others. We are also exceptionally grateful to those who lent work to the exhibition. Every work is rare and precious; we thank you for entrusting these treasures to our care.

Finally, I want to thank the many generous funders without whom none of this project's many dimensions would have been possible. One anonymous donor stepped forward very early with a promise of major underwriting. To that wonderful person, I offer my eternal gratitude. The following have provided significant and very generous gifts: Ann Hatch and Paul Discoe, Frances Hellman and Warren Breslau, Dr. Rosalyn M. Laudati and Dr. James Pick, Alexandra Bowes and Stephen Williamson, Nion McEvoy and Leslie Berriman, an anonymous donor, the Blitt Family, The John and Natasha Boas Art Fund, Agnes Bourne, Rena Bransten, Richard Buxbaum and Catherine Hartshorn, Graham Foundation for Advanced Studies in the Fine Arts, Marian Lever and Arthur S. Berliner, Ama Torrance and C. J. David Davies, and the BAMPFA Board of Trustees.

Lawrence Rinder, BAMPFA Director

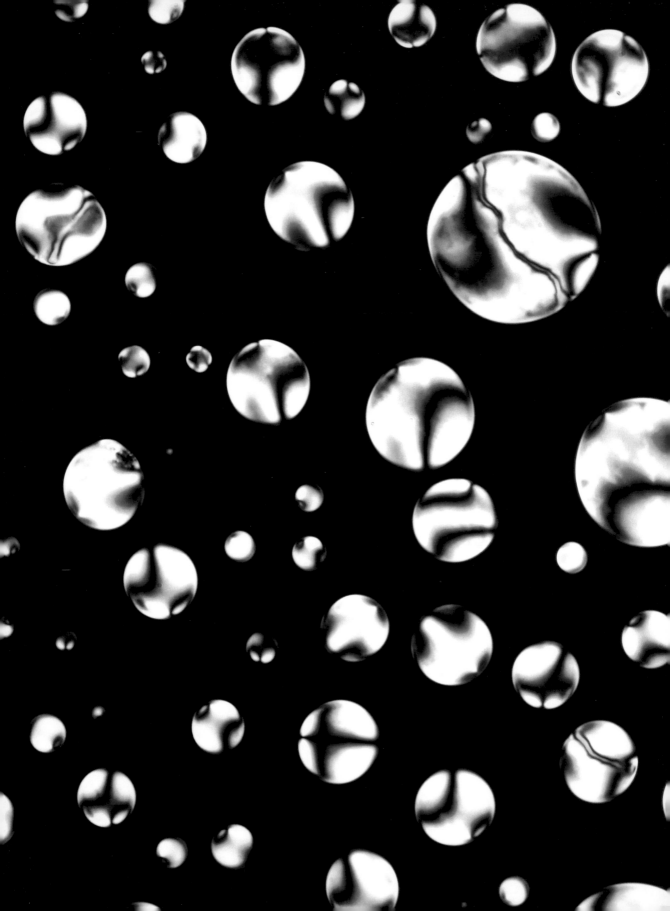

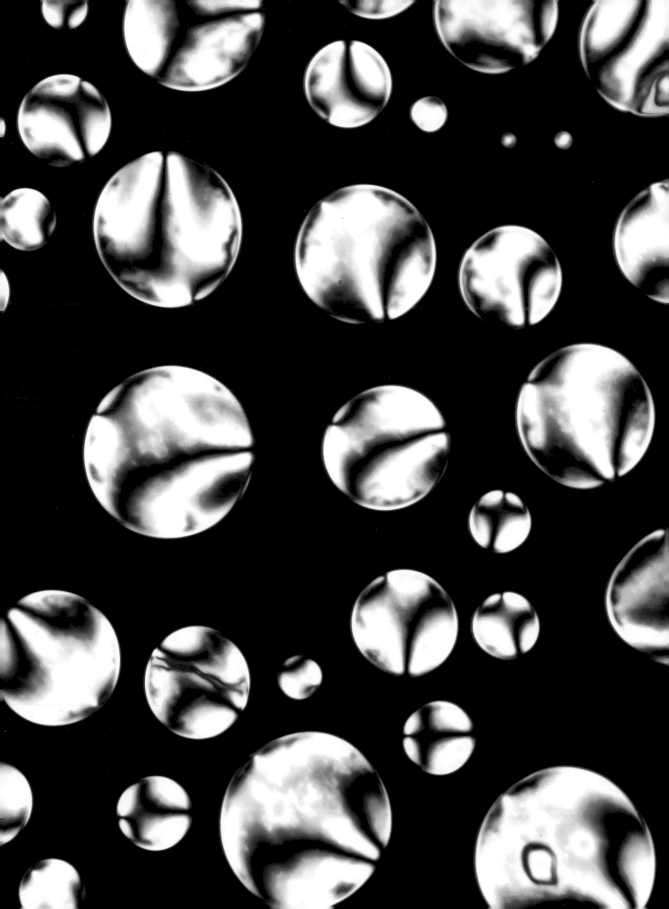

PRELUDIO

I *If you do not change low to high, left to right,*
 back to front, you shall not enter my kingdom . . .

 a riddle found buried in the desert,
 ink scribbled in Aramaic on parchment,
 sewn into leather, and sealed in a
 jar. The author, unimportant, is
 a scribe for someone else. The parchment
 date is interesting, 50 AD—
 but not conclusive.

 The *kingdom* could be anything.
 The apocryphal one could have been
 a physicist; he could have been speaking
 about dark matter: the still space between
 lands of light. Photons and their mirror
 photons can change into each other:
 presence into image, image into presence.
 Mirror photons are undetectable,
 but they can form into mirror planets
 and even mirror stars, also undetectable.
 Darkness is reason enough to leap.

 Somewhere, there is a parallel world.
 The irrational with its own art of meaning,
 few will bear it, dross loosened from the
 mind turns to gold the moment you see
 your image in the void.

 Essence of awareness comes down to
 this: we yearn for presence, yet we
 pursue sequence. It is not in the order,
 nor in the things for which we long.
 It is in the still sense of how things
 are related. Dwelling, important too:
 enough windows to see a world beyond,
 walls with permeability, a few doors, and
 still more, an architect for our building.

Sabrina Dalla Valle
From *7 Days and Nights in the Desert (Tracing the Origin)*

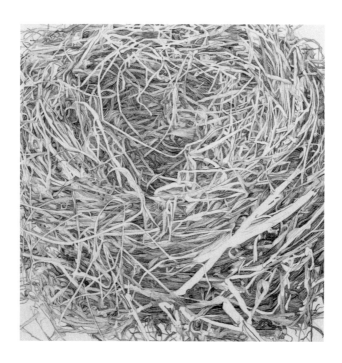

Jesse Schlesinger, *Construct III (to forget the name)*, 2009 (detail) (pl. 201)

Architecture of Life

Lawrence Rinder

The works discussed in this essay are illustrated in the plates beginning on page 71.

Architecture of Life celebrates the opening of BAMPFA's new Diller Scofidio + Renfro–designed home in downtown Berkeley, while looking beyond the physical design of this particular building to consider architecture as a potent metaphor for a variety of life conditions and experiences. Over the centuries, the idea of architecture has been widely employed as a framework through which to understand the fundamental nature of reality; intricacies of social relations; spiritual hierarchies; and the organization of self and psyche. Architecture helps to locate us in space and time while serving as a potent tool for reimagining and reshaping our world. This exhibition explores these themes with works spanning nearly two millennia from many corners of the world (and beyond), across diverse disciplines, from architecture itself to science, music, and art. *Architecture of Life* is a poetic excursion rather than an argument or comprehensive history. It aims to present revelatory images and objects that stimulate reflection on our experience of life through the lenses of structure and imagination.

Fig. 1 University of California Press Building, gravure by S. H. Murnik, c. 1940

The new BAMPFA is an amalgam of an existing building—a former printing plant designed in 1939 by the San Francisco firm Masten & Hurd (fig. 1)—and new interior and exterior spaces designed by Diller Scofidio + Renfro (DS+R). The most dramatic design gesture of the new building is a stainless steel–enclosed form that cuts across two sections of the old building: it extends from and encompasses the large theater, the main axial corridor and mezzanine, the entrance lobby, and the cantilevered cafe. The architects have compared this form to a sliced-open body or fruit, and appropriately, its interior is suffused with a visceral red. An early wooden model of this key element of the building possesses an uncanny, almost surrealist quality of ambiguous identity, suggesting a fossilized organ, a sex toy, or a strange tool for divination. The form is simultaneously mechanical and organic and has a hint of latent sentience. In a photograph submitted by the firm as part of the original competition, a hand presents the wooden model, but gingerly, as if squeezing too hard might wake it up (fig. 2).

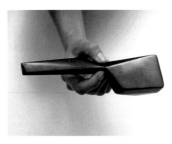

Fig. 2 Diller Scofidio + Renfro, *Hand holding a model for BAMPFA*, 2012 (pl. 70)

Even before the advent of the Internet of Things and the concept of the "smart house," architects were aware of the resonances between buildings and the bodies of those who inhabited them. Frederick Kiesler was one of the twentieth century's most ardent advocates of a visceral architecture. His Endless House designs proposed dwellings composed of continuous curved surfaces and cavernous, stomach-like volumes. Kiesler contradicted the prevailing functionalist approach to architecture, which he called the "mysticism of hygiene." He developed his own method, "correalism," embracing technical, aesthetic, psychological, physical, and spiritual aspects of experience within a matrix of constant change.

Lebbeus Woods, who like Kiesler was both an artist and an architect, extended the metaphor of buildings as bodies to imagine structures that have the power even to heal their own wounds, that is, to adapt to the damage caused by the inevitable disturbances of war, earthquakes, and economic catastrophe. Woods's view of architecture was based on a fundamentally dynamic view of nature and society. Rather than practicing architecture per se, Woods articulated a philosophical framework for understanding the interrelationships among individuals, buildings, politics, and natural forces. The works by Woods included in this exhibition—drawings from his series *War and Architecture*—represent a seemingly apocalyptic, yet strangely optimistic, vision of architecture in the devastated war zone of Bosnia. While showing buildings and landscapes in a state of ruin, Woods's drawings suggest spaces of possibility, gaps and accretions that might allow room for new life and new social formations. Woods's visionary buildings share with organic bodies the capacity for change and adaptation.

The architecture of society comprises its structures, hierarchies, and narrative underpinnings. David Chalmers Alesworth's intimate, realistic gouache drawings of street trees in Pakistan capture the improvisatory nature of everyday life: each of the trees has been imaginatively coopted into service as shelter, furniture, product display, or space for advertising. A novel could be written about the lives unfolding beneath each of Alesworth's trees. Narrative is even more explicit in Till Roeskens's video made with residents of the Aida refugee camp. Drawing as they speak, each subject—children as well as adults—makes visible the arduous pathways of daily life in a community divided by physical, political, and psychological barriers. Chris Johanson's paintings similarly map the maze of the urban environment. In his work, the inhabitants' thoughts are expressed in cartoonlike thought bubbles. Society gone awry is expressed allegorically in German Expressionist Willy Jaeckel's etching *The Tower of Babel* (1920), which shows a catastrophic spiral of doomed human forms. By contrast, the carved and painted model pole by Haida chief John Robson provides a perfectly structured vision of social order in the form of a sturdy, upright column composed of diverse symbolic beings. Each creature stands for a specific family or clan.

Buildings of various kinds figured prominently in Louise Bourgeois's imagery—whether in drawings, prints, or sculpture—and are almost always a metaphor for some aspect of her own inner experience. Her "lairs" resemble animal nests while evoking an identity that is hanging in plain view—naked and exposed—and yet also deeply internalized and replete with darkened cavities well suited for hiding. In a later drawing, she represents an infinite stair that, for her, symbolized the ladder of success; however, here too there is a potent ambiguity: Is her ladder going up or down? The contemporary Belgian artist Mark Manders's dreamlike work has comprised, since 1986, an ongoing project called *Self-Portrait as a Building*. One series of works within this larger project consists of casts of faces that appear to be wedged between layers of construction materials, like fossilized afterimages of the human spirit haunting built forms. A peculiar twist to this project is that the artist claims not to be the person of the same name (Mark Manders) whose identity is symbolically depicted in these works. Jay Nelson's monumental drawing *The Goodbye Ranch* (2007–9) pays homage to his friend and mentor, Carol Schuldt, who described to the artist her ideal home. Simultaneously portrait and architectural study, Nelson's drawing captures the peaceful cottage imagined by the legendary "Benevolent Queen of Ocean Beach."

A. G. Rizzoli—a Bay Area architect, artist, and novelist—created fantastical images of classical Beaux Arts buildings that were intended as portraits

of family members, friends, and acquaintances. The grandeur of Rizzoli's imaginary structures symbolized a quasi-spiritual experience of individual identity. Various personalities—even neighbors who hardly knew him—took on mythic dimensions in these exquisite renderings. In contrast to Rizzoli's over-the-top drawings, Will Yackulic's stoneware vessels are minimal and miniature. Like Rizzoli's, however, Yackulic's work is intended to translate individual identity into an architecture-like morphology or, in the artist's words, "a guide for a geometric taxonomy of personality."

Architectural interiors and gardens, too, possess a potent metaphorical resonance with aspects of self and psychology. James Castle, who was deaf and lacked the ability to speak, repeatedly returned to images of architecture as a means by which to organize his perceptions. In his studies of the interior of his rural Idaho home, the use of exaggerated perspective serves to locate the artist and viewer in space, providing a feeling of rootedness in relation to the built environment. In contrast, Dieter Roth's fifteen-color screen print *At Home* (1970) is imbued with a powerful feeling of erotic ebullience. The title of Roth's work provokes us to imagine his scene of incomprehensible frenzy taking place within the confines of a *gemütlich* domestic interior. Kenneth Anger's early film *Eaux d'Artifice* (1953) captures the architectural beauty and engineering wonder of the Renaissance fountain garden at the Villa d'Este while simultaneously expressing an intense, maniacally libidinal charge. Close-ups of patterns of spraying and falling water are interspersed with shots of the film's sole character—a woman in eighteenth-century dress—making her way around the labyrinthine garden. The channeling of potent natural forces by means of human design (the garden features some five hundred water jets) flirts with an apocalyptic outcome as the mysterious woman disappears in a paroxysm of water.

The classical Chinese literati garden was designed for the scholar gentry who practiced art, poetry, and politics and formed an official class in the highly regimented Confucian society. These gardens were aestheticized copies of nature used as private sites for meditation and renewal. For this exhibition, Qiu Zhijie has painted a large-scale wall mural using traditional ink brush technique to represent a literati garden from a contemporary perspective. The garden as a microcosm of life is captured with succinct poetry in Bruce Baillie's pastoral film *All My Life* (1966). Shot in a single slow pan and accompanied by Ella Fitzgerald singing Sam H. Stept and Sidney Mitchell's "All My Life," the film lyrically follows a rose trailing along an old wooden fence to evoke the image of life as an ephemeral, unpredictable meander.

The mandala is one of the most nuanced and quintessential motifs representing the architecture of mind and spirit. Originating in South Asia and widely used in Hindu and Buddhist traditions, mandalas are abstract images of the structure of consciousness and the cosmos. Their geometric form, akin to the Tantric diagram known as a yantra, is meant to evoke a spiritual architecture. Himalayan Buddhism has a very long tradition of complex mandalas that represent not only states of mind but also incarnations of various deities and enlightened beings—such as the two ancient and exquisite Tibetan mandalas of the deity Hevajra in this exhibition. Another, more recent, set of mandalas—brought out of Tibet in 1937 by the spiritual seeker and adventurer Theos Bernard and restored for this exhibition—represents a diverse range of spiritual personalities.

Stupas, which house sacred Buddhist relics, were sometimes built as part of elaborate complexes that mimic the form of mandalas. Included in this exhibition is a thirteenth-century Khmer bronze stupa distinguished by four niches, each of which holds a Buddha facing a different direction. This composition is suggestive of awareness that expands outward from a central point. Another instance of sacred architecture serving to direct and unify awareness is the mihrab, a niche built into a mosque that orients Muslims throughout the world to the holy city of Mecca. A portable version of the mihrab is found in Islamic prayer rugs, such as the Turkish example included in this exhibition, which depict an abstracted image of this sacred niche.

In some spiritual traditions the body itself takes the place of the mandala as a symbol of spiritual architecture and order. In a fourteenth-century sculpture from Tibet, the Buddha sits in meditation touching a finger to the ground, a gesture known as

the *bhumisparsha* mudra, which signifies his calling on the earth to witness his enlightenment. The *bhumisparsha* can be seen as an instance of meta-architecture, a moment in which the entire universe became organized around a flash of profound awareness. The body as focal point of cosmic awareness is suggested, too, in the Yoruba divination tray, a device used as means of communication with the spirit world. These trays, called *Opon Ifa*, are square or round wooden slabs that depict—through both representational and abstract means—the body, mind, and soul. With the face of Eshu—messenger of Ifa—carved at one end, the tray center becomes both literal body and figurative arena for divining *odus* (signs) made by the patterns of cast nuts, not unlike the trigrams of the *I Ching*.

In the twentieth century, mandala-like forms appeared in Western art as a motif with diverse spiritual connotations. Body, spirit, and architecture unite in Johannes Itten's *Encounter* (1916). Itten, one of the founders and key theorists of the early Bauhaus, was influenced by Theosophy as well as a quasi-Zoroastrian sect, Mazdaznan. In this painting Itten represented a shadowy human figure and building morphing together into a spectral double helix. The pioneering experimental filmmaker brothers James and John Whitney produced a number of extraordinary works from the 1940s through the 1970s that represent mandala motifs and incorporate a wide range of influences including Jungian psychology, alchemy, Hinduism, Taoism, and computer animation. James Whitney's film *Yantra* (1957) took nearly eight years to complete and was made by pin-poking complex, shifting patterns into 5×7 cards, which were then used to create an animation. He was able to finish his next film, *Lapis* (1966), in only two years thanks to his brother's donation of an analog computer, making this one of the earliest experimental films to incorporate computer technology. John Whitney's *Arabesque* (1975) is considered to be a seminal work of digital animation. Its vector-based images recall the complex curvilinear forms of Islamic architecture and are accompanied by a soundtrack featuring Manoochehr Sadhegi, master of the Persian hammer dulcimer, or *santur*. All three of these films have in common a spellbinding visual quality that shares with ancient

mandalas the capacity to transport viewers to an altered state of consciousness.

The American artist Ad Reinhardt created a series of nearly black abstract paintings that, like John and James Whitney's films, were meant to raise the viewer's level of awareness and perceptual acuity. In their strict geometry and organization around a central square, the *Abstract Paintings* recall the structure of a mandala; however, the profound sense of void imparted by these imageless works suggests the influence of Zen, which Reinhardt was exposed to through the Trappist monk and poet Thomas Merton. Although he was far better known for his proto-minimalist paintings, Reinhardt also made incisive and often caustic cartoons that laid out the structure and mechanics of the art world. One of the most complex and humorous of these diagrams was *A Portend of the Artist as a Yhung Mandala* (1956), which was designed as a double-page insert for the magazine *Art News*. In this work, Reinhardt borrows the geometric, hierarchical form of the Tibetan mandala to describe the various dimensions of an artist's career. Like Reinhardt, Marcel Duchamp combined Buddhist influences with a keen sense of humor and an awareness of the complexities of modern life. His sculpture *Boîte* (1966) is mandala-like in its use of an architectural metaphor to organize an image of the psyche; however, rather than representing religious deities, the contents of Duchamp's box are his own works of art, rendered in miniature. The box itself unfolds to become a tabletop gallery, or museum, for the artist's work, complete with walls and mounted displays.

Architect Gordon R. Ashby created several mandalas in the late 1960s and early 1970s to represent his vision of a more balanced and harmonious earthly existence. Several of these were printed for mass distribution as posters—using sepia and blueprint techniques—as well as appearing in the July 1970 issue of the *Whole Earth Catalog*, which Ashby guest edited with Doyle Phillips. In *The Transformer #2* (1970), images of human bodies, plants, animals, and planets coexist with an image of a computer's printed circuit board. Ashby's inclusive utopianism contrasts with the dystopian vision of Argentine artist León Ferrari's heliographic print *Planta* (1980/2008), from the series *Architecture of*

Madness. Designed to resemble an architectural blueprint, Ferrari's schema suggests a mandala of bureaucratic society, filled with offices as well as toilets and, oddly, plenty of beds. The central square in this office-city is empty except for a single figure, suggesting an experience of spiritual void. In 2005, the artist collaborated with Gabriel Rud to create a digital animation based on the original print. In this work, we are treated to a close-up fly-through of the soul-numbing spaces of Ferrari's imagined environment.

Some of the oldest works in this exhibition use architecture to organize an image, physically, narratively, and symbolically. The carved stone relief of the Great Departure, made in the Gandhara region of what is now Pakistan in the second or third century, and the twelfth-century Tibetan thangka depicting scenes from the life of the Buddha Shakyamuni both represent stories from the life of the Buddha ensconced in architectural settings. Another Gandharan stone piece from the second or third century uses the image of an architectural enclosure to focus attention on the Buddha—who holds his hands in the *vajra* ("teaching") mudra—while two pairs of muscular Herakles figures are depicted holding up the Buddha's dais in a manner that recalls the Greek caryatid. This mixture of Indian and Greek iconography and mythology is typical of the art of the Gandhara region.

Contemporary artists imbue elements of architectural form—such as posts, lintels, and arches—with evocative, personal resonances. Suzan Frecon's work merges a fascination with ancient architecture—especially Islamic building forms—with her own expressive painting style. Drawing the viewer's attention to the subtle qualities of her materials, Frecon brings them to a place where gesture, material, form, light, and color are unified within an imaginative architectural image. References to everyday reality in Avery Preesman's art are filtered through the artist's memory. His large silver painting was made in part as an homage to his father's childhood home, a farmhouse in the small Dutch village of Noorden. His wall relief, *Within S.W.S*, has the character of abstract architecture: Preesman describes it as "a mental dwelling/space." Laeh Glenn's untitled painting from 2013 is a colorless composition of curves, arches, and hollows that

evokes a dreamlike experience of architectural form. Al Taylor's wall reliefs similarly bring a lyrical sensibility to the exploration of built form. Taylor used found materials to create works that are both whimsical expressions of basic structural principles and mandala-like vortices.

The architecture of location is, metaphorically speaking, the creation of an awareness of relations through the organization of images and forms. Just as architects may choose to orient or disorient the occupants of their buildings, artists manipulate perceptions in order to underscore a particular sense of place or placelessness.

Gustave Caillebotte's painting *Le Pont de l'Europe* (1876) is a midday view of a busy thoroughfare in mid-nineteenth-century Paris. It is an actual location —a street close to the Saint-Lazare Station— represented with striking clarity. As realistic as the image may appear, however, research by Claude Ghez has shown that it is artfully constructed from several different perspectival views. The multiple angles that underlie the image of bridge, street, and buildings are analogous to the diverse human perspectives represented in this deceptively simple work: a strolling man and woman, a tradesman resting at the edge of a bridge, and a confidently striding dog each invest the image with a distinct experience and point of view. Caillebotte's bold depiction of the girders of the bridge suggests the underlying social and physical structures that unify any incidental dichotomies. George Ault's painting *August Night at Russell's Corners* (1948) is also a depiction of an actual place, a lamp-lit intersection in the town of Woodstock, New York. As much as this painting describes a specific location, it is equally redolent with the poetic resonances of the proverbial "crossroad" or mythical *axis mundi*.

Ganesh Haloi's gouache paintings scramble our sense of locale with compositions that oscillate between landscape, floor plan, and aerial view. These diminutive yet capacious works were inspired, in part, by the artist's recollections of the Ajanta Caves, where he was employed between 1957 and 1963 by the Archaeological Survey of India to document the site's ancient Buddhist frescoes. Haloi's fractured compositions recall the Cubist style of artists such

as Fernand Léger, whose 1912 study drawing for *Nude Model in the Studio* deftly interweaves marks evoking the contours of a female nude with lines defining the angles of the studio's interior forms and furniture.

Another work with a dramatic and (for its time) unconventional perspective is James Wallace Black's photograph of Boston shot from a balloon in 1860. The first aerial photograph made in America, this work is whimsically entitled *Boston, as the Eagle and the Wild Goose See It*. One hundred and fifty years later, satellite technology combined with digital imaging and computer algorithms made possible Muhammad Hafiz Wan Rosli's recent video *Point Cloud* (2015), which represents a year of lightning strikes on Earth. Much as Black's aerial photograph enabled a revelatory view of the structure of the city, Wan Rosli's animation allows us to see for the first time the patterns of electrical charges as they pass across the globe over the course of the seasons. A similarly vast scale is implied in Julie Mehretu's abstract print *Unclosed*. In this work, marks that allude to natural forms and forces are overlain with star-shaped motifs suggestive of a targeting or measuring apparatus.

While these works transform our sense of location by providing an expanded view, Paul Kos and Marlene Kos's seminal video *Lightning* (1976) presents a poetic challenge to the experience of location itself. Insofar as a sense of position depends on reliable coordinates, points of reference against which to establish one's own location, *Lightning* offers a simultaneously frustrating and dry-humored negation of this kind of dependable perception. The video consists solely of a shot of a woman seated in front of an automobile windshield. "When I look for the lightning, it never strikes," the woman says. "When I look away, it does." Indeed, the lightning only flashes when she looks away. The "Wow!" signal is an instance where the proverbial lightning strike was indeed witnessed. This signal—an apparent extraterrestrial communication—was captured by the Big Ear radio telescope, part of the SETI project located at Ohio State University, in 1977. A volunteer astronomer, Jerry R. Ehrman, noticed the anomaly in a sequence of numbers on a computer printout. He circled the evidence and wrote the word "Wow!" in the margin.

The ever-expanding definition of location is one of the themes of Yuri Ancarani's film trilogy *La malattia del ferro* (*The Malady of Iron*, 2010–12), which explores three extraordinary instances in which humans have extended their reach and expanded the spaces they can occupy through technology. One work in the series, *Da Vinci* (2012), was made using an endoscopic camera that takes the viewer inside a human body to witness a surgical operation involving a remote-controlled robotic arm. We see alternately the surgeon, seated at a computer console manipulating the hand controls of the so-called da Vinci machine, and the robotic mechanism cutting away diseased flesh deep inside the patient's body. *Il capo* (2010) is a study of a man whose job is to use delicate hand motions to guide—like a conductor—the operators of enormous tractors at a marble quarry. These machines are so large that the operators are unable to see directly the machines' motions and effects. *Piattaforma luna* (2011) documents the life of deep-sea miners, enclosed underwater for weeks at a time in a spaceship-like metal cocoon. In Ancarani's videos human beings manipulate space, material, and location in dramatic ways and stand on the verge of powers formerly unknown to them.

Even before the advent of high-tech machines, humans used devices to expand their ability to occupy ever-wider reaches of the planet. Micronesian stick charts condense information about the position of Pacific islands and ocean currents into succinct and beautiful geometric patterns. These charts enabled the adept Pacific navigators to make their way to and from remote atolls across the inconceivable vastness of the ocean.

Architecture is often used as a metaphor to suggest the passage from one state of being to another: interstitial experiences are represented through motifs such as doors, windows, screens, and ladders. Doors, for example, are a key motif in the work of Georgia O'Keeffe, who may have been initially inspired by a mandala she saw in the esoteric Buddhist publication *Secret of the Golden Flower*, assigned to her by her teacher Arthur Wesley Dow. Her paintings of doors include many depictions of a simple entryway to a house near Taos that she purchased in 1945. Her image of this dark, square portal suggests entry points into altered states of consciousness.

In Hedda Sterne's late drawings, a common motif is an ordinary window frame (often overlaid on the image of a branching tree), which provides a structuring principle as well as a powerful metaphor for her explorations of the imagery and energy that emerged during her meditative engagement with mark making. Her semi-abstract works capture a sensation of reality in a constant state of transformation, balanced uneasily between observation and imagination. Korean-German artist Hyun-Sook Song is similarly fascinated with transitional spaces; in one painting a ghostly figure appears to brush against a diaphanous curtain, as if touching the ephemeral boundary between realities. In another of Song's paintings, we see her mother's lifeless body, swaddled after death in preparation for burial. Here, the body itself forms a lintel beneath which lies access to another world. Do Ho Suh, also originally from Korea, similarly suggests a site of mystical transition in his image of a stair and doorway that appear to coalesce out of a formless scribble of red thread embedded in paper. Here, paradoxically, the same thread embodies both the condition of chaos and the passage out of it. For the Dogon of Mali, the transition between this world and the realm of the dead is traversed by way of a forked ladder that is propped against the deceased person's shrine, while in Stephen Kaltenbach's remarkable portrait of his dying father, the passage out of life is represented as a reabsorption into an infinite, spectral web. In Kaltenbach's monumental painting the "architecture" of transition is conveyed as reintegration with a deep, harmonic structure.

The forms of nature provide a primal architecture that has inspired artists, scientists, and architects alike. Berkeley artist Bob Stocksdale used the technique known as woodturning to create functional plates and bowls that reveal the exquisite inner structure and growth patterns of various species of trees. In his work, an awareness of the patterns of growth informs the ultimate form of the carved vessel. Jesse Schlesinger's drawing of a bird's nest combines exquisite draftsmanship with an acute attention to natural detail. Through modulations of light and shade, line and space, Schlesinger expresses the combination of

improvisation and order that is essential to the construction of the bird's woven dwelling.

In the late sixteenth century Bernard Palissy, a pioneering French ceramicist and engineer, combined his interests in ceramics and fossils (he was one of the first Europeans to understand the cause of these mysterious formations) to invent a remarkable new form of pottery. Palissy's ceramics incorporated casts of animals, especially the diverse creatures (such as crustaceans, snakes, and frogs) that inhabited the marshes near his home. Like Palissy, contemporary artist Tomás Saraceno harnesses natural forms and processes to create previously unimaginable structures. For his most recent series of sculptures, Saraceno placed spiders of different species within carbon-fiber armatures, some of which were periodically turned, resulting in remarkable web designs not seen in nature.

Images made as scientific illustrations can be equally powerful as artistic expressions of the fundamental forms of nature. Santiago Ramón y Cajal and Otto Lehmann each made significant contributions to scientific understanding of the world while representing their discoveries with extraordinary artistic skill. Cajal's youthful ambitions to be an artist were never realized—because of his father's disapproval—but his skill as a draftsman enabled him to make exquisitely detailed studies of neural networks. He won the Nobel Prize in 1906 for his studies of the nervous system and is considered to be the father of modern neuroscience. Cajal's contemporary Lehmann was among the first scientists to observe liquid crystals under a microscope. Lehmann made evocative drawings, photographs, and films of this phenomenon that capture its peculiar dynamism. Indeed, Lehmann's observations of liquid crystals' capacity for movement, as well as their apparent ability to copulate, inspired another leading scientist of the day, Ernst Haeckel, to propose that liquid crystals constitute a previously unknown form of inorganic life.

Haeckel, a biologist, devoted his career to furthering the understanding and acceptance of Darwin's theory of evolution. His drawings of diverse life forms were published as *Art Forms of Nature* in 1904, inspiring many Art Nouveau artists, designers, and architects with their fantastical

designs. Among the organisms Haeckel drew most often are the exquisite single-celled sea creatures called radiolarians. For this exhibition, Nipam Patel, professor of genetics, genomics, and development at UC Berkeley, has employed new imaging technologies to create animations of the same species that Haeckel first drew more than a hundred years ago. Ben Rivers's film installation *Origin of the Species* (2008) offers a highly personal take on Darwin's legacy. The film is a poetic portrait of a seventy-five-year-old hermit whose isolation in nature is enriched by his ongoing reflections on the evolution of life. Essential to the experience of Rivers's film is the fact it is screened inside a small shack not unlike that inhabited by the old man himself. For Rivers, the physical spaces we occupy are integrally linked to the spaces of the mind within which we imagine, feel, and think.

Viktor Schauberger was an Austrian forester who developed unique theories of fluid dynamics based on years of observing the flowing water in Alpine streams. During and immediately following World War II, when materials for constructing experimental prototypes were scarce, Schauberger made numerous beautifully rendered drawings of his concepts for machines driven by fluid vortices. Similarly, Wilson Bentley's discoveries came not from academic study but from close observation of nature. Bentley, a farmer and naturalist, made thousands of photographs of individual snowflakes, which he called "tiny miracles of beauty."[1] Inspired by Bentley, the Japanese photographer Yuji Obata developed a method for capturing images of snowflakes as they fall. The ability of photography to reveal the formal and structural properties of things—as well as their unique beauty—was exploited with particular grace by Karl Blossfeldt, whose black-and-white images of dozens of plant species possess a haunting, uncanny allure.

The forms of matter are inexhaustible: combined with the human imagination, life's possibilities can become extraordinary. Lee Bontecou's drawings and sculptures evoke unearthly creatures whose delicate bone-like structures surround pitch-black centers suggestive of an unfathomable existential abyss. In his disturbing portrait-like painting *Interior Landscape* (c. 1947), Pavel Tchelitchew appears to offer an X-ray view of the veins and arteries coursing through a human head. In this imaginary view, identity is reduced to the channels of life's vital fluid. The slightly unhinged feeling of Bontecou's and Tchelitchew's biomorphic imagery is echoed in Trenton Doyle Hancock's collage-painting *Rememor with Membry* (2001), in which the artist overlays a cacophony of text onto a cartoonlike forest scene. Hancock's piece suggests a barely repressed mania coursing through the fabric of life. The relatively understated work of Noriko Ambe nevertheless suggests the potent capacity of the imagination when unleashed on built form. Her exquisite abstract sculptures, composed of countless layers of cut paper, suggest both an eroded, tectonically shifting landscape and the eddies and currents of consciousness.

A similar juxtaposition of objective observation and subjective expression can be found in a drawing by the Renaissance artist Giovanni Battista Piazzetta. This work appears to be a classical study of hands; yet, in one corner of the work one notices that two of the hands are covering a weeping face. Luca Cambiaso's figure studies, representing the human body as a dynamic array of cubic volumes, offer another peculiar juxtaposition of rational and irrational affect. Particularly arresting are his drawings in which this structural approach to the human body is set within a dramatic, narrative composition, such as *Christ Nailed to the Cross* (early 1580s). The oddity of Cambiaso's style pales in comparison to the eccentric figures of Giovanni Battista Bracelli, especially his suite of drawings entitled *Bizzarie di varie figure* (1624). Here, bodies are given over entirely to the dictates of inorganic materials and structures such as boxes and ribbons.

The architect Mies van der Rohe strove for an anti-individual architecture; however, in his drive to expunge subjectivity Mies created works of crystalline clarity and visionary possibility. Mies's Barcelona Pavilion (1929) captures the architect's vision of a building as something so abstract that it virtually loses its function. This groundbreaking experiment in pure architecture—a celebration of transparency and interpenetration—served to display a single work of art and hosted just one event before it was demolished. Fred Sandback's sculptures, made from lengths of yarn arranged in simple geometries, sharpen our sense of space even as we are tricked

[1] Wilson A. Bentley, quoted in " 'Marvel of the Snow Gems': Microphotographs of Snow and Ice Crystals by Wilson A. Bentley," Richard F. Brush Art Gallery, St. Lawrence University, http://www.stlawu.edu/gallery/exhibitions/f/11bentley.php.

into seeing planes that aren't there. His sculptures are Miesian in their embrace of void as an architectural building block, yet the lyricism of his forms preserves a sense of idiosyncrasy and physical poetry. Order and harmonious geometry prevail in the work of Buckminster Fuller and Ruth Asawa, who spent time together at Black Mountain College in the late 1940s. Fuller's famed geodesic dome—based on mathematical formulas—revolutionized architecture and introduced a host of new formal possibilities. Asawa, working with similar principles, channeled her creativity toward sculptural works that recall diaphanous sea creatures or perhaps the skeletons of limpid hanging plants.

European lace is an extraordinary manifestation of the intersection of imagination and engineering. Derived initially from Venetian net making, in the sixteenth century lace evolved into one of the most refined art forms of Europe. While early lace often involved removing areas of a linen fabric to create a grid-like matrix into which designs could be embroidered (known as *reticella*), the medium arrived at a stage of creative maturity when its practitioners learned how to create intricate fabrics solely from needle and thread, without a pre-existing ground (known as *punto in aria*, or "stitches in air"). The designs, and sometimes imagery, of antique lace suggest the profoundly inventive spirit of the makers who were able to construct, at a microscopic level, physical structures that express the subtle energies of the natural world. In her documentary video *Thread Routes—Chapter II* (2011), Kimsooja explores the practice of lacemaking in Europe, touching on the implicit relationship between the finely articulated lace patterns, natural geometry, and architectural—especially Islamic and Gothic—ornament. The sense of harmonious connection between art and nature in Kimsooja's video is echoed in the barkcloth drawings of the Mbuti people of Central Africa's Ituri Forest. These drawings are remarkable for their dynamic structural complexity, suggesting either maps or, perhaps, notations of forest sounds. Each drawing evokes a world of profound balance and interconnection.

The baskets of California's Pomo tribe are extraordinary not only for the fineness of their techniques (plating, coiling, and twining) but also the inventive use of materials, such as shells, beads, and feathers, to create visually stunning and sensual surface compositions. Whether made as functional containers, gifts, ceremonial offerings, or marketable aesthetic objects, Pomo baskets derive their beauty from the subtlety of their structure combined with a keen attention to the visual effects of pattern, proportion, material, and color. Like the lace and basket makers, the early twentieth-century American ceramicist George Ohr combined virtuosic technique, formal innovation, and an exuberant personal spirit. Known as the Mad Potter of Biloxi, Ohr perfected a method that enabled him to create exceptionally thin ceramics; however, he purposely contorted the forms into grotesque shapes that challenged the tastes of his day. June Schwarcz's enameled vessels share some of the idiosyncrasy of Ohr's work. Her ability to create a seemingly inexhaustible variety of forms derived in part from the innovative use of a copper foil or mesh substrate. The copper material can be folded, twisted, gathered, and pinched before being electroplated.

"String figures" are diagrammatic images composed of lengths of string held between two hands and manipulated into various patterns. They incorporate a shorthand lexicon of geometric lines to represent aspects of the maker's environment and imagination and are often created in sequence as a means of visual communication and storytelling. The eccentric artist, musicologist, and filmmaker Harry Smith amassed the collection of string figures included in this exhibition. Renaissance artist Carlo Urbino's *Huygens Codex* (which for a long time was believed to be the work of Leonardo da Vinci) resembles the string figures in its condensation of information—in this case, the structure of the human body—into a series of geometric patterns. This series of figure studies is remarkable especially for its visually arresting time-lapse images of bodily motion.

The twentieth-century composer Iannis Xenakis combined sonic forms based on the principles of mathematics and physics with personal expressive nuances. Xenakis also studied architecture and worked for a time in the studio of Le Corbusier. Throughout his career, Xenakis integrated music and architecture in a mutually inspiring dialog. One of his early works, *Metastasis* (1953–54), incorporated Le Corbusier's mathematical ideas, Einsteinian notions

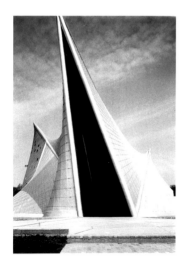

Fig. 3 Exterior view of the Phillips Pavilion, designed by Le Corbusier with Iannis Xenakis, c. 1958

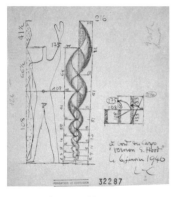

Fig. 4 Le Corbusier, Modulor diagram, 1946

of time, and Xenakis's personal recollections of the sound of gunfire experienced during World War II. Upon completing *Metastasis*, Xenakis used elements of the musical score—such as parabolic curves—to inspire his architectural design for the Philips Pavilion at Expo 58 in Brussels (fig. 3). Xenakis borrowed a design system, called the Modulor, from Le Corbusier. Based on the proportions of an "average" European male, the Modulor (fig. 4)—reminiscent of Carlo Urbino's mathematically proportioned drawings of a human body—was used to determine the ratios among the varying widths of panes of glass in the innovative facade Xenakis designed for the Convent of Sainte Marie de La Tourette. Xenakis likened this design to musical polyphony and Le Corbusier himself described it as "musical panes of glass."[2]

Felix Schramm's sculptural works create the impression of a powerful explosion of architectural fragments. The piece in this exhibition looks as if it were a portion of another building that has been thrust through the wall of the museum. The violence implicit in Schramm's work is balanced, however, by the uncanny impression of a freeze-frame or time standing still. Robert Overby's *Broken Window Maps* (1972) resonates with Schramm's piece as an expression of frozen destruction. Here the panes of a broken window are presented as a serene series of canvas cutouts, which themselves are based on latex molds taken from the original broken glass. Through these stages of representation, Overby transforms an instance of violence into an opportunity for reflection and even serenity. Gordon Matta-Clark's series of photographs *Window Blow-Out* (1976), on the contrary, eschews mediation to portray raw destruction: an array of images of broken windows at an abandoned South Bronx housing project. However direct they may appear, Matta-Clark's photographs set the stage for a much more immediate act of violence. Invited to participate in an exhibition, *Idea as Model*, at the Institute of Architecture and Urban Studies, the artist first proposed to include these South Bronx photographs (a critical gesture in the context of the conceptual bent of the other architects' work on display), framed by a number of broken windows. Matta-Clark brought a BB gun to the gallery and, instead of breaking just a few windows, shot out all the windows on the floor, while raging against

[2] Le Corbusier, quoted in Kirsty Beilharz, "Designing Sounds and Spaces: Interdisciplinary Rules & Proportions in Generative Stochastic Music and Architecture," *Journal of Design Research* 4, no. 2 (2004), http://www.inderscience.com/jdr/backfiles/articles/issue2004.02/Art2.html.

the work and ideologies of the other exhibitors, his former teachers at Cornell University.

Architecture as a healing act is the subject of Brent Green's feature-length film *Gravity Was Everywhere Back Then* (2010). The film was shot in the artist's Pennsylvania backyard, where Green constructed a replica of a house designed and built in the 1970s by Leonard Wood, a clerk at a hardware store in Kentucky, as a means to heal his wife's terminal cancer. The catastrophic Tohoku earthquake and tsunami inspired architect Toyo Ito and a group of colleagues to devise a design and construction system that would enable the people of the affected communities to restore their built environment. With the residents of the devastated village of Rikuzentakata, Ito and his team—including Akihisa Hirata, Sou Fujimoto, and Kumiko Inui—designed and built a small community center from saltwater-soaked logs and other detritus. Rosie Lee Tompkins's quilts—which Africanist Robert Farris Thompson has compared stylistically to Mbuti barkcloth drawings—were made as healing meditations: each quilt that Tompkins pieced was composed with a particular person, and their well-being, in mind. Structure and rhythm combine with an imaginative use of material and color, as well as openness to chance and variation, to create visually exquisite and emotionally powerful works.

What is the "architecture of life"? It is the architecture of the body, mind, spirit, and society. It is the architecture of matter, energy, and form. And it is the architecture of buildings themselves, buildings that not only shelter us and help to shape the forms of our daily lives but also are imbued with the powerful metaphors of this versatile idea.

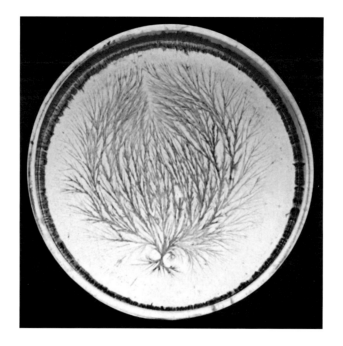

Fig. 5 Sabrina Dalla Valle, *Untitled (crystallography experiment with lemon verbena decoction)*, 2001

Hearing the Metron

Sabrina Dalla Valle

In mother's pulse, her soul's tempo between elation and crisis—
expanding and contracting with her breath in tension of her body

trawled in the medium, through dynamics of intangible arrangement—
a Meter working through density and dissolve: we are made.

Body and breath are symbiotic houses; attention inhabits
as if it were its own being—drawn in, extending outward . . .

The notion that life has its own architecture suggests there are subtle designs in human experience that somehow form a coherent unity. One way to become more intimate with this dynamic is to look at *manifested presence* as an occasion of an interiorized sense of time, a state of being in a practiced place that gives birth to its own tempo, which can be externalized through our creative work.

On a very practical level tempo can be understood as movement between expansion and contraction, inherent in forces that hold matter together. Buckminster Fuller was an engineer who worked with this principle. He is best known for his semispherical geodesic domes that appear to cohere as if by magic (pls. 82–83). These isodecahedron constructions are built by leaning individual triangular planes into each other to form a ball without the need for interior supports, as the whole is suspended by intertensional forces (continuous tension and discontinuous compression).

Fuller took a novel approach to structure and its stabilization by making direct contact with the underlying forces of matter. His methodology of construction arose from a deep awareness that led him to break out of what he considered an "artificially flattened and verticalized conceptualization of the world," a boxed-in attitude that could only generate unsustainable, contrived systems as opposed to naturally lawful ones.[1]

Not concerned with invention constructed in abstraction, Fuller followed "the free mind" as it flows *into, out of,* and *around* the forces of physical dynamics that make up the integral universe. By doing so, he unwittingly realized solution-driven knowledge. "Commit yourself to what nature wants to be done and you will be supported by nature."[2] In this devotional relationship, we can expect no lesser consequence than emergent vitality.

Our mythical consciousness also points to this union, as portrayed in the Greek myth of Atlas. More than the Titan who stands as scaffold of the *kosmos* and guide for those navigating through it, Atlas is the consort of Pleione, a

1. Buckminster Fuller, in "Into the 20th Century," *Buckminster Fuller: The Lost Interviews* (Santa Monica, CA: Group W Cable, 2005).

2. Ibid.

nature spirit with whom he creates the Pleiades, the constellation known by ancient Egyptians as *Per Ankh*, the "House of Life." Since *life* is processual with time, in its broadest definition, *nature* is here understood as the cosmic tempo pulsing in matter.

In contemplating creative work through time, it is possible to explore the atlas of the mind's own processes while attending to the fulcrum of the metronome disclosed in the resonances of the universe. Consciously or unconsciously, those who create join in building a "house of life" by internalizing nature's tempo, showing a personal sensibility for relationships or a sense of proportion and measure through rhythm. This suggests there are deliberate systems of living structure that come through a given work made out of its own *metron*, a measuring which in turn gauges the very nature of the artist energized by hidden pressures and internal resistances. Ultimately, the *metron* is music as it appears to us through intricate ratios entangling the artist, the medium, and the context. For music is a cymatic event; it is everything that happens.[3]

Indigenous people experience the tempo of nature as an event, and create with it for their physical and spiritual survival. Micronesian stick charts (pls. 142–43) and Mbuti barkcloths (pls. 135–40) are two kinds of documents that express direct and individualistic systems of visual signs as notations of intangible subtleties that shape two different environments: ocean and forest. Both record how people perceive place through the sense of listening—one through sound, one through pauses between sounds.

Precolonial Micronesian people lived in a world of wide-open ocean studded with islands spread across vast distances. Their navigational guides were the sounds of waves throbbing against the canoe. An experienced canoer could lie down in the dark hull and through acute listening accurately visualize wind direction, water depth, and current flow as proportional functions of distance from shore. With closed eyes, one could perceive the contours of a course from origin to destination. After a journey had been completed, the canoer could make a stick chart as a navigational map indicating movements in water and air along the way. But this documentation was never confused with the immediate connection between navigator and ocean. Rather, it served as a rhythmic, mnemonic device, an experience of the *metron* that was purely personal and never to be shared.

The Mbuti of the Congo dwell in a different natural matrix: in the immense forest's imposing presence. Their migrating, forager life follows the rhythms of intensifying and diminishing light pouring through the canopy in mercurial array. The Mbuti collectively speak to their arboreal world in songs without words, to wake up the trees, hear their own lyrical beauty, and safeguard a delicate dependency. With the energy of quick improvisation, specially trained artists, each in their own style, inscribe this sacred syncopated score between human and environment on tree-bark cloths. Their notation is a sequence of curves and lines—direct signs of nature's camouflaged patterns in combination

3. Cymatics is the study of visible sound wave vibration moving through and influencing matter.

with simple geometric shapes. What could look like a futuristic binary map is in fact a careful designation of the forest matrix, a deep observance of movement, form, and primordial sound frequencies.

These frequencies ring in internal conversation with nature, incorporating "the quiet between sounds," what is known in Mbuti language as *ekemi*. This quiet is "the nature of gesture, mime, and the hunt," which heightens spiritual presence as a structure.[4] The Mbuti concept of *ekemi* points to what lives outside of ordinary feeling in a sensitivity for what is both present and absent within the deeper structure of reality. Can we say there is a human-neutral quality of archetypal marks, a kind of dynamic cipher of movement decoded in limitless ways according to the maker's quality of presence?

One need not live in direct relationship with nature to sense the *metron*. There are many ways to sense the pacing of units that flow into a kind of rhythm that integrates all parts into a holistic permeable state—but there is always a fulcrum. Le Corbusier created the Modulor, subsequently adopted by Iannis Xenakis, as a fixed unit of measurement to determine the proportions of architectural structures. It uses the height of a six-foot man as a basis for construction, establishing a human scale within a given periodicity. This periodic nature of design was the key signature that Xenakis carried over to his musical composition. For Xenakis, each beginning already has a set tempo, no matter what the random or intentional process may be. This tempo releases indeterminate possibilities of form into the world.

This notion of periodicity first occurred to Xenakis as a physical kind of epiphany or satori at a moment when he was protesting in a crowd in Athens. He was struck by the periodic pulse of slogan chants interspersed with clouds of sound, spontaneous and unified like a flock of swallows in movement. Xenakis explored this very nature of periodicity in his contemporary music compositions by aiming for density, which can be understood in terms of a number of events per second, with intervals from periodic to chaotic. Each musical score is built from a series of sound sequences ordered through mathematical probability (pls. 253–54, 256, 260). This makes his music more spatial than temporal—demanding that listeners stand within an experience of listening as dwelling in a space of unfamiliar angles and depths. Xenakis's music can generate an intuitive sense of how parts relate to a whole within a personal experience of biosphere.[5]

But this communication between inner and outer space is not always so easily accessed, as we see in the case of the controversial Ernst Haeckel, who struggled to reconcile this duality for most of his life before finding his own harmonious tempo. Haeckel was both an oceanographer who measured the ocean's depths and a plein air painter who freely interpreted the moods of nature—living in tension between meticulous scientific observation of the outer world and the imaginative quality of the inner world. Was one more significant than the other? Could they be separate? He sensed that somehow

4. Colin Turnbull, *Wayward Servants: The Two Worlds of the African Pygmies* (New York: Natural History Press, 1965), 278–86.

5. Iannis Xenakis, "Autobiographical Sketch," http://www.iannis-xenakis.org/xen/bio/biography, originally published in Gérard Montassier, *Le fait culturel* (Paris: Fayard, 1980).

the structures of outer forms disclosed an inner dynamic life. His professional research on radiolarians (pls. 88–93)—protozoa built out of mineral skeletons, each unique as a snowflake with its own structural alphabet spelling out inexhaustible possibilities—became his portal to an apprehension of the creative power of nature's tempo.

Haeckel was influenced by Goethe's botanical writings, which introduced a novel approach to botany. This method focuses on observing the living form of a plant in its full life cycle from seed to seed, guiding the observer to an inner experience of formative forces. The signature of a plant is understood not as a picture of its mature physical form, but rather as a processual movement from one structural phase to another.

Moreover, Goethe observed that there is something about the rhythm of the movement of the imagination when it follows the plant from one stage to the next that kindles the inherent powers of thinking. With a holistic orientation, the mind is trained to perceive the forces that shape the cohesion of observer, observed, and observation. For Goethe, thinking is stimulated by such a practice, just as eyesight is stimulated by light, hearing by sound, and so on. Goethe considered thinking itself an organ of perception; this kind of botanical observation of what is dynamic in the plant could lead what is dynamic in the human being to what is dynamic in the universe.[6]

After a long epistemological struggle, Haeckel's most deeply integrated realization was that with focused attentiveness we can begin to hear the inner content of the nature of things to the point that "when you feel their life, you are moved by such great love."[7] This suggests that there is a reciprocal quality that occurs in consorting with the periodicity of nature. Time (life) as a subjective experience of being (love) means time itself is being, and all being is time.

This notion of presence as an interiorized spatial quality insinuates a kind of experiment with reality. Leaning on the pillars of etymology, the Latin word for "experience," *experimentum,* also means "experiment." As we engage with building a house of life, we shift in our experience of time from a quantity to an inner quality, and in our experience of space as a three-dimensional reality to an inward experiment on a field of tension that is the agent of the acute energy of time.[8]

For at its most basic unit, the pendulum is always swinging.

Whether we are aware of it or not, we live in function with the *metron,* with the possibility to bring our own glossolalia to bear on the house of life. Accessing the deeper structures of reality through our being is a simple process. Breath exists in rhythm. We can catch this moment if we look at the Greek word *metron,* which describes the poetic measure in the cadence of the spoken word. The Latin translation is *meditor,* which also means "to meditate." So even language as a score for pure thinking is a kind of meditation or presence that moves the mind in tempo with the soul to hear the *metron.*

6. As described by Rudolf Steiner in *Goethe's World View,* trans. William Lindeman (Spring Valley, NY: Mercury Press, 1985).

7. Ernst Haeckel, quoted in *Proteus: A Nineteenth Century Vision,* written and directed by David Lebrun (Los Angeles: Night Fire Films, 2004).

8. Concept derived from Jean Gebser, "The Irruption of Time," in *The Ever-Present Origin,* trans. Noel Barstad (Athens: Ohio University Press, 1985).

Perhaps Fuller's notion of gravity—"What man thinks is physical is not physical"[9]—can provide an entry into a place of listening to the syncopations of vivacious montage that live in the undercurrents of our attention, in the deeper structures of reality. If we can find a way to interiorize our awareness of time and space, affording new possibilities in the architecture of the universe, we can perhaps make more concrete bridges *into, out of,* and *around* our multiple cacophonies, to apprehend the ever-present in a place of power and self-sustaining harmony.

> Invisible parts in perfect ratio with visible ones, yet more than proportion, building is a gauge of one's very nature.

> This is the Metron: steering in so far as we can endure the greater dimension— what covers the distance between our current necessity and the mystery of provenience.

> The invisible preserves its presence in what is familiar, ourselves measured against where we came from: spanning and returning.[10]

March 2015
St. Petersburg, Florida

9. Fuller, in *Buckminster Fuller: The Lost Interviews*.

10. Concept derived from Martin Heidegger, ". . . Poetically Man Dwells . . . ," in *Poetry, Language, Thought*, trans. Albert Hofstadter (New York: Harper & Row, 1971).

SKETCH-PLAN, SHOWING THE MORAINES, *a, b, c, d, e,* OF THE MER DE GLACE.

Fig. 6 Sketch-plan of the Mer de Glace from John Tyndall's *Forms of Water*, 1875

Architecture and Life: Biological Analogies and Tectonic Oppositions

Spyros Papapetros

"What is life?" The question posed by Nobel Prize–winning physicist Erwin Schrödinger in the title of his well-known 1944 essay has no singular answer.[1] Descriptions attempting to interpret life are themselves vital forces—motivating agents that impel the natural and the human sciences, as well as the arts, to rethink their own existential conditions. Through their circular transformation from antiquity to the present, questions about the origin of living matter offer a *model* of life in its diachronic complexity and strenuous resistance to a singular system of interpretative coordinates.

If life adheres to such interpretative variety, what would its *architecture* be or look like? Is the "architecture of life" a unified system of harmoniously organized particles or a chaotic pile of fragments whose aggregate condition reflects life's own mutability and heterogeneity? It appears that the title that encompasses the rich variety of objects in this exhibition describes an analogical relationship between architecture and life whose parameters remain constantly fluid. Is the architecture itself living or does it simply provide the conditions for life? Are the objects—drawings, paintings, sculptures, and architectural models—alive or do they activate life by their material inertness? In other words, is the architecture collectively articulated by the artifacts on display a rigid, inorganic frame that protects life via its stark opposition to the vital plasticity of organic beings, or is it a pliable threshold that vibrates sympathetically with the living matter it temporarily encloses but can never permanently possess? And finally, moving from what this architecture *is* to what it can *do*, is the "architecture of life" a mechanism that converts social, political,

and cultural conditions into spatial, territorial, and geographic parameters, or a device for undermining and transgressing previously established limits and fixed ontological or epistemological boundaries?

The exhibition *Architecture of Life* does not attempt to interpret or explain life. Refusing to classify "living" architectures and works of art in morphological or other identifiable categories, it creates a heuristic *pattern* of life by arraying, ornamentally, the variable responses of eponymous artists, architects, and anonymous artisans to life's variable architectural and cultural inscriptions. We tend to associate the term *architecture* with a clear structural and methodological system or a fixed set of tectonic principles that form solid analytic propositions in either physical or mental space, but it is precisely this systematic architectural view that both modern conceptions of life and this exhibition refuse to consolidate.

The inner vitality of *Architecture of Life* springs from the dynamic redistribution of the processes of the living world and products of human labor across temporal periods and geographic borders. It potentiates the building of new alliances and analogical correspondences between seemingly distant material species and families of art into alternate cosmological constellations. Because *Architecture of Life* resists closure into a regular symmetrical design, it is essentially a blueprint, not of a building materialized in the past, but for a future, perpetually incomplete project. By way of understanding this project, one could in fact regroup the exhibition's markedly heterogeneous artifacts according to the various degrees of fixity and fluidity that they manifest in their ontological

1. Erwin Schrödinger, "What Is Life? The Physical Aspects of the Living Cell" (1944), in *What Is Life? Mind and Matter & Autobiographical Sketches* (New York: Cambridge University Press, 2012).

oscillation between man-made artifacts and natural specimens. Following a drastically condensed survey of architecture's diachronic, albeit uneasy, relation to life, this essay retraces a virtual trajectory from static form to fluidity in a series of analogical stages arranged in a nonchronological order, including the several loops and spiral regressions that such an architectural reconstruction of life necessarily entails.

Life out of Bounds

One of the strongest ambitions of interdisciplinary scientists of life such as the German biotheorist Ernst Haeckel was the elimination of limits not only between the objects of the natural world, such as organic and inorganic substances, but also between the areas of knowledge that inquired about their formation. From the human sciences of anthropology and ethnology to the natural sciences of animal and plant physiology as well as geological, mineralogical, and crystallographic discourses, a general idea of animate life that bridged organic with inorganic materials also steered a radical reclassification of the scientific faculties that investigated the development of both human and natural beings.

In the preface to his book *The Life of the Inorganic World* (1914), Walter Hirt, a medical scientist, polymath, and disciple of Haeckel, proposes a methodological unification of the specialized fields of botany, chemistry, histology, geology, medicine, physics, physiology, and zoology, with the ambition of discovering analogical relations between the biological and mineralogical sciences.[2] Life and death are not definite conditions for Hirt. Even living organisms can periodically escape the biological demands of life—as with animals during the period of hibernation or the Indian fakirs, who in their prolonged periods of meditation become as imperturbable as stones.[3] And certain proteins that are considered essential for the production of life, Hirt reminds us, are in fact absent from several animal substances, such as nails, teeth, hair, or the bark of trees.[4] Inorganic matter shields the appendages of organic bodies, human, animal, and vegetal, with the solidity of a mineral substance. "Everything that has an effect as something living, must be enveloped," Goethe had once famously declared.[5] Following Goethe, turn-of-the-century scientists like Hirt (and, a few years later, Freud in his remarks on the inorganic

nature of the "protective shield" covering the psychic apparatus) remind us that this very envelope that grants the effect of life needs to be, at least partially, inert.[6] The tectonic division of a dense yet permeable threshold regulated the exchanges between not only an organism and its environment but also the very processes of life and death. Stretching this threshold to its limit, and following the studies of liquid crystals produced by Haeckel and the crystallographer Otto Lehmann (whose drawings are featured in this exhibition; see pages 46–47 and pls. 127–130), Hirt argued that minerals also have outer surfaces similar to skins through which they can breathe and communicate with their environment.[7]

The formation of permeable tectonic divisions such as skins within an otherwise "fluid" state of being signaled that within this seemingly indiscriminate amalgamation of sciences and substances created around the turn of the twentieth century, there still needed to be a guideline or contour—some epistemological parameter that, even if reduced to the level of a metaphor, would describe the methods of organization within the processes of life now expanding from human and animal organisms to vegetal and mineral structures. This metaphor was properly *architecture*: the very practice that would initially appear to fix and stabilize matter was reemployed in order to transform, move, and even animate formerly dead materials by its tectonic powers of organization. And it was precisely the emerging science of *tectonics*—the discipline interrogating the formation of buildings, mineral formations, and animal organisms—that offered an insight into the processes of life and their impending *architecturalization* (to borrow a term used in the twentieth century by Le Corbusier) as they strived to adapt within a rapidly transforming environment. Architecture, then, was understood not only as a system that facilitated living processes, such as the movement or repose of human bodies, but an entity that is itself animated—akin to an enclosure that, like the crystalline skin outlined by Goethe and Hirt, was not independent but actively participated in the events it enveloped. Furthermore, tectonics here signified not only the interior or exterior structure of a building or a living organism, but a comprehensive mode of organization on both a formal and a spatial level.[8]

2. Walter Hirt, *Das Leben der anorganischen Welt: Eine naturwissenschaftliche Skizze* (Munich: E. Reinhardt, 1914), iii, vi.

3. Ibid., 23.

4. Ibid., 12.

5. "[A]lles was lebendig wirken soll, muß eingehüllt sein," from Goethe's "The Purpose Set Forth" ("Die Absicht angeleitet"), foreword to his 1807 text "On Morphology" (*Zur Morphologie*). See Johann Wolfgang Goethe, *Naturwissenschaftliche Schriften*, in *Goethes Werke* (Hamburg: Christian Wegner, 1948–1960), 13:54–59; and J. W. Goethe, *Scientific Studies*, in *Collected Works*, vol. 12, ed. and trans. Douglas Miller (Princeton, NJ: Princeton University Press, 1996), 63–66 (translation modified).

6. On Freud's use of the term "protective shield" or "protection against excitation" (*Reizschutz*) in his *Beyond the Pleasure Principle* (1920), see the entry on this term in *The Language of Psychoanalysis*, ed. J. Laplanche and J.-B. Pontalis, trans. Donald Nicholson-Smith (New York: W.W. Norton, 1973), 357–58.

7. Hirt, *Das Leben der anorganischen Welt*, 78.

8. On a history of theories of tectonics in architecture, see Kenneth Frampton, *Studies in Tectonic Culture: The Poetics of Construction in Nineteenth and Twentieth Century Architecture* (Cambridge, MA: MIT Press, 1995).

This analogical relation between life processes and tectonic modes of organization unites most of the objects in this exhibition. Architecture and life are neither ontologically nor epistemologically the same. The architecture of life describes an *analogy* predicated on distance and emulation and not a *homology* produced by copying and grounded on identification. Nineteenth-century vitalist philosophers describe "the soul as the *architect* of its own body"—an agency that organizes all functions in animate organisms and yet remains ontologically distant from the body it possesses.[9] The soul itself is not life; it is not "living" (*vivant*) but "vivifying" (*vivifique*), as it only enables the conditions of life to take place.[10] Similarly, architecture is predominantly considered as a *condition* for human and other forms of life; though potentially animated, it is not alive. And, while animist and vitalist conceptions of matter envelop architecture in the late nineteenth century, their respective "influence" is not the same, as each is based on a different philosophical and ontological framework.

The Tectonics of Nature, Part I: Forms of Water

For a long period of time, life and its enabling conditions were thought of as a unit. "Life and the conditions of life are in necessary harmony. This is a truism, for without the suitable conditions life could not exist. But both life and its conditions set forth the operations of inscrutable Power. We know not of its origin; we know not of its end." Thus writes the nineteenth-century British physicist John Tyndall in his popular study *The Forms of Water*, examining "clouds, rains, and rivers" as well as "ice, snow crystals, and glaciers."[11] For Tyndall, water may not be alive, but it is a necessary "condition" for the emergence of life. Water acquires a living quality via its circuitous transformation from cloud to rain, river, and glacier traversing the aerial, liquid, and solid condition. It transitions from content (river or oceanic stream) to container (glacier) that punctuates with its hard surface the masses of liquid matter. Water *is* architecture, an architecture of life, in its very indecisiveness between frame and content, structure and force, including the all-pervasive yet "inscrutable Power" invoked by the nineteenth-century physicist.

Historians and critics often describe the nineteenth century as the era in which the main

signifying term representing life shifts from "structure" to "power," a vital force that does not have a permanent form, but continuously transforms, and which Tyndall describes as having no knowable "origin" or "end."[12] From nineteenth-century science and natural philosophy to the literature and art of Romanticism, life is presented not as a predetermined or a priori formed structure, but as a force that is often unpredictable, irrational, and transgressive, moving against the very parameters that attempt to regulate or formalize its impact into repeatable standards. Within the cataclysmic revolutions of the new industrial age, development and evolution become the defining processes of life and therefore its "architecture" has to adapt to these shifting parameters. If life and the vital impulse are informed by their very resistance to a stable definition, such a nonconformist attitude expands to the architecture that ostensibly shelters these riotous life processes.

Tyndall evokes this *fluid* form of architecture in sections of his *Forms of Water* on the "Architecture of Snow" and the "Architecture of Lake Ice," while demonstrating that even in the solid form of a large glacier, such as the Mer de Glace (Sea of Ice) glacier in the French Alps, water is still in movement and propels the motion of these crystallized architectural formations on both a micro and a macro level.[13] For example, after analyzing the tectonics of individual snow crystals (similar to the microphotographs by Wilson Bentley included in this exhibition; pls. 31–42), Tyndall describes the tapestry of "beautiful" microscopic "liquid flower[s] with six petals" created by the nonuniform "diffusion" of the liquefaction of an ice beam.[14] Then the scientist transitions into a large-scale aerial view of the massive bifurcating "branches" of the glacier drawn in a "sketch-plan" (fig. 6).[15] The inner life of the icy landscape informs Tyndall's lively narration, which addresses readers as fellow travelers and observers of these Alpine landscapes in real time, breaking with the usual pattern of normative scientific descriptions.[16]

Water's architecture in motion is reanimated by Kenneth Anger in his 1953 short film *Eaux d'Artifice*, shot at the Villa d'Este in Tivoli (fig. 7, pl. 19). Throughout the twelve minutes of the film, we witness a stream of water channeled through a series of architectural features as it

9. Albert Lemoine, *Le vitalisme et l'animisme de Stahl* (Paris: Germer Baillière, 1864), 66.

10. Ibid., 54.

11. John Tyndall, *The Forms of Water: In Clouds and Rivers, Ice and Glaciers* (New York: Appleton and Company, 1900), 125.

12. Denise Gigante, "Introduction," in *Life: Organic Form and Romanticism* (New Haven, CT: Yale University Press, 2009), 1–48.

13. "Architecture of Snow" (29–32), "Architecture of Lake Ice" (35–38), and several sections on the "motion" of glaciers (59–98), in Tyndall, *The Forms of Water*.

14. Ibid., 35.

15. Ibid., 50–52.

16. Tyndall addresses criticisms of the "vividness" of his description in his "Preface to the Fourth Edition," in ibid., xviii.

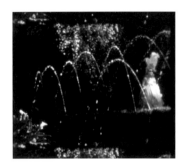

Fig. 7 Kenneth Anger, *Eaux d'Artifice*, 1953 (still) (pl. 19)

Fig. 8 Interior view of Henry van de Velde's house in Uccle, *Architectural Review*, 1948

constantly flows forward along with the movement of the camera and a mysterious human figure (dressed in an eighteenth-century costume with oscillating feathers) who runs swiftly from one space—cave, grotto, garden—to the next.

But perhaps this is not the *real* architecture of the film. The film's mineral architectural devices, stone fountains and acroteria with human faces in the Villa d'Este, do not conduct the "inscrutable" force of water, but appear as if they themselves were objects created by water, similar to the glaciers and alluvial terraces formed by the erosion and sedimentation of matter transferred by large liquid streams described by Tyndall in his geological treatise. The artificiality mentioned in the title of Anger's film alludes not only to the similarity between "*eaux*" and "*feux* d'artifice"—explosive water displays and pyrotechnics—but also to the very instability of the division between artifice and nature, externalizing nature's inner "building" and/or "forming principle" (what the nineteenth-century philosopher Johann Friedrich Blumenbach characterized as *Bildungstrieb*).[17] Similar to the mask and elaborate costume worn by the mysterious female figure in Anger's film, architecture is the shifting theatrical prop that allows nature's own structural drive to disguise itself under the persona of an unstoppable, natural power, namely, water—one of the primary conditions as well as *symptoms* of life.

Life in Opposition, Part I: Architecture "Expecting"

Glimpses of architecture's animation by a pervasive "living force" (*Lebenskraft*), here further formulated as a forming principle of *Bildungstrieb* manifested in rocks, glaciers, and other natural formations, are perceivable in nineteenth-century architectural theory, as for example in Gottfried Semper's writings on style, which were informed by Arthur Schopenhauer's theories of natural philosophy.[18] However, architecture's identification with a living force becomes more explicit in modern architectural practice with the turn-of-the-century European movement of Art Nouveau or *Jugendstil*. Art Nouveau designers like Victor Horta and Henry van de Velde embrace life not only by rehearsing the movement of animal or vegetal organisms via the use of curvilinear "force-lines" (*Kraftlinien*), but also through the implementation of an integrated design system that

17. Gigante, *Life*, 16–24; and Robert J. Richards, "Kant and Blumenbach on the Bildungstrieb: A Historical Misunderstanding," *Studies in History and Philosophy of Biological & Biomedical Sciences* 31, no. 1 (2000): 11–32.

18. Gottfried Semper, "Prolegomena," in *Style in the Technical and Tectonic Arts*, trans. H. F. Mallgrave and M. Robinson (Los Angeles: Getty Research Institute, 2004), 71–100; and Harry F. Mallgrave, "The Animate Brain: Schinkel, Bötticher, and Semper," in *The Architect's Brain: Neuroscience, Creativity, and Architecture* (Oxford: Wiley-Blackwell, 2011), 61–75.

coordinates every object, furnishing, and architectural detail within a building interior based on a closed pattern of organic life.

Here the architect does not simply imitate life, but shields and enhances life as a prophylactic device against the afflictions of modern metropolitan existence. It is perhaps no accident that van de Velde designed and built his first house in the exclusive suburb of Uccle near Brussels after an infectious disease claimed the life of his first child four weeks after its birth. In his *Memoirs*, the architect likens the "ugliness" of contemporary buildings to an "infectious disease" that can profoundly "deform" human beings even before birth. "Hideousness is contagious. . . . My wife and I felt in duty bound to shield our children from the sight of ugly things by banishing everything that is liable to pervert a child's visual sensibility even *before they were born*" (my emphasis).[19] The only way that the spreading of such deforming ugliness can be countered is via the "concerted resistance" offered by the "practical antidote" of good design. Architectural intervention, according to van de Velde, has to appear *before* life proper begins; like water, architecture is not simply a condition, but a *precondition* for life. In empathy with van de Velde's spouse (artfully installed and photographed as a model inside the architect's organic or living interiors; fig. 8), architecture itself is *expecting*.

In spite of its vital claims, Art Nouveau's own life span was rather short. Soon after it appeared in several media—private residential or commercial interiors as well as journals and exhibitions across numerous countries in Europe—Art Nouveau itself was discredited as an infectious disease (or was contaminated by the very infectious disease it was supposed to provide an "antidote" for) and vanished soon after. Architectural historians Manfredo Tafuri and Francesco Dal Co describe it as a "negative prologue" to modern architecture, which implies that something of its impetuous life survives, albeit "negatively" or clandestinely.[20] Perhaps the living legacy of Art Nouveau as a diverse architectural movement consists in its establishment of a new form of life, which is properly a series of *afterlives* unfolding throughout the course of the twentieth century, such as the "Neo-Liberty" movement in postwar Italy, all of them vibrant yet highly episodic.[21]

Underpinned by organic physiology and the interior pathology of the human body, the empathetic aesthetics of Art Nouveau was supplanted in early twentieth-century modernity by an aesthetic of inorganic abstraction energized by resistance to the organic contingencies of nature such as decomposition and decay. And yet this architecture of inorganic rigidity was still considered "living," even more living than any of the organic formulations of its eighteenth- or nineteenth-century precedents. In a chapter entitled "Living Space" from his *Work of Living Art* (*L'oeuvre d'art vivant*, 1921), scenographer and stage innovator Adolphe Appia writes:

> The first principle of *living* art—perhaps the one from which all others are consequently and automatically derived—must be: all inanimate forms must *oppose* rather than embrace all living forms. . . . To receive its portion of life from the living body, space must oppose this body; space that embraces our body only further augments its own inertness. But opposition to the body gives life to the inanimate forms of space. *Living* space is the victory of bodily forms over inanimate forms. The mutuality is complete.[22]

Notice that this "principle" of "opposition" between the living body and the inanimate forms of space reverberates in all other principles determining the attitude of "living art." It is as if the "opposition" itself is a contagious organism whose living influence can "automatically" polarize all other aspects of architectural space, such as the architectural column or the floor. As the latter is soft, carpeted, and yielding—giving in to the touch of the human body—it paralyzes both animate and inanimate surfaces as soon as they come into contact.[23] By contrast, the "rigid column" or the "rigid floor slab" that offers "resistance" to the body works to reactivate both itself and the animate member that stumbles against it: "By opposing itself to life, the ground, like the pillar, can receive life from the body."[24]

Appia's principle of "opposition" was originally energized by a juxtaposition between Appia's geometric architectural forms and the absorptive aesthetics of Art Nouveau, which were informed by the empathetic value of organic forms. A similar "opposition" lives through a large part of twentieth-century modernism through a series of periodic juxtapositions between architectural movements

19. Henry van de Velde, "Extracts from His Memoirs, 1891–1901," ed. and trans. P. Morton Shand, *Architectural Review* 112 (September 1952): 153.

20. Manfredo Tafuri and Francesco Dal Co, "Introduction," in *Modern Architecture* (1976) (London and Milan: Faber and Faber / Electa, 1986), 1:12.

21. On Neo-Liberty and its purported relation to Art Nouveau, see Reyner Banham, "Neo-Liberty: The Italian Retreat from Modern Architecture," *Architectural Review* 125 (April 1959): 230–35.

22. Adolphe Appia, "Living Space," in *The Work of Living Art & Man Is the Measure of the Universe: A Theory of the Theater*, ed. Barnard Hewitt (Coral Gables, FL: University of Miami Press, 1981), 27.

23. Ibid., 28.

24. Ibid., 29.

Fig. 9 Adolphe Appia, *Rhythmic Spaces*, 1909

with contrasting formal ideologies and attitudes towards life. Architecture's simultaneous opposition to and embracing of life as disclosed by Appia speaks of the polarity that "automatically" energizes modernist architectural environments. However inadvertently, the same opposition discloses the sympathetic analogies between the body and the building that reactivate modern architecture's arid spaces. Polarity and analogy are reciprocally employed and reanimated in modernist spaces and aesthetic ideologies of the early twentieth century.[25] While plain and seemingly emptied of human presence, Appia's theatrical stage sets (such as those represented in his well-known drawings of "rhythmic spaces," c. 1909; fig. 9) are animated not by the actual contact with a living body but by the anticipation of contact with life. Like van de Velde's interiors reverberating in empathy with his pregnant wife, Appia's architecture is also *expecting*. While in stark opposition to the aesthetics of Art Nouveau, these seemingly barren architectural interiors are in fact animated by the expectancy no longer of a single human being but of a social collectivity, such as the one steering Appia's performances of "Orpheus in the underworld" (based on scenes from Gluck's opera *Orfeo ed Euridice*) at the utopian community of Hellerau.[26] The architectural features themselves become specimens of a collective "latent" life—a life that is no longer externalized by vigorous dynamic lines or boisterous gestures, but by a "pregnant" immobility and silence whose frozen signs are revitalized by a furtive inorganic expression.[27]

Latent Life

This latent form of life runs through several strands of early twentieth-century modernism.[28] In his *Myth and Science*, the late nineteenth-century animal psychologist Tito Vignoli, known from his influence on the cultural historian Aby Warburg, distinguishes between "static" and "dynamic" forms of animation— instances where animals either freeze and remain silent or react with violent movements and cries to an intensely vivifying phenomenon (as, for example, the waving of a handkerchief by a human agent who, in Vignoli's carefully staged experiments, remains hidden so that the source of movement is unknown).[29] One could similarly describe instances in which artworks and buildings are permeated by a form of life that is hardly perceptible yet provokes strong reactions to the

25. I invoke here the classic study by G. E. R. Lloyd, *Polarity and Analogy: Two Types of Argumentation in Early Greek Thought* (1966) (London and Indianapolis: Bristol Classical Press and Hackett Publishing, 1992).

26. Marco de Michelis, "Modernity and Reform, Heinrich Tessenow and the Institut Dalcroze at Hellerau," in *Theatre Theatricality and Architecture*, ed. Hans Baldauf, Baker Goodwin, and Amy Reichert, special issue, *Perspecta* 26 (1990): 143–70.

27. On "latent life," see Sophia Roosth, "Life, Not Itself: Inanimacy and the Limits of Biology," *Grey Room* 57 (Fall 2014): 57–81.

28. Here I expand on a series of arguments put forward in my *On the Animation of the Inorganic: Art, Architecture, and the Extension of Life* (Chicago: University of Chicago Press, 2012).

29. Tito Vignoli, *Myth and Science: An Essay* (1880) (New York: D. Appleton and Co., 1882), 58–59; and my *On the Animation of the Inorganic*, 12–13.

30. Aby Warburg, "Grundlegende Bruchstücke zu einer monistischen Kunst-psychologie," *Warburg Institute Archive,* III.43.1–3; and my *On the Animation of the Inorganic,* 21–23.

31. Edward Burnett Tylor, *Primitive Culture: Researches into the Development of Mythology, Philosophy, Religion, Language, Art and Custom* (c. 1871), 4th rev. ed. (London: John Murray, 1903); and James Frazer, *The Golden Bough: A Study in Magic and Religion* (1890–1900, abr. ed. 1922) (London: Penguin, 1996).

32. Émile Durkheim, *The Elementary Forms of the Religious Life* (1912), trans. J. W. Swain (New York: The New Press, 1965), 349.

33. See my "Malicious Houses: Animation, Animism, Animosity— From Mies to Murnau," *Grey Room* 20 (Fall 2005): 5–37.

34. For example, R. H. Francé, *Bios: Die Gesetze der Welt* (Stuttgart: Walter Seifert Verlag, 1923). On Mies's reading of Francé, see Fritz Neumeyer, *The Artless Word: Mies van der Rohe on the Building Art,* trans. Mark Jarzombek (Cambridge: MIT Press, 1991), 102–6. On the relationship between Mies's architecture and Francé's writings, see Detlef Mertins, "Living in a Jungle: Mies, Organic Architecture and the Art of City Building," in *Mies in America,* ed. Phyllis Lambert (New York: CCA, Whitney, H. Abrams, 2001), 598–602.

living subjects that experience the agency of these seemingly self-animated objects. Informed by animist descriptions of artifacts provided by contemporary comparative anthropology as well as monist views of nature promoted by biologists and crystallographers alike, this static form of life, mainly represented by specimens of the vegetal and the mineral realms, is perceived as both an expansion and invasion, moreover a transgression, extending the territorial claims of living matter to areas where life did not formerly belong.

As in nineteenth-century Romantic literature, part of this inorganic life appears menacing or even monstrous. The phrase "You live and do me nothing" (*Du lebst und thust mir Nichts*), used as an introductory epigram in Aby Warburg's unpublished collection of aesthetic aphorisms titled *Fragments for a Monistic Psychology of Art* (1888–1903), speaks of the prophylactic role of art (reminiscent of the prophylactic role of design in van de Velde's interiors).[30] If the "you" refers to an artwork and the "me" to its viewer, then Warburg's exhortation discloses the possible threat emitted from the side of the object, always lurking in the dark like an animal ready to attack the unsuspecting human viewer who treads on its territory. But the same phrase also presages the pacifying reassurance provided by the living artwork, which, while resituated inside the protective interior of a private house, museum, or picture gallery, becomes seemingly harmless: "Even though you live, [I know] you cannot harm me!" But yet again, does not this overly reassuring tone inadvertently portend a relapse to the menacing side of things, when the seemingly friendly faces of increasingly lifelike object simulations become once again uncanny?

It is essential to underline the growing presence of these shifting views of animation and life in the domain of architecture, which during the turn-of-the-century era when these epistemological changes occurred was also undergoing a series of profound changes. The role of architecture in anthropological descriptions of animist rituals in late nineteenth-century accounts such as Edward Tylor's *Primitive Culture* or James Frazer's *Golden Bough* is indeed striking precisely because of the deeply ambivalent role of buildings, bridges, huts, columns, and other architectural features in such narratives.[31] Architectural enclosures represent both a safe abode for the soul that is in "peril," such as the soul of the warrior preparing for battle, and an ominous vessel containing the menacing spirits and phantasms of dead ancestors that congregate inside deserted building shelters.[32] The parallels between these anxiously ambivalent views of architecture taking place in colonial forests and the contemporary scenes of agoraphobia emerging in modern Western metropolises disclose the intimate affinities between these geographically disparate domains and the *mise-en-abyme* effect of their transcontinental reflections.

Also contemporary to the influx of animist narratives of buildings in anthropological literature are the literary and cinematic perspectives describing the precarious "life" and imminent death of historical buildings within the process of modernization. The "evil ancestors" that have to be exorcized from maliciously disposed architectural enclosures reflect contemporary metropolitan citizens' ambivalent attitude, encompassing both nostalgia and animosity, toward the houses of their fathers and grandfathers that are about to be demolished. This profoundly ambivalent psychological state finds plastic expression in the equally phantasmatic gestalt of modern architecture's first glass buildings. In an earlier study, I tell the story of "parallel action" between the origins of Mies van der Rohe's 1922 "Glass Tower" project and F. W. Murnau's film *Nosferatu,* also released in 1922, a few months before the first photographs of Mies's glass skyscraper model were published.[33] Both Murnau's medieval vampire and Mies's twentieth-century skyscraper oscillate between the drive for growth of the vegetable and the lively inertia of the crystal—natural states that reflect Mies's avid reading of the books of the multi-biotheorist Raoul Francé, whose theories of morphological and functional analogies between human structures and natural specimens were influential among a circle of designers in the Bauhaus.[34] Both the filmic vampire and Mies's glass tower (which was never built, yet its gestalt was reproduced in an endless series of future skyscrapers) live in perpetual afterlife—the type of *half* or inorganic life that permeates building agents in modernity.

Fig. 10 Ludwig Mies van der Rohe, *German Pavilion, International Exposition, Barcelona, Spain, Interior Perspective*, c. 1928–29 (pl. 144)

Even Mies's "phenomenally" seemingly transparent Barcelona Pavilion (fig. 10, pl. 144), assembled six years after the 1922 Glass Tower model, sustains the afterglow of these *filmic* projections. The pavilion is a large-scale cinematic apparatus made for the projection of "other," mostly future, architectures. The life of this rigidly inorganic (glass and travertine) envelope consists precisely in the anticipation of these animated effects. Framed by shallow pools of water, the orthogonal enclosure projects a vision of life that merges the liquid with the mineral, a more formalized expression of the architectural forms of water proposed by Tyndall in his study of glaciers. Mies's architecture of "skin and bones," inspired, as the architect describes in one of his lectures, by the image of an "Eskimo summer tent," finds here its metaphorical expression transposed from northern climates to the southern Mediterranean landscape of Barcelona.[35] In the drawing included in the exhibition, it is as if the life of the building model were concentrated in the liminal zone between the glass window and the pool of water that here appears to extend inside the pavilion and flood the travertine floor. Recent interventions in Mies's reconstructed pavilion, such as a temporary installation by Andrés Jaque's Office for Political Innovation, showcase the building's "secret life," invisible in the public eye, including the salt and other products used periodically by the building's maintenance team to kill the marine microorganisms that grow inside the shallow pools of water.[36] But these are not the only covert biological agents festering inside Mies's glass pavilion.

Histories of Biological Analogies (and Fallacies)

While signs of life abound in the architecture of the last two centuries, the critical reception of this life has not been uncontroversial. Twentieth-century architectural historians, theorists, and critics have alternatively described the correspondence between architecture and life either as a precarious analogy or as a fallacy. Famously in his *Architecture of Humanism* (1914), Geoffrey Scott spoke of the "biological fallacy."[37] Scott's targets were "evolutionist" readings of architecture, which described buildings as products of "heredity and environment." This type of reading did not apply to Renaissance architecture, Scott argued, because that architecture "scorned heredity"

35. "Illustration 5 (summer tent of an Eskimo). This fellow even has a summer villa. The building material is skin and bones." Mies van der Rohe, "Solved Tasks: A Challenge for Our Building Industry" (lecture for the Association of German Architects, Berlin, December 12, 1923), in Neumeyer, *The Artless Word*, 245.

36. Andrés Jaque, *Phantom: Mies as Rendered Society, Intervention in the Mies van der Rohe Pavilion* (Barcelona: Mies van der Rohe Foundation, 2013), 16.

37. Geoffrey Scott, "The Biological Fallacy," in *The Architecture of Humanism: A Study in the History of Taste* (1914) (New York: W.W. Norton, 1974), 127–40.

and defied "the blind suasion of an evolutionary law."[38] Scott also attacked the parallels between the life histories of buildings and those of human beings—a parallel established in the art histories of Vasari and Winckelmann: "This perfect image of the life of man—why should we look to find it in the history of architecture? This sequence of three terms—growth, maturity, decay—is the sequence of life as we see it in the organic world, and as we know it in ourselves. To read the events of history and the problems of inanimate fact in the terms of our own life, is a natural habit as old as thought itself." Yet Scott objected that "the criticism of architecture, with the solemn terminology of evolution, now too often forces the facts to fit this preconceived description. . . . Architecture is still presented to us as an organism with a life of its own, subject to the clockwork of inevitable fate."[39] Scott particularly resisted the idea of "decay" applied to architecture in terms of stylistic "decadence." On the contrary, the British critic underlined the importance of "spontaneity" that upsets any predetermined sequence among architects and buildings, as well as stylistic phases. Instead of invalidating the relevance of biological theories for architecture, Scott's polemical juxtaposition between aesthetics and science demonstrated how one rhetoric of life could battle with another. The rhetoric of "spontaneity" was part of a vitalist conception of life that favored accident over the functionalist determination of organic development based on climatic and other environmental conditions.

In his *Changing Ideals in Modern Architecture* (1965), the Canadian architectural historian and critic Peter Collins returned to the theme of the "biological analogy" as one of the underlying ideas behind the shifting concept of "functionalism" running through modern architecture from 1750 to 1950.[40] Writing fifty years after Scott, Collins offers a more nuanced historical reading of the shifting relation between developments in the study of vegetal and animal organisms and the criticism of architecture. Starting with the work of eighteenth- and nineteenth-century naturalists like Buffon and Lamarck and emerging biologists like Xavier Bichat, Collins demonstrates differences and parallels in the study of movement and growth in animals and plants, as well as crystals.

Similar tectonic analogies would be put forward by theorists of living and social organisms such as Herbert Spencer, whose "biological works" influenced, according to Collins, Louis Sullivan and Frank Lloyd Wright.[41] Yet ultimately, Collins, like Scott (whose skepticism he appears to echo), had only limited trust in the relevance of biological analogies for architecture: "It would seem as if the [biological] analogy must always be general and poetic, and in fact the features held in common seem limited to four: the relationship of organisms to their environment, the correlation between organs, the relation between form and function, and the principle of vitality itself."[42] Collins would then continue to challenge the importance of each of these four analogies for contemporary architecture, starting with the relevance of environmental and climatic factors by pointing out recent "improvements in air-conditioning equipment" that made building techniques such as "glass plate walls" or "traditional frame construction" equally relevant (or irrelevant) for countries as different as Japan and Canada.[43] Further, Collins reiterates the ambiguities in Frank Lloyd Wright's use of the term "organic architecture" and its (covert) adherence to the functionalist grasp of life: "But primarily [organic architecture] meant to him *living* architecture; an architecture in which useless forms were sloughed off as part of a nation's growth, and in which every composition, every element, and every detail was deliberately shaped for the job it had to perform."[44] Collins's ultimate target was the rhetorical claims of modernist architectural critics dividing "all new buildings into two categories: 'evolutionary' and 'vestigial' "[45]—a polarizing view about "progress and regression" in (modern) architecture fervently debated in contemporary architectural circles.[46]

Throughout the twentieth century, analogies between biological and architectural theories are not abstract philosophical debates but concrete polemics triggered by particular historical problematics surrounding the "life and death" of specific "styles," ideologies, and formal practices in contemporary architecture. In the case of Collins, writing in 1965, such discussions concerned the end of high modernism and the emergence of a postmodernist (and occasionally antimodernist) sensibility. A similar

38. Ibid., 130.

39. Ibid., 134.

40. Peter Collins, "The Biological Analogy," in *Changing Ideals in Modern Architecture* (Montreal: McGill University Press, 1988), 149–58.

41. Ibid., 151–52.

42. Ibid., 153.

43. Ibid., 154.

44. Ibid., 156.

45. Ibid., 157.

46. See, among others, Bruno Zevi, "Architecture 1967: Progress or Regression?" (lecture delivered at the conference *Man and His World / Terre des Hommes, The Noranda Lectures / Expo 67*), in Andrea Oppenheimer Dean, *Bruno Zevi on Modern Architecture* (New York: Rizzoli, 1983), 146–53.

Fig. 11 Cover of Philip Ritterbush's
The Art of Organic Forms, 1968

reaction against the modernist masters—
Le Corbusier, Mies, and Gropius (all three of whom
would die in the second half of the 1960s)—was
orchestrated in the rediscovery of an alternative
"organic" tradition in prewar and postwar
architecture, as, for example, in the work of German
architects Hans Scharoun and Hugo Häring (and
by extension the architectural "biotechnique" of
Austrian-American architect and artist Frederick
Kiesler), whose contributions to the modern
movement would receive belated appreciation by
architectural historians.[47]

In the summer of 1968, Philip C. Ritterbush, then
director of academic programs at the Smithsonian
Institution and a self-described "modern-day natural
philosopher," organized an exhibition under the title
The Art of Organic Forms, held at the Smithsonian
Museum of Natural History (fig. 11). A former Rhodes
scholar, having completed his dissertation at
Oxford on the prehistory of biology in the work of
eighteenth-century naturalists, Ritterbush structured
the exhibition around the idea of "organic form"
as consisting of "biological imagery in modern
painting and sculpture."[48] The exhibition included
paintings, drawings, and sketches by, among others,
Paul Klee, Wassily Kandinsky, Willi Baumeister,
Herbert Bayer, Arshile Gorky, Max Ernst, Joan Miró,
Yves Tanguy, György Kepes, and Roberto Matta (who
had studied architecture in Chile and worked for
Le Corbusier in Paris in the 1930s before devoting
himself to painting). The curator's eclectic selection
was based on the artworks' allusion to biomorphic
structure, specifically their ability to "suggest the
visual content of the science of biology and more
particularly resemble those of cells and protozoa that
lie beyond the range of unaided vision."[49] While rather
diverse in terms of style, chronology, and country of
origin, the selected paintings displayed a prominent
morphological affinity based on their similarity with
elementary forms of life—a similarity that attempted
to transform the heterogeneous artworks themselves
into microorganisms of related biological species.

Though Ritterbush's aesthetic agenda was based
on eighteenth- and nineteenth-century natural
philosophy, all of the artworks in the exhibition
belonged to the twentieth century; the earliest work
was a small painting by Odilon Redon, *At the Bottom
of the Sea* (*Au fond de la mer*), c. 1905 depicting

47. See Peter Blundell Jones, "Organic versus Classic," *Architectural Association Quarterly* 10, no. 1 (1978): 10–20

.48. From the dust-jacket description of the book accompanying the exhibition: Philip C. Ritterbush, *The Art of Organic Forms* (Washington: Smithsonian Institution Press, 1968).

49. Ritterbush, *The Art of Organic Forms*, iii-iv.

fantastic marine organisms. Ritterbush argues that "there is little sign of the primary importance of organic form for the advancement of aesthetics in the paintings of nineteenth-century artists" and that "the sensuous curves of Art Nouveau were to be its first visual manifestation in art."[50] Even if painters like Millais painted "veined leaves" under "hand-lens" and thinkers like Ruskin "sprawled out upon the grass, painting blades as they grew," Ritterbush associates the *art* of organic form with compositional principles that move beyond mere observation and the copying of nature. In a chapter entitled "Esthetics and Analogies of Life" from his lengthy essay in the book accompanying the exhibition, Ritterbush repeats the principle of Romantic natural philosophers that "living forms" (including those of plants) are more "complex" than those of nonliving entities and are based on the "interdependence between part and whole" as opposed to the mechanical aggregation of parts in inanimate substances.[51] An antimechanicist worldview supports this revival of interest in nineteenth-century organicism in the second half of the twentieth century, evident in Ritterbush's praise of subjective intuition and imagination versus computerized thought: "The Romantic stress on imagination served to counter a simplistic notion of mind very much like that of twentieth-century writers who suppose that the electronic computer offers an adequate representation of human mentality."[52]

One of the most rigorous and thorough studies of the relationship between architecture and life processes is provided by Philip Steadman in his book *The Evolution of Designs: Biological Analogy in Architecture and the Applied Arts*, first published in 1979.[53] Steadman is aware of certain dangers in the practical application of biological analogies in architecture, as for example in the functionalist and environmental determinism of contemporary cybernetic theories of design and particularly theories of order by architect and theorist Christopher Alexander. In his defense of the "organic" versus the "evolutionist analogy," Steadman reflects contemporary concerns about "anonymity," loss of agency, or even the disappearance of the individual designer in the face of automatic design processes: "The craftsman, in the evolutionary analogy, becomes merely a kind of midwife, his purpose to assist at the rebirth of the inherited design. The real,

effective 'designer,' in this view, is the 'selective' process which is constituted by the testing of the object in practical terms when it is put into use."[54] Steadman also refutes teleological approaches in the historical analysis of buildings and design artifacts, disclosing an engagement with contemporary critiques of (neo-)historicism reflected in the work of Karl Popper and Ernst Gombrich. Steadman quotes Scott's "biological fallacy" in the titles of two of his chapters, only to refute his arguments by dismissing Scott's facile equation of evolutionist approaches to history with the application of "life cycles" in the reading of architectural styles in terms of "rise and decline."[55] Steadman, on the contrary, redeems biological analogies by demonstrating the role of complexity, heterogeneity, and unpredictability in organic theories of design and their importance for building an intricate idea of history and cultural transmission. He argues that biological inheritance in the area of design exists less in resemblances among its living agents than through the objects they design and manufacture; it is the artifacts that carry certain common characteristics from one generation to the next and that ultimately survive, albeit in a perpetually modified form. Steadman's study demonstrates once again that the life and evolution of designs relies not on homology, the copying of forms or genetic processes from the area of nature to that of design culture, but on analogy, a relation predicated on distance, variation, and difference.[56]

The Tectonics of Nature, Part II: Radiolarians and Living Crystals

The chapter on "living symmetry" in Ritterbush's *The Art of Organic Forms* ends with a discussion of the studies of radiolarians by Ernst Haeckel, whose two-volume monograph on the subject was published in 1862. In his morphological studies, Haeckel classifies all organic forms according to three types of symmetry: the radiolarians, along with certain sponges, belong to the simplest form of "spherical" symmetry, followed by those of the lower invertebrates that share a "radial" symmetry, and finally there is the "bilateral" symmetry of higher animals. According to Haeckel, the "symmetry principles of organisms closely approached those of crystals" based on a "pre-morphological foundation" common to organic and inorganic structures.[57]

50. Ibid., 23.

51. Ibid., 25.

52. Ibid., 17.

53. Philip Steadman, *The Evolution of Designs: Biological Analogy in Architecture and the Applied Arts*, rev. ed. (London: Routledge, 2008).

54. Ibid., 182.

55. Ibid., 203. See the chapters "The Consequences of Biological Fallacy: Functional Determinism" and "The Consequences of Biological Fallacy: Historical Determinism and the Denial of Tradition," ibid., 179–216.

56. Tellingly, Steadman's book was republished in a revised edition in 2008 with an "afterword" on "developments since 1980." Among these new developments occasioning the revision and republication of his 1979 work he includes the tendency towards a new "organic architecture," as well as the use of "genetic algorithms" in contemporary design.

57. Ibid., 63–64.

Fig. 12 Ernst Haeckel, *Thalassicolla (Thalassoplancta) cavispicula*, 1860

Fig. 13 Otto Lehmann, Microscopic view of liquid crystals, c. 1888–89 (pl. 129)

In Haeckel's skillful drawings (fig. 12, pls. 88–93), the radiolarians appear almost perfectly geometric and unlike any other living organism. Ritterbush argues that "Haeckel altered his drawings to conform to his belief in the geometric character of organic form. A process of generalizing abstraction resulted in representations that were improvements upon nature. The observer who inspects a radiolarian under the microscope today will be disappointed at his impressions of reality as compared to the crisp and symmetrical outlines of Haeckel's superb lithographs."[58] In fact, recent microphotographs of radiolarians (such as pl. 157) show that Haeckel's representations were quite accurate, even if the same microorganisms would not always appear as perfectly geometric at all times; there would always be slight deviations from the perfectly symmetrical shapes of a regular geometric body, as the thin extensions of the radiolarians would sway or oscillate when they moved in water. These slight irregularities, even more perceptible in the original drawings by Haeckel, were further proof that these natural "geometries" were indeed living.

However, for Ritterbush, Haeckel's drawings remained essentially "works of art" or artful illustrations of the aesthetic principle of "regularity" in organic form. According to Ritterbush, Haeckel himself was wont to compare "the generation of form by protoplasm" to the "creation of works of art by man."[59] Like the "beautiful snow flowers" Tyndall saw inside ice beams, radiolarians were also ostensibly geometric formations growing inside water, even if the latter was no longer frozen. In Haeckel's association of the radiolarians with crystals, including the symmetrical forms of snow crystals, it is as if the marine organisms not only emulated the geometric shapes of their mineral counterparts but also emulated the static life of the crystals' milieu. Radiolarians were the products of an ontological osmosis performed at a distance, that is, by analogy.

Ritterbush also mentions Haeckel's final monographic study on "crystal souls," *Kristalseelen* (1917), which essentially "identified crystalline order with that of living organisms," and thus, for Ritterbush, contradicted the basic principle of organic form. Haeckel's work on "crystal souls" builds upon the discovery of "liquid" or "flowing crystals," first

58. Ibid., 64.
59. Ibid.

60. See Otto Lehmann, *Die scheinbar lebenden Kristalle; Anleitung zur Demonstration ihrer Eigenschaften sowie ihrer Beziehungen zu anderen flüssigen und zu den festen Kristallen in Form eines Dreigesprächs* (Esslingen, München: J. F. Schreiber, 1907); and *Die neue Welt der flüssigen Kristalle und deren Bedeutung für Physik, Chemie, Technik und Biologie* (Leipzig: Akademische Verlagsgesellschaft, 1911). Lehmann's later books emphasize the connections between crystallography and biology, for example, Otto Lehmann, *Die Lehre von den flüssigen Krystallen und ihre Beziehung zu den Problemen der Biologie* (Wiesbaden: Bergmann, 1918).

61. Otto Lehmann, *Flüssige Kristalle und ihr scheinbares Leben. Forschungsergebnisse dargestellt in einem Kinofilm* (Leipzig: Voss, 1921), 70.

62. Lehmann's microphotographs were included in a section on magnification. See *The New Landscape in Art and Science*, ed. György Kepes (Chicago: Theobald & Co., 1956), 146, figs. 134, 135.

63. For the application of liquid crystals in contemporary art, see Yves Charnay, "A New Medium for Expression: Painting with Liquid Crystals," and David Makow, "Liquid Crystals in Painting and Sculpture," *Leonardo* 15, no. 4 (1982): 219–21, 257–61.

analytically described by the crystallographer Otto Lehmann, also a Haeckel disciple. As a tribute to Heraclitus, who 2,500 years earlier had declared that "everything flows" (*ta panta rhein*)—including stones—Lehmann also called these substances *rheocrystals*. Using a specially formulated microscope and through the application of polarized light, Lehmann managed to measure changes in the expansion and contraction of these crystals under heat and cold, which allowed him to argue that these mineral substances had plastic qualities.[60] Liquid crystals also had the ability to form a skin through which they appeared to breathe like living organisms. Moreover, these flowing crystals, although sexless, could multiply by means of a peculiar form of "copulation." While Lehmann had called these substances "virtually living crystals" (*scheinbar lebende Kristalle*), Haeckel upgraded them to specimens of "real life" (*wirkliches Leben*).[61]

Equally important to how these crystals behaved was how they looked. As shown in drawings and published microphotographs, their structure had little to do with the hexagonal snowflakes and other symmetrical polyhedra of the nineteenth century, such as the regular architectonic formations illustrated by Tyndall in his *Forms of Water* and multiplied in Wilson Bentley's photomicrographs of snow crystals. In Lehmann's drawings (fig. 13, pls. 127–30), these crystals appear animated by an internal movement; they resemble geological formations made of parallel layers that gradually transform into liquid streams. Such fluidity is even more pronounced in the microphotographs reproduced in Lehmann's and Haeckel's publications, where these new crystals appear flowing and circular, forming complex spider webs or sprawling oil-like patches, and producing ambient light effects. Had these crystals been discovered in the 1960s, they would have been called psychedelic (and it would then be easier to envisage Haeckel's claim half a century earlier that they possessed "souls").

If the radiolarians were crystalline animals, then the rheocrystals were animal-like crystals. Radiolarians and liquid crystals were the double proof that the distinction between the organic and the inorganic world did not exist. All matter was animate and had a soul. This was the main principle of Haeckel's doctrine of monism, which encompassed physics, biology, ethics, and religion. All objects of nature had force and energy. In the organic, this force was active; in the inorganic, it was latent yet potent, perhaps more potent than the matter we normally call living.

The energetic "life" of Lehmann's and Haeckel's theories of liquid crystals was in fact rather brief, yet similar to the fate of Art Nouveau (whose origin is almost contemporary with the first appearance of these fluid minerals), they, too, experienced a rigorous afterlife. During the interwar period, scientists disputed Lehmann's claims and argued that these organisms were not crystals, but the products of emulsion between two different compounds, thus the entire theory of liquid crystals appeared to collapse. But this ostensible eclipse proved to be only another phase of these substances' "latent life" as they transitioned into hibernation. After two decades of silence, liquid crystals would spring again into action when new experiments in the 1950s and 1960s brought similar substances back to vibrant life, mainly because of their benefits in electro-optic applications.

The same microphotographs of liquid crystals from Lehmann's early twentieth-century publications would be reprinted in György Kepes's *The New Landscape in Art and Science*, a popular almanac of postwar visual culture amalgamating scientific imagery with modern and contemporary art and architectural design, first published in 1956.[62] Here, Lehmann's microphotographs of blob-like and spider-shaped crystals, along with Haeckel's radiolarians, mingled with the biomorphic furniture and molecular structures of postwar total design, such as Eames chairs and Buckminster Fuller's geodesic domes. Their iconographic association with architectural structures was only a small sign of liquid crystals' massive use in postwar product design. Today, liquid crystals are used in a plethora of consumer products, from alarm clocks and wristwatches to television and computer screens employing Liquid Crystal Display (LCD) technologies.[63] We may no longer *see* the liquid crystals in their molecular shapes as clearly as we did in Lehmann's drawings and microphotographs, but we can marvel in the *clarity* they add to the screens we look at, often entirely stupefied, in our everyday lives. In their periodic transition from inconspicuousness to

omnipresence, liquid crystals serve as proof of modern material and design culture's latent life and its oscillation not only between fixity and fluidity but also between clarity and utter mystification.

Life in Opposition, Part II: The Contrast of Forms

The permeable thresholds of the liquid crystals' "breathing" skins signaled that the compositional logic of tectonic organizations had radically transformed during the transition from the nineteenth to the twentieth century. Crystallization no longer signaled the fixity of tectonic formations either in animate or inanimate nature, but rather the hybridization and destabilization of boundaries between different ontological and epistemological states. It is perhaps no accident that Wilhelm Worringer, the art historian and theorist who revitalized aesthetic thought with his groundbreaking dissertation *Abstraction and Empathy* (1907), mentions the theory of "liquid crystals" in an essay of 1921 addressing "art historical questions of today." There, Worringer specifically refers to "the phenomenon of liquid crystals" (*das Phänomen der flüssigen Kristalle*) as an example of the impeding "crystallization of our thinking," a means of overcoming the polarity between the creation of art and human thought.[64] Based equally on the epistemological tropes of polarity and analogy, this impending "crystallization" appeared to destabilize boundaries between art and science. Perhaps, though, its most altering tectonic effects were manifested in early twentieth-century art, particularly painting, which at that point staged its own alliance (and occasional battle) with architecture.

The work of Fernand Léger, the painter who presented himself as "the most conscientious mason" among the artists of the French avant-garde, serves as an example.[65] Apropos of Léger's first exhibit in the Salon des Indépendants in Paris in the spring of 1911, where his grand tableau later known as *Nudes in the Forest* (*Nus dans la forêt*, 1910–11) was shown for the first time, Léger's colleague, the painter and theorist Jean Metzinger, remarked: "An austere painter, Fernand Léger is passionately drawn towards that profound side of painting that touches upon the biological sciences—an aspect foreshadowed by Michelangelo and Leonardo. And is it not there after all that we can find the materials with which we would like to build the monument of our own

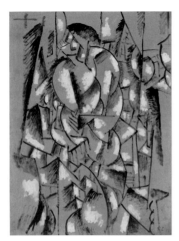

Fig. 14 Fernand Léger, Study for *Nude Model in the Studio*, 1912 (pl. 126)

64. "Es ist, als ob das Phänomen der flüssigen Kristalle sich in einer neuen Kristallisation unseres Denkens vollzöge." Wilhelm Worringer, "Künstlerische Zeitfragen" (1921), in *Schriften*, ed. H. Böhringen, H. Grebing, and B. Söntgen (Munich: Fink, 2004), I:907.

65. See my "The Most Conscientious Mason: Léger's Architectonic Analogies," in *Léger: Modern Art and the Metropolis*, ed. Anna Vallye (Philadelphia: Philadelphia Museum of Art, 2013), 201–12.

times?"[66] It is striking to see the painter, whose later pictorial production would be most intimately associated with the iconography and compositional logic of machines, here being attached to the "biological sciences." Metzinger's "monumental" claim perhaps traces the interdisciplinary analogies informing the artist's often prodigious projects weaving living with mechanical forms. But what is "biological" in the painting of Léger? What kind of life do we see in the sprawling assemblages of his *Contrast of Forms* series? And what is the "masonry" or tectonics of these seemingly indiscriminate piles of rotating cylindrical volumes?[67] Art historians have remarked on the presence of the philosophical movement of "unanimism" in Léger's early depictions of clouds of smoke hovering over (or inside) urban landscapes, as in his *Smoke over Rooftops* series (1911–12).[68] Léger's pictorial "unanimism" would translate into an ambient uniformity that balances the contrast between the large plain surfaces of "clouds" with the more dense or complex surfaces of all other bodies, including humans and buildings, represented inside the same landscape.

The 1912 drawing from the BAMPFA collection included in this exhibition (fig. 14, pl. 126), probably a preparatory study for the painting *Nude Model in the Studio* (*Le modèle nu dans l'atelier*, 1912–13), ostensibly belongs to an intermediate stage between Léger's paintings of urban landscapes with smoke clouds and his more abstract 1913 series *Contrast of Forms* (*Contraste de formes*), with its assemblages of cylindrical part-objects. In this 1912 study drawing, one may still decipher aspects of semi-concrete figures, such as the rectangular volumes of buildings battling with the volumes of a phenomenally transparent human body. What were once clouds may now be the pictorial rudiments of human flesh that at once invite and resist the invasion of objects that contest their corporeal and territorial limits. Similarly, what were formerly the steps or railings of a building may now be the digits of a human hand represented by sets of four to five parallel lines that rhythmically punctuate the canvas, reminiscent of prehistoric tectiform symbols. What is most intriguing in the drawing is the 'polysemic' character of its pictorial elements: they do not mean either anything or nothing but suggest a limited

number of identifiable options, all of them equally viable. Both subjects and objects in Léger refuse to be pinned down in only one ontological possibility. Therefore, the 1912 drawing appears as a mosaic made of overlapping remnants of living forms as they pile up against one another in a kaleidoscopic assemblage that dynamically balances all "contrasts" between abstract and figurative elements. Perhaps the "biological" element deciphered by Metzinger in Léger's paintings lies precisely in the increasing rudimentation of its living agents into a fossilized yet vigorously animated pile of pictorial remnants. This mounting pile of fossilized fragments could be another version of the biological "monument of our times" that Metzinger was asking contemporary artists to erect.

If in Appia's stage sets "living space" originates in "opposition," produced whenever the organic body bounces against the rigid surface of the propped-up architectural envelope, here life emerges by *decomposition*—the gradual dissolution of contrast and the liquefaction of forms into an ambient stream of rudimentary biological and pictorial agents. Such liquefaction might be analogous to the fluid animate processes undermining the solidity (albeit supporting the life) of "liquid crystals," which, immediately after their "discovery" in Germany, became known in France as *cristaux plastiques*"—plastic crystals.[69] This liquefied crystalline stratum is the "masonry" foundation that both supports and motivates Léger's archetypically tectonic constructions. At least *half* of the architecture of life is based on perpetual deformation and destruction; it has little to do with solid construction or the erection of enduring form. The architecture of life is, and should remain, a contradiction—a permanent reaction not limited to the level of form. Once again, architecture is *not* life, and Léger's crypto-vitalism alludes to this foundational analogical difference.

Cosmological Appendix: The Ornamentalization of Life

To close, let us return to our initial scientific reference, Schrödinger's *What Is Life?* Describing the "chromosome fiber" as the essential property of a living cell, the physicist compares it to a natural entity that he introduces as an "aperiodic crystal," a lattice structure that contains genetic information. Up until that point physicists dealt only with "periodic

66. "Peintre austère, Fernand Léger se passionne pour ce côté profond de la peinture qui touche aux sciences biologiques et que des Michel Ange et des Leonard pressentirent." Jean Metzinger, "Cubisme et tradition," *Paris Journal*, August 16, 1911.

67. On Léger's *Contrast of Forms* series, see the essays by Matthew Affron and Maria Gough in *Fernand Léger: Contrast of Forms*, ed. Matthew Affron (Charlottesville, VA: University of Virginia Art Museum, 2007).

68. On Léger's relationship with the philosophical movement of unanimism and the poet Jules Roman, see Judy Sund, "Fernand Léger and Unanimism: Where There's Smoke..." *Oxford Art Journal* 7, no. 1 (1984): 49–56.

69. Paul Gaubert, "Cristaux liquides et liquides cristallins," *Revue générale de science* 16 (1905): 983–93.

crystals," which are already very "complex structures," writes Schrödinger, yet "compared to aperiodic crystals they are rather plain and dull."[70] To illustrate the difference between periodic and aperiodic crystals, the scientist enlists a contrasting example from design practice and the history of art:

> The difference in structure is of the same kind as that between an ordinary wallpaper in which the same pattern is repeated again and again in regular periodicity and a masterpiece of embroidery, say a Raphael tapestry, which shows no dull repetition, but an elaborate, coherent, meaningful design traced by the great master.[71]

Once more, it is not regularity and repetition that characterize the crystal that Schrödinger calls the "material carrier of life," but a more "elaborate" sense of "coherence."[72] The tapestries woven based on Raphael's cartoons for the Sistine Chapel at the Vatican (1515–16) depict scenes from the lives of the Apostles Paul and Peter; other than the ornamental frames with meandering motifs that are repeated from one tapestry to the next, each iconographic scene is unique, and yet there is still a sense of contrasting rhythm among all the tapestries (many of which feature elaborate architectural structures), which might have compelled the physicist to compare them to the aperiodic crystal. It is also interesting that both of Schrödinger's examples—the "wallpaper" and the "tapestry"—are cladding layers of built architectural features, and also that the artwork chosen to represent the "material carrier of life" that is the aperiodic crystal is a "tapestry"—a textile whose material thickness is greater than that of a wallpaper. Other than the intricacy of Raphael's design, the woven layer itself has a certain liveliness based on the movement of the textile threads, reminiscent of the "chromo fibers" in Schrödinger's description of cells. Let us remember here that van de Velde rehearsed some of his lively ornamental motifs in surfaces of varying thickness: from wallpapers to ceramic wall-tiling and knotted carpets. At a young age, the artist-designer asked his aunt to teach him "embroidery" because he felt his designs would be better executed in the medium of tapestry. Formerly condensed inside the thinness of the wallpaper, the contour-lines of van de Velde's ornamental patterns would appear to sway and vibrate inside the thickness of his knotted carpets. As in the living geometries of

Fig. 15 Venetian Rose Point lace, 17th century (detail) (pl. 122)

70. Schrödinger, *What Is Life?*, 5.

71. Ibid.

72. Ibid.

the radiolarians, life was once again experienced in the peripheral vibration of its edges.

In their relief texture, tapestries possess a different dimensionality of "life," which might justify why Aby Warburg inserts the term "biology" (*Biologie*) next to "tapestry" (*Teppich*) in one of the labels of his "scientific notes" including information on Renaissance tapestries.[73] However, in Warburg's case, biology does not signify the scientific discipline established in the beginning of the nineteenth century but a more general, perhaps archaic, discourse (*logos*) about life (*bios*). If Haeckel had to go back to a "pre-morphological" state to rediscover the primary geometries of life, one may also have to return to a pre-biological period to rediscover life in its *pre-architectonic* condition—a state preceding the erection of monumental building structures when architecture consisted in a freer, less permanent, and less solid arrangement of people and things.[74]

These pre-biological and pre-architectural threads might help us understand why lace designs (fig. 15, pls. 120–25) are rightfully included in an exhibition on the "architecture of life." It is not only because the patterns of these decorative structures evoke objects of nature such as "coral" or "trees," but mainly due to the animate supplement that such textile extensions add to the human body that wears them. The prolific cultural historian of clothing Max von Boehn starts his book *The Accessory of Fashion* (*Das Beiwerk der Mode*) with a brief historical account of lace (*Spitzen*) from its appearance in Europe in the sixteenth century to the end of the nineteenth century.[75] This overview of the origin and movement of these woven commodities among several cities, such as Venice and Brussels, retraces the vital threads of Europe's cultural and economic histories. Especially when set against the curvilinear surface of the human body, the geometric regularity of lace patterns becomes animated by the suppleness and weightlessness of the fabric's material surface—reminiscent of the irregular and later "aperiodic" structures that characterize life in contemporary science. In fact, some of the lace designs included in *Architecture of Life* appear to have no discernible pattern; their surfaces are not products of a periodically repeated geometric motif but mappings of the aperiodic and continuously evolving trajectory of a community of

interdependent agents whose movement exceeds the limits of the textile fragment. Life, in this case, consists in what one does not see in the materialized artifact—the hypothetical yet unrealized extension that supports the living core by its very absence.

By the time Boehn's history of fashion accessories was first published in 1928, the striking photographs of lace textiles set against a black uniform background would appear as X-rays or scientific microphotographs of organic and mineral substances. In its application in male and female neck collars and arm bracelets, lace showcased the addition of geometry not just in the microscopic cellular interior of the human body but also in its larger exterior surface. Like fretwork applied in medieval furniture and other ornamented frames, lace originates in perforation, opening holes in an existing woven fabric, until the moment, as Lawrence Rinder remarks in his essay for this volume, it starts rebuilding itself around these original voids as "stitches in air"—a creation *ex nihilo* fashioned around not a metaphysical but a man-made *nothing*.[76] Contrary to the "accessory in motion" (*Bewegtes Beiwerk*) described by Aby Warburg in Renaissance paintings as a self-animated agent largely independent from the movement of the person who wears it, lace signifies an entirely different decorum: here the accessory enhances the human body with the cosmic regularity of a geometric pattern, not as an inflexible framework but as a transparent layer that retraces, intermittently, the body's own *aperiodic* crystalline structure.[77] Lace accessories are additional proof that life starts at the edges, the small things that embellish the self with peripheral movement yet have the power to activate the larger structures that frame the body's inner living core. This precariously "thin" or threadlike web of lines is the aperiodic rudiment of the architecture of life—a meandering aggregate of tectonic analogies that progressively liquefy polarities and oppositions between the two dimensions of a hypothetical graphic representation and its projective expansion into physical space.

73. I refer to the title "*Teppich Biologie* (*Tapestry Biology*)," Warburg Institute Archive III.2.1 ZK/4/11. On Warburg's use of the term *Biologie*, see also my "On the Biology of the Inorganic: Crystallography and Discourses of Latent Life in the Art and Architectural Historiography of the Early Twentieth Century," in *Biocentrism and Modernism*, ed. Oliver Botar and Isabel Wünsche (Franham, UK: Ashgate, 2011), 77–106 (here 94).

74. On the "pre-architectonic condition," a term first used by Gottfried Semper, see my "Modern Architecture and Prehistory: Retracing *The Eternal Present*," *RES: Anthropology and Aesthetics* 63/64 (2013): 173–89.

75. Max von Boehn, "Spitzen," in *Das Beiwerk der Mode* (Munich: Bruckmann, 1928), 1–33. See also Mrs. Bury Palliser, *History of Lace*, 4th rev. ed. (New York: Scribner's, 1902).

76. See essay by Lawrence Rinder in this volume, 25.

77. On Warburg's study of "accessories-in-motion" (*Bewegtes Beiwerk*), see the text of his 1892 dissertation "Sandro Botticelli's *Birth of Venus* and *Spring*," in Aby Warburg, *The Renewal of Pagan Antiquity*, ed. Kurt Forster, trans. David Britt (Santa Monica: Getty Research Institute, 1999), 89–156.

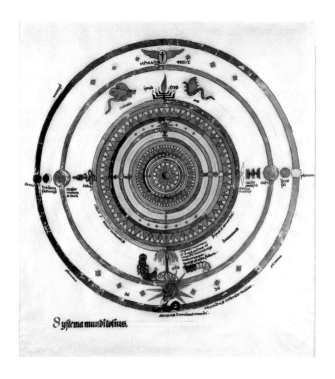

Fig. 16 Carl G. Jung's first mandala, 1916

Mandalas: Whole Symbols

Padma D. Maitland

Mandala is a whole-ing technique; it is the alchemy of opposites reuniting a blueprint that can be placed upon anything, or any man or being. It is a vision, it is a song, it is a story and a dance—the "infinitely renewed seed that contains in its nucleus the collective dream of its kind, the energy of its species."
—José Argüelles and Miriam Argüelles [1]

Mandalas organize and idealize. They gather together multiple, individuated parts into a unified field. Essential to the mandala is a strong center; geometries of squares, circles, and triangles, organized in concentric layers, indicate transitions between the interior and exterior, the mundane and supramundane, the heart and the periphery. Layered, fractured, and fractal, mandalas coalesce to form dynamic visions of order.

Associated with a variety of esoteric traditions, mandalas are most commonly seen in Buddhist, Jain, and Hindu art. The student-teacher relationship is fundamental to their transmission, and instructions on how to use and make mandalas are often passed down orally, in some cases only to a single disciple. Known as tantric traditions, such practices derive from intricate instructions for ritual, formalized in aids for visualization called mandalas or yantras. The forms and significance of mandalas and yantras are similar, but if a distinction is to be made, a yantra is more specifically a tool for visualization, associated with a single deity or practice, while mandalas are more intricate representations, or plans, of complex cosmographies.

Mandalas are holding devices. They take on and transmute symbols and meanings through their design. Formally, they embody their own process of initiation as well as coded references to multiple experiences and levels of meaning. They can be generalized and generic or specialized and highly personal. Writing about mandalas in 1949, Giuseppe Tucci suggested that since mandalas are a guide for enlightenment, they must be as diverse and varied as the people who use them. [2]

A survey of mandalas suggests that they are often more expressive of the time and place in which they were created than of any consistent idea or symbolism. What most unites the different manifestations mandalas take, along with their formal attributes, is an ability to incorporate diverse references and bodies within a single image. Part reflexive, part generative, mandalas adapt, and so to explore mandalas is to consider them doubly: first as governing devices that harmonize complexity, and second as cultural artifacts whose history functions like the mandala itself—collecting and gathering multiple influences to produce one picture, a picture of cultural ideals unified into a whole symbol.

Buddhist and Hindu Cosmographies

The tension between squares and circles that creates the dynamic patterns of mandalas is also the tension between ground and influence. Often translated simply as "circle," the word *mandala* can refer to spheres of influence, the rings of authority emanating from a ruler, or the sway of what O. W. Wolters would call the "soul stuff" of great men and women. [3] Much as a map can suggest both physical and conceptual ways of understanding the world, mandalas describe physical and mental ideals focused on locations of power within expanded terrains.

Usually depicted in plan, mandalas can also be imagined as three-dimensional structures. Temples, stupas, and even the modern designs of architects like Charles Correa suggest the different

1. José Argüelles and Miriam Argüelles, *Mandala* (Berkeley, CA: Shambala, 1972), 20.

2. Giuseppe Tucci, *The Theory and Practice of the Mandala: With Special Reference to the Modern Psychology of the Subconscious*, trans. Alan Houghton Brodrick (Mineola, NY: Dover Publications, 2001).

3. O. W. Wolters, *History, Culture, and Region in Southeast Asian Perspectives* (Singapore: Institute of Southeast Asian Studies, 1982).

Fig. 17 Anthony Ashworth,
Vastupurushmandala, n.d.

forms mandalas can take when imagined in three dimensions. Stupas are Buddhist monuments usually constructed to house relics. From above, every stupa appears like a mandala, the structure's spire marking the center, expressing a dynamic interaction between the horizontal and the vertical, the *axis mundi* and *imago mundi*.[4]

Not just monuments, mandalas can be constructed as a way of establishing boundaries and limits. Building disciplines the landscape through the construction of seats of power and points for worship. When Buddhism spread to Tibet in the eighth century, the great monastery of Samye was designed as a mandala in order to tame the region. Rituals of drawing borders and consecrating ground related to mandalas have been used for centuries in Cambodia as part of efforts to define religious and sacred ground.[5] While not literal markers of territorial boundaries, mandalas reflect formalized visions of influence often mapped onto physical and conceptual landscapes.

Mandalas can also be overlaid one on top of another, each layer representing a self-contained system of order and primacy. Arranged in this way, they define different grounds associated with ascending levels of perception and realization. These multiple layers are formalized in the spires of stupas. Early Buddhist stupa spires had three rings. Later traditions extended this to include five, seven, and then thirteen rings as practices evolved to articulate ever greater and more nuanced steps towards liberation. The famous stupa at Swayambhu in Nepal, for example, has thirteen rings, the supports of which create distinct mandalas at each level associated with different deities. The higher one climbs, the more rarefied the planes of practice and understanding. The whole system describes a complex cosmology of overlapping psychosomatic planes of existence.

Writing in the 1960s about the art of Nepal and Tibet, Stella Kramrisch, then curator of Asian art at the Philadelphia Museum of Art, stressed the role of the mandala as an expressive ground.[6] For her, the art of the region was basically of two types: geometric and figurative, the mandala as plan and "the shape of man" as an ideal. It is through the interplay of body and mandala that notions of enlightenment, transformation, and cosmic order are conveyed. Like

4. Mircea Eliade, *Images and Symbols: Studies in Religious Symbolism* (Princeton, NJ: Princeton University Press, 1961).

5. Ian Harris, "Rethinking Cambodian Political Discourse on Territory: Genealogy of the Buddhist Ritual Boundary (sīmā)," *Journal of Southeast Asian Studies* 41, no. 2 (June 2010): 215–39.

6. Stella Kramrisch, "The Art of Nepal and Tibet," *Philadelphia Museum of Art Bulletin* 55, no. 265 (Spring 1960): 23–38.

many scholars writing about mandalas, Kramrisch focused on the *vastupurushmandala* (fig. 17) as a driving formal system for art and architecture in the region. It shows the male body contained within a grid of squares, with points of significance marked at prominent meridians or chakras.

As abstract designs for ritual, only accessible to the initiated, and imagined behind the outward form of a body or a structure, mandalas speak to subtle, rather than gross, forms. Within a Hindu temple, different chambers or abodes are designated for specific gods and goddesses suggestive of distinct mandalas. This is equally true of the internal meridians of the human body. Relating to complex networks of internal channels and flows of energy, mandalas can be visualized inside the body at the different meridians as part of yogic practices.

In Buddhist tantric traditions, practitioners are invited to project their own bodies into mandalas. After taking vows and undertaking preliminary practices, a neophyte is trained to imagine him- or herself as the central deity of a mandala. The mandala's concentric geometric layers serve as a series of thresholds. Passing through them, one purifies oneself and the phenomenal world before arriving at the celestial abode of the central deity. We can see these distinct phases marked as different grounds in the *Hevajra Mandala* from fourteenth-century Tibet (pl. 234). The ring of fire removes impurities and obscurations, giving way to a series of training grounds, such as graveyards, where practitioners train amidst corpses, demons, and *nagas* (snakelike deities). Multicolored lotus petals open onto the next plinth, inscribed with a double *dorje* (a ritual symbol of the adamantine foundation of the world), forming the ground for the main celestial palace. The four gates are strung with jewels and flowers, opening onto an inner chamber delineated by four colors. The final level depicts a large lotus with Hevajra and his consort in the center.

Western Interpretations

The popular understanding of mandalas in the West has largely been through the forms of Buddhist mandalas from Tibet and Nepal, interpreted as general spiritual or psychological schemas. Giuseppe Tucci's seminal text *The Theory and Practice of the Mandala* (published in Italian in 1949 and in English in 1961) is demonstrative of this approach. While considering mandalas more generally, Tucci's text focuses on Buddhist mandalas in conversation with burgeoning ideas in psychology and art at the time. Tucci's work represents a larger tendency to see mandalas as universal archetypes, highlighting similarities while eliding the formal, cultural, and religious differences among mandalas from Hindu, Buddhist, and Jain traditions. The emphasis on Buddhist art is due, in part, to the stunning examples of highly articulated mandalas kept in monasteries and temples in Tibet that became available to the world through art sales and exhibitions after the 1950s. In other traditions, mandalas have tended to be used ephemerally, as elements in rituals, and thus they have not been preserved as art objects.[7]

No one has had a larger impact on the understanding and use of mandalas in the West than Carl G. Jung. Not only did Jung write introductions to English translations of *The Tibetan Book of the Dead* and the *I Ching*, he also wrote extensively about mandala drawing as a form of personal analysis. Where early studies of mandalas recognized the link between bodies and mandalas, Jung's insight was to privilege a first-person account, and to understand the mandala as an architecture for the psyche of the self in the world. According to his autobiography, Jung first began exploring mandalas in 1916, but only took them up as a serious practice between 1918 and 1919 while he was a prisoner of war (fig. 16). Jung discovered through drawing mandalas that all paths lead to a center: "I saw that everything, all the paths I had been following, all the steps I had taken, were leading back to a single point—namely, to the mid-point. It became increasingly plain to me that the mandala is the center. It is the exponent of all paths. It is the path to the center, to individuation."[8]

While Jung's references largely follow from a hermeneutical tradition, his search was for universal archetypes. In 1937 Jung traveled to India, where, as he discussed in "Concerning Mandala Symbolism" (1950), he saw a mandala drawn on a temple porch in Madura (present-day Madurai). When asked what it meant, the young woman drawing the form with chalk on the ground did not have an answer. Nor did the temple priest standing close by. Jung uses this example to show how

7. Gudrun Bühne-mann, *Mandalas and Yantras in the Hindu Traditions*, Brill's Indological Library, Vol. 18, ed. Johannes Bronkhorst (Leiden and Boston: Brill, 2003).

8. Carl Gustav Jung, *The Essential Jung*, ed. Anthony Storr (Princeton, NJ: Princeton University Press, 2013), 234.

Fig. 18 Gordon R. Ashby, *Be a Transformer*, 1970

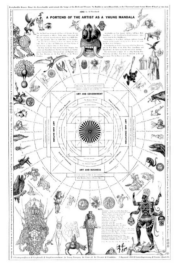

Fig. 19 Ad Reinhardt, *A Portend of the Artist as a Yhung Mandala*, 1956

mandalas can function personally and culturally without formal explanation or education. The mandala meant something to the woman drawing it, and it meant something to Jung; that was enough.[9] Like any archetypal symbol, mandalas can make visible the structure of a universal unconscious, and invite each individual to define them in relationship to him- or herself. But for Jung, mandalas are unique as an archetype of the whole.

Writing about myth and religion, Joseph Campbell similarly searched for common archetypal motifs. Campbell was particularly influenced by Jung's theories, and once again foregrounded the circle and the mandala as holistic symbols. Discussing what he called the "Universal Round," Campbell wrote, "As the consciousness of the individual rests on a sea of night into which it descends in slumber and out of which it mysteriously wakes, so, in the imagery of myth, the universe is precipitated out of, and reposes upon, a timelessness back into which it again dissolves."[10] Within Jung's and Campbell's works, Vedic texts, or what we might more commonly call today Hindu texts, joined with Jung's theories of the universal unconscious to offer a language for addressing collective experience. These lessons from India suggested a philosophy of life that merged mysticism with science and yoga with empiricism.

Hinduism first became part of the fabric of American intellectual history in the writings of Ralph Waldo Emerson, who was familiar with the Vedas, the Upanishads, the Mahabharata, and the Ramayana. It did not strongly impact popular consciousness, however, until the late nineteenth century when a "scientific" version of Hinduism was promoted by Swami Vivekananda at the 1893 World Parliament on Religions in Chicago. Years later, Maharishi Mahesh Yogi would expound a similar approach, introducing the idea of Transcendental Meditation (TM), which became widely popularized when the Beatles traveled to the Maharishi's ashram, Rishikesh, in 1968. A deeper and more lasting influence was the founding, in Los Angeles, of the Ramakrishna Monastery by the British mystic Gerald Heard, a follower of Swami Prabhavananda. This site became the meeting point of many extraordinary spiritual seekers including Aldous Huxley, Christopher Isherwood, and the experimental filmmaker James Whitney.

9. Carl Gustav Jung, *Mandala Symbolism*, trans. Richard Francis Carrington Hull (Princeton, NJ: Princeton University Press, 1972), 72.

10. Joseph Campbell, *The Hero with a Thousand Faces* (Novato, CA: New World Library, 2008), 223.

James Whitney and his brother John were not only pioneering in their use of new technologies to create films, they also invented dynamic new approaches to the visualization of mandalas. James Whitney drew on esoteric traditions in films such as *Yantra* (1957; pl. 243) and *Lapis* (1966; pl. 244). *Yantra*, made over the course of eight years, consists entirely of patterns made by painting tiny dots punched by hand with a pin into 5×7 index cards. When animated, the swirling, gyrating particles draw the viewer into an experience of cosmic creation. *Lapis*, too, was made using hundreds of hand-punched cards, which Whitney animated into a hypnotic visual meditation. The graphic motion in *Lapis* was controlled by an analog computer salvaged by John Whitney from a World War II antiaircraft gun, while the film's soundtrack features Indian sitar music, *Raga Jogiya*, played by the master musician Ravi Shankar. John Whitney himself took the computational dimension of abstract film even further, creating what is widely regarded as the most important early digital computer animation, *Arabesque* (1975; pl. 245). In this work, sinuous curves reminiscent of sine waves oscillate in three dimensions to suggest the filigree of Islamic architectural decoration.

The novel art of the Whitney brothers was grounded in the spiritual and cultural eclecticism of mid-twentieth-century America, in which "James practiced yoga, filmmaking, computer animation, Japanese brush painting, and raku pottery, and also studied Taoism and nuclear physics."[11] The mandala was the formal representation *par excellence* of this cultural mélange. Understood holistically or, to borrow from Joseph Campbell, as a "hero with a thousand faces," the mandala was an ordering principle that could hold together the kind of supersaturated and complex imagery favored by the emerging counterculture. From the 1950s through the 1970s, mandalas were ubiquitous, in forms as diverse as the geodesic dome system of Buckminster Fuller (pls. 82–83), the cover design for the wildly popular spiritual guide *Be Here Now,* the psychedelic posters of the San Francisco–based company East Totem West, and the later ecological mandalas of Gordon R. Ashby (fig. 18, pls. 26–28).

Even the painter Ad Reinhardt nodded to the popular currency of the mandala in his parodic *A Portend of the Artist as a Yhung Mandala* (1956; fig. 19), a graphic diagram designed as a page for *Art News*. Playing off both the name "Jung" and James Joyce's *A Portrait of the Artist as a Young Man*, this piece positions the artist at the center of a mythic mandala of the art world, at the nexus of the here and now, surrounded by global archetypes and symbols. In contrast to this humorous approach to the theme, Reinhardt's later paintings draw on the mandala motif with apparent gravity. The dark, nearly black works of his *Abstract Painting* series (pl. 181) are composed of subtly varying shades of deep blue, gray, and maroon arranged in mandala-like interlocking geometries. Not conventionally expressive, these dense images are nevertheless rich with affect and fervor. About the color black, Reinhardt wrote:

> Leave temple images behind
> Risen above beauty, beyond virtues, inscrutable, indescribable,
> Self-transcendence revealed yet unrevealed.[12]

Mandalas are compositions in the atmospherics of color and form. They describe a sense of place in the cosmos, creating holistic forms that can take on almost any arrangement. To dive into their center is to be submerged, and thus to be lost within an ocean of complexity, part of something constructed and yet limitlessly diffuse.

11. Zabet Patterson, "From the Gun Controller to the Mandala: The Cybernetic Cinema of John and James Whitney," *Grey Room* 36 (Summer 2009): 40–41.

12. Ad Reinhardt, "Dark," in *Art-as-Art: The Selected Writings of Ad Reinhardt*, ed. Barbara Rose (Berkeley, CA: University of California Press, 1991), 90.

Fig. 20 Richard Jensen, *Synthetic Riot*, 2002 (detail)

Rubus Armeniacus

Lisa Robertson

From *Occasional Works and Seven Walks from The Office of Soft Architecture*

Illegitimate, superfluous, this difficult genus of frost-tolerant hermaphrodites seems capable of swallowing barns. It propagates asexually. Purplish thumb-thick stems nudge forth several feet per year. Thorns enable the plant to climb. Last year's shoot with inflorescences, this year's shoot with leaves.

In *Species Plantarum* (1753), Linnaeus identified two European species of rubus within the large, five-petal Rosa family, thus beginning one of taxonomy's largest fields of study—Batology. He described rubus as polygynic: "twenty males, many females."

Our own relation to rubus has been as jam makers rather than batologists. The sweet, plump drupelets of the *Rubus armeniacus*, or Himalayan blackberry, grow free and copious in lesser-groomed residential alleyways, vacant lots, chain-linked sites of abandoned factories, and similarly disturbed landscapes of our city. Environment Canada classifies this nonnative introduced taxon as "minor invasive alien." It makes tasty, if somewhat seedy, pie.

In late nineteenth-century America, rubus enthusiasm was a faddish adjunct to horticultural orientalism—the identification and importation of Chinese brambles enriched the picturesque aspect of shrubberies, pergolas, and pleasure grounds. Our favorite blackberry was introduced to this continent by the Californian entrepreneurial horticulturalist Luther Burbank in 1885. Burbank approached botanical hybridization using mass production methods. He sought novelty, hardiness, and yield; each taxon was a potential product. He selected this new bramble import, purportedly "Himalayan" (now proven by chromosome-counting taxonomic technologies to be European in origin), for its exuberant productivity, subjecting the alien taxon to rigorous hybridization. By crossing it with a pale indigenous bramble, Burbank would make a seemingly bleached fruit, wonder of plantsmen, "the white blackberry," almost disproving his own pantheistic claim that "the human will is a weak thing beside the will of a plant."

The Himalayan blackberry escaped. The plant's swift rhetorical trajectory from aestheticized exotic to naturalized species to invasive alien, all the while concealing a spurious origin myth, displays a typically hackneyed horticultural anthropomorphism.

Rubus's habits are also democratic. In Fordist fashion it maximized distribution through the temperate mesophytic forest region; that is, from California, up the Northwest coast as far as southwestern British Columbia, and inland to Montana. But what we have come to appreciate most about

this rubus, apart from the steady supply of jam, is its bracingly peri-modern tendency to garnish and swag and garland any built surface it encounters. In fact, the Himalayan blackberry insistently makes new hybrid architectures, weighing the ridgepoles of previously sturdy home garages and sheds into swaybacked grottoes, transforming chain-link and barbed wire to undulant, green fruiting walls, and sculpting from abandoned cement pilings Wordsworthian abbeys. We, too, are fascinated by its morphological lust.

After some study the Office for Soft Architecture reached the opinion that our alien is the dystopian epitome of the romance of botanical pattern as applied architectural decoration. To illustrate our opinion we'll lead the reader through a picturesque landscape of quoted fragments. We'll pursue an etymology of ornament, following the rubus runner back to the screen memory of the nineteenth century.

If architecture is entombed structure, or *thanatos*, ornament is the frontier of the surface. It is at the surface where lively variability takes place. The architect Gottfried Semper said of Cuvier's display of comparative anatomy at the Jardin des Plantes, "We see progressing nature, with all its variety and immense richness, most sparing and economical in its fundamental forms and motives. We see the same skeleton repeating itself continuously but with innumerable variations." The Office for Soft Architecture finds the chaos of variation beautiful. We believe that structure or fundament itself, in its inert eternity, has already been adequately documented—the same skeleton repeating itself continuously. We are grateful for these memorial documents. But the chaos of surfaces compels us toward new states of happiness. We concur with John Ruskin, who, in *The Stones of Venice,* stated:

> We have no more to do with heavy stones and hard lines; we are going to be happy: to look round in the world and discover (in a serious manner always however, and under a sense of responsibility) what we like best in it, and to enjoy the same at our leisure: to gather it, examine it, fasten all we can of it into perishable forms, and put it where we may see it for ever.

This is to decorate architecture.

Yes. For Ruskin, foliage, flowers, and fruit, "intended for our gathering, and for our constant delight," are paradisial decorative motifs. And paradise has room for both parts of binary Man: "The intelligent part of man being eminently, if not chiefly, displayed in the structure of his work, his affectionate part is to be displayed in its decoration." Although Ruskin insisted on the balance of intelligent and affective tectonics, he defined balance as an orderly subordination of decoration to structure. Finally he preferred to govern ornament. (It would be gentler to say that Ruskin's delight unconsciously mirrored taxonomic systems of subordination.) Gottfried Semper, however, proposed a four-part unsubordinated architectural topology, where surface was in a nonhierarchical dynamic relationship with molded plasticity, a framework of resistance, and foundational qualities. The transience and nonessential

quality of the surface did not lessen its topological value. Architectural skin, with its varieties of ornament, was specifically inflected with the role of representing ways of daily living, gestural difference, and plenitude. Superficies, whether woven, pigmented, glazed, plastered, or carved, receive and are formed from contingent gesture. Skins express gorgeous corporal transience. Ornament is the decoration of mortality. Nor did Cuvier participate in the subordination of surface to structure. For him, sheer variability kept the surface in vibrant dialectic with structural essence:

> We find more numerous varieties in measure as we depart from the principal organs and as we approach those of less importance; and when we arrive at the surface where the nature of things places the least essential parts—whose lesion would be the least dangerous—the number of varieties becomes so considerable that all the work of the naturalists has not yet been able to form any one sound idea on it.

We are Naturalists of the inessential. Our work will never end. In the researches of Semper, Cuvier, Ruskin, and Rubus, we recognize the dialectic that we believe continues to structure architectural knowledge: Modification vs. Frugality. Enough of the Least. The limitless modification of the skin is different from modernization—surface morphologies, as rubus shows, include decay, blanketing and smothering, dissolution and penetration, and pendulous swagging and draping as well as proliferative growth, all in contexts of environmental disturbance and contingency rather than fantasized balance.

Rubus armeniacus is an exemplary decoration, a nutritious ornament that clandestinely modifies infrastructural morphology. Here, affect invades the center. Rubus puns upon the proprietous subordination of affective expenditure to intelligence. Tracing a mortal palimpsest of potential surfaces in acutely compromised situations, rubus shows us how to invent. This is the serious calling of style.

Private in Public

Rebecca Solnit

On Not Belonging

To be without a home is to be on exhibit. It is to be in the public space everyone else is free to enter and exit, to be without respite or refuge, to be subject to the gazes and judgment of others. Those without homes are both forced to appear and urged to disappear. Some manage to live quietly on the margins; others try to survive by putting their suffering on display and asking for engagement, with pathos, with wit, with charm, with puppies or kittens, with signs about hunger or how luck abandoned them.

To be homeless is to be a refugee without refuge. Services—soup kitchens, homeless shelters—may give stations on the route, but these too can be disrupted, and to try to stay in the system—to stand in line for a chair in a shelter (many oblige people to sleep sitting up), to get a meal, to get services—is a bureaucratic job that not everyone succeeds at. Most homeless people are constantly being told that they are not wanted, that they must move on. The overarching mandate is: go away, disappear, don't display yourself here. Move on. Go somewhere else. You don't belong.

At lunchtime, sitting across the street from the Berkeley Art Museum and Pacific Film Archive while it is under construction, we see a scruffy man with a coyote tail pinned to his rump pushing two small dogs in a wagon, wrapped in elaborate textiles, ruffled, like the ruff of a jester. Then another man, elderly, brown, pushing a wheelchair decorated with artificial flowers, enters the Iranian restaurant and tries to sell us honey and honeycomb. Whether he is a person who actually owns that stable nexus of the floral landscape, a beehive, or is a reseller, we debate later; during the visit, we squirm a little, declining his very expensive wares. He gives up eventually, goes and sits in his wheelchair at the door for a minute, and moves on. These two passersby seem medieval in their colorfulness, as well as part of the America we know too well, the one that damages so many people's souls and pushes so many lives to the margins.

A couple of days later, I walk to campus from BART on Center Street, and someone is sleeping in the doorway of the restaurant, and others are in other doorways. The row of restaurants is a temporary dormitory. Part of the geography of homelessness is repurposing odd niches and corners, leftover and temporarily unused spaces; part of the geography of anti-homelessness is the spikes on window ledges, sprinklers, and other items to make places uninhabitable.

That morning of the doorways full of sleepers, I return to the BART train and sit kitty-corner from a woman whose body is bent and hunched into crags and hollows, but whose brown face is a smooth diamond of endurance under a hat. She has a substantial rolling suitcase and two grimy plastic bags with her, about as much as she could possibly carry. I wonder if she is riding the train all day for a safe, comfortable place to be, or going someplace in particular. I wonder if she is homeless. It seems likely. Or perhaps she is teetering on the brink, rotating between places.

Belongings are not the essence of belonging, but without belonging to someplace and someplace belonging to you, it is hard to own anything. Objects come and go, are rain-soaked or stolen or confiscated by the law or the shelter system. The belongings of the homeless are often thrown out, a reminder that their things and, by extension, they themselves are of no value.

The presence of people without homes in a city transforms its geography, redefining the physical landscape and calling attention to the unevenness of the social landscape. It reshapes them, or renders visible that those places are deformed, with a deformation at once spatial, economic, imaginative, emotional, and ethical.

On Emptiness and Plentifulness

It is not often recalled that very few were without homes thirty-five years ago. I remember in the late 1970s the clochards of Paris, men in long coats with matted hair, presumed to be alcoholics, like the small population of what we then called skid-row bums in my hometown San Francisco. They were rare birds, seldom seen and confined to a few places.

Skid row is a term that comes from Seattle, from small streets on which actual skids were used to slide logs; the city's Pioneer Square is the original Skid Row. Pioneer Square: many of the people without homes who passed through that plaza were Native American, displaced by the invasions of their homelands and the replacement of their culture with ours. In 1991 the artist Edgar Heap of Birds installed a pair of panels inscribed, in English and Lushootseed, the native language once spoken there, "Far away brothers and sisters, we still remember you" and "Chief Seattle, now the streets are our home." It is that great rarity, public art that directly addresses those who live in public.

By the time Heap of Birds's piece was installed, the population of people without homes was considerable, and the word *homeless* became a noun, rather than an adjective. Thus it was that in the Reagan era and after, a wide variety of people could be reduced to that faceless term for their housing status, or lack thereof, the way that people with leprosy are reduced to lepers, with addictions to addicts, without legal standing to illegals. To be reduced to the noun that describes the worst of your situation and erases the rest is a cold fate and a common one now.

Workers with jobs but no homes, families with children but without shelter, people homeless because of mental illness or overwhelming debt or addiction did not exist in quantity in the decades before the 1980s. Policies made this problem. The problem is now so old it existed before many of us were born, has come to seem natural, inevitable, a given in the social landscape. It is often described as the result of individual failure. But it is also the result of choices we made together and the powerful made for us, here in this country whose poverty is always the result of distribution rather than genuine scarcity.

In the Bay Area, we have often been told that we can build our way out of the lack of affordable housing and the overall housing shortage, but the majority of San Francisco's new structures are luxury condos and many of those are now second homes, empty most of the time, as are many of the luxury homes in cities from San Diego to Manhattan. Empty homes and people shut out of housing are the paired faces of our economic arrangements, of a society in which some have too much and some not enough.

In the landscape experienced from this perspective, it is as though the buildings all became solid objects, like trees, under whose sheltering branches, among whose roots, you might curl up, but never enter. I think of Rachel Whiteread's famous concrete cast of a house as a solid object and imagine that for those who have no homes and live on the streets most buildings must appear something like that: solid objects whose porticos, doorways, overhangs might provide shelter but whose interiors are irrelevant. There are a certain number of places the visibly homeless are allowed to enter, but most are impenetrable (and part of the geography of anti-homelessness is the spikes on window ledges, sprinklers, and other items to make even exteriors uninhabitable). Even public libraries, de facto daytime homeless shelters in earlier decades, seem to have found ways to dissuade most of the more obviously unhoused from taking refuge.

They are outsiders in the most literal sense, those who are condemned to survive outside rather than inside. They face cold, heat, bad weather, encounters with strangers, violence, the lack of safe space for everyday activities, the lack of privacy, as though the city itself, or the society, had become wild, wilderness, savage, shattered. The ability to carry one one's everyday activities in private, from excreting to sleeping to eating to resting, is the privilege homes provide us.

There was a distraught woman who sat at the corner of Turk and Van Ness for many years, rocking and comforting herself with a tattered stuffed animal, receiving handouts but not soliciting them. She might have been young, but her face was creased with anxiety and pain, and her hair was straggling, brown, unwashed, her body sturdy and somehow gnarled, like a tree. Then one day, perhaps a decade ago, she wasn't there anymore. I will likely never know what happened to her, any more than to the older man with the broad-brimmed hat who always seemed to be on the benches of the Panhandle of Golden Gate Park, looking rather as though he were from an earlier era, a scout or trapper.

These two homeless people seemed to have found a coherent geography, a center in the mandala of the city, if not a home in it. Others ceaselessly wander, pushed onward. In downtown San Francisco's Powell Street underground transit station, men, mostly African American, sprawl in sleep, their bodies in repose reminiscent of the corpses in photographs of the Civil War. What war are they casualties of? What series of calamities or traumas ejected them onto the street? What is it like to sleep without privacy, without security, without the sense of protection of a bed beneath you, a blanket and then a roof above you, walls around you, the embrace of a home? At the same time I notice that they are all men, that even this public collapse may be too unsafe for women to partake of.

On the City as Wilderness

Their vulnerability is terrifying. Hermit crabs live in shells formed by other creatures, and when they outgrow one shell they scurry to find another and in that phase are vulnerable. Human beings in our time and place are, perhaps more than we have calculated, like these creatures, dependent on shelter that is a sort of exoskeleton, an armor, for the psyche as well as the body. To be at home is a state of mind and geography at once. Contemplating the homeless, I wonder how many days or weeks without shelter, without safety, without privacy, it would take to wreck me. Not many, I assume.

Man Is Wolf to Man was the title of a book about survival in wartime, and cities are wildernesses to men, women, and children without homes, that vast heterogenous population we render faceless and homogenous as the homeless. *Wilderness* is a word that conveys pleasure and virtue nowadays, but it was the term for the places that outcasts were driven into, and perhaps cities are now wildernesses in that sense. The biblical wilderness into which Hagar and her son Ishmael were driven was dangerous and lonely. But those older wildernesses for scapegoats were remote, outside the crowd; this is exile in the center, or the center become wilderness, a new geography.

In the wilderness we are hunters and gatherers, and something about the way that some unhoused people live remakes the city as that kind of place. They scavenge recyclables to redeem for cash or they scavenge directly for food, they roam in quest for services and shelter. They live in uncertainty; when you are outside you can be disturbed or violated at any time, by the authorities as well as by hostile housed and unhoused people.

Near where I now live, a small group of tents are pitched on a still-industrial corner, where no one is likely to phone in to demand they be removed, a reminder that the camping some of us engage in voluntarily in beautiful places is more or less the perpetual condition of others, though even to have a tent is an advantage, a thin layer against exposure.

One of the remarkable things about the Occupy movement of 2011 was how it created, in many of its thousands of occupations/encampments, an egalitarian landscape in which many slept outside together, the differences between the destitute and the voluntarily unhoused less evident, while

community kitchens and free clinics provided services to people at all levels of need. It was a generous moment of nonseparation, of no us versus them. And the situation was congruous with the meaning of the protests against the economic injustice that was breaking lives with the burdens of medical, housing, and student debt and driving people into homelessness.

On the Theft of Nothing and the Displacement of Meaning

The rest of the time, those without homes wander, seeking the fundamentals for survival: food, water, shelter or a place to rest, a place to relieve themselves. All these basic human acts and needs have been criminalized, as we become a Dickensian society, a society in which poverty and criminality are conflated, and falling into the former means falling into the latter. Serving food in public is criminalized in many places, and in 2010 San Francisco criminalized sitting and lying in public after a newspaper columnist and mayor insisted repeatedly that homeless people were criminals and allowing such people to rest, rather than remain in perpetual motion, was to encourage danger. They were not victims. We were their victims, in this narrative. Berkeley, too, considered such an ordinance, but voters rejected it in 2012.

What we do in private they must do in public. Policy is debated, laws passed, regulating if and where and when they and, for that matter, we may sit or lie down, eat or drink or urinate or defecate. To sleep is to commit a crime in many places (though to be forced to go without sleep is a form of torture banned under international law). The homeless are driven onward by the law and by subsidiary authorities in stores, libraries, parks, driven even from church steps (the Catholic cathedral in San Francisco was recently caught using sprinklers to soak sleepers at its doors), always being told to move on.

It's an interesting paradox: that to have nothing is to be a criminal, even though criminality is often the result of illicitly seizing something—of robbing, stealing, purloining. If this population successfully robbed and stole, surely they would have the means to pay for homes? In a false meritocracy, failure is crime.

But there is another operation underway in regarding the homeless as criminals, an intentional confusion of categories. The logic, so far as I can understand it, goes something like this: these people threaten one's sense of self, one's sense that our society is a good society, that our economy is a just economy. They demonstrate that any one of us could become desperate, mad, hungry, filthy, a person who does not belong. They reveal that there is, in the geography of these places, an outside as well as an inside, and anyone could be cast out into it, into the wilderness. That you can fall and keep falling and that all of us are precarious.

Rather than accept that evidence, many reframe the threat they pose as a physical threat, a violent threat. To recast them as posing literal, criminal danger is to deny that moral, philosophical, political threat. A similar thought process turns political activists or any other kind of outsiders or disturbers of the peace into criminals. Indeed, criminality is a way of taming the threat of otherness,

of ignoring the questions it raises. Thus it is that through a kind of reshuffling of categories the victims of economic violence are imagined as perpetrators of another kind of violence.

On Garbage and Giving Alms

Yet another group demonizes those who live in public as garbage. One of the most notorious examples came from a tech executive who in an infamous 2013 screed said that San Francisco suffered from a lack of segregation:

> In downtown SF the degenerates gather like hyenas [. . .] Like it's their place of leisure... In actuality it's the business district for one of the wealthiest cities in the USA. It's a disgrace. I don't even feel safe walking down the sidewalk without planning out my walking path.
>
> You can preach compassion, equality, and be the biggest lover in the world, but there is an area of town for degenerates and an area of town for the working class. There is nothing positive gained from having them so close to us. It's a burden and a liability having them so close to us. Believe me, if they added the smallest iota of value I'd consider thinking different, but the crazy toothless lady who kicks everyone that gets too close to her cardboard box hasn't made anyone's life better in a while.[1]

He regards it as an aesthetic or spatial problem; the privileged should not be exposed to the desperate.

It is undoubtedly true that there are violent and criminal people without homes, as there are among those of us with homes; I only know that in thirty-five years of wandering San Francisco and Berkeley alone, day and night, I have never been menaced by one; that everyone who menaced me appeared to be the kind of person who had a home and resources, and that my greatest chronic danger is cars. I have, almost daily, however, faced the other kind of pressure: to decide whether to give or turn away. I've done both, do both, daily, and I try to give respect no matter what.

To witness the plight of those without homes, those who live in public, is to see that this society has fissured and split. We talk often, nowadays, post–Occupy Wall Street, about the great and widening economic divides. But those are also spatial divides. Neoliberalism's abandonment of the common good is also an abandonment of public and civic space. The majority of us withdrew into private space and the minority were left out in public. In other parts of the world, public space is a celebratory place inhabited by many—I think of the gracious old city of Guanajuato in Mexico, now a college town, where people stroll, gather in plazas to listen to music or to dance, sit on benches in other quieter plazas; of the sense even in New York City and New Orleans that sitting outside in public is a pleasure. In the Bay Area it often seems to be regarded— unless you are at a playground with children or a designated park, and not alone—as a form of dereliction or vagrancy. Outside has, thus, been lost to the rest of us in some way. We have withdrawn to the private sphere. When we did so the public sphere withered away, or became a wilderness. Some were left behind. In this wilderness that is not home.

1. Greg Gopman, Facebook update, December 10, 2013, quoted in Sam Biddle, "Happy Holidays: Startup CEO Complains SF Is Full of Human Trash," Valleywag, December 11, 2013, http://valleywag. gawker.com/happy-holidays-startup-ceo-complains-sf-is-full-of-hum-1481067192.

Plates

David Chalmers Alesworth
Selections from the series *The Trees of Pakistan*

1. *"The Striped Eucalypt" (Safeda)*, Eucalyptus camaldulensis *Dehnh., Dr. Ziauddin Ahmed Rd., Karachi,* 2004

2. *"The Bottle Palm in Black and White" (Royal Palm)*, Roystonea regia *(Kunth) O.F. Cook, Nr. Karsarz, Karachi,* 2005

3. *"The Fortress Sniper Tree" (Arjun)*, Terminalia arjuna *(Roxb. ex DC.) Wight & Arn., Fortress Check-Post, Nr. Mian Mir Bridge, Lahore,* 2010

4. *"The Political Tiger Tree" (Devil's Tree, Blackboard Tree)*, Alstonia scholaris *L. R. Br., Neela Gumbad, Lahore,* 2013

5. *"The Tyre Shop Tree" (Neem)*, Azadarachta indica *A. Juss., Ravi Bridge Stop, Lahore,* 2013

6. *"The Two Barbers' Tree" (Kubabhal, Babul)*, Leucaena leucocephala *(Lam.) de Wit, Railway Underpass, Nr. Seven-up, Lahore,* 2013

7. *"The Bells and Baskets Tree" (Gul e Nishtar)*, Erythrina suberosa *Roxb., D-Block, Model Town, Lahore,* 2013

8. *"The Bird Boxes Eucalypt" (Safeda)*, Corymbia maculata *(hook.) K.D. Hill & L.A.S. Johnson, E-Block, Model Town, Lahore,* 2013

9. *"The Main Mkt. Barber Shop Tree" (Maulsary)*, Mimusops elengi *L., Main Mkt., Lahore,* 2013

10. *"The Disused Pylon Pine" (Chir Pine)*, Pinus roxburghii *Sarg., Abid Majeed Road, Cantt., Lahore,* 2014

11. *"The Cobbler's Tree" (Bachain)*, Melia azedarach *L., Batti Chawkh, Lahore,* 2014

12. *"The McDonald's Tree" (Peepal)*, Ficus religiosa *L., 63-Main Drive Through, Off Main Blvd., Lahore,* 2014

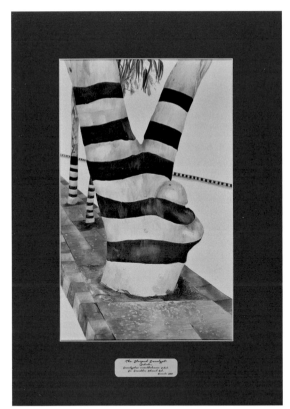

The Striped Eucalypt
(Lahore)
Eucalyptus camaldulensis plus
Dr. Dieuddin Ahmad Rd.
Karachi 2000

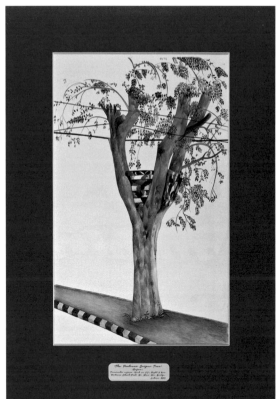

The Featureless Saigon Tree
(Saigon)
Fernandoa urigera Gink on 52, Right 8 pm.
between Chard Rost Dr. Gint Nn Bridge
Lahore 2001

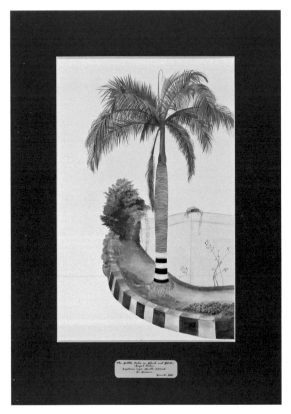

The Golden Palm in Black and White
(Royal Palm)
Roystonea regia (south S.Africa)
Dr. Karimova
Karachi 2000

The Political Tiger Tree
(Devils Tree, Blackboard Tree)
Alstonia scholaris L.R.
Mole Gardal
Lahore 2001

1. 3. 73
2. 4.

The Bells and Borehole Tree
God's Weakler
Erythrina caberense O.A.
© Black Walnut Press
Graham 2010

The Tea Garden Tree
Rebekah Gabel
Leucaena leucocephala 'Lam.' de Wit
Railway Subnorphane for Green Life
© Black Walnut Press
Graham 2010

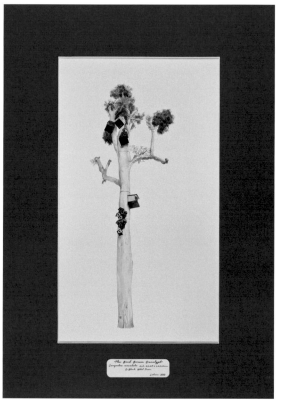

The Bird Brain Eucalypt
Corymbia maculata sub-0648 x 0648mm
© Black Walnut Press
Graham 2010

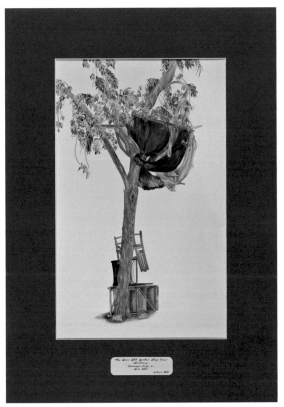

The Have Not Broken Shop Tree
Wandering
Gronage shop 2,
Hira Shd.
Lahore 2010

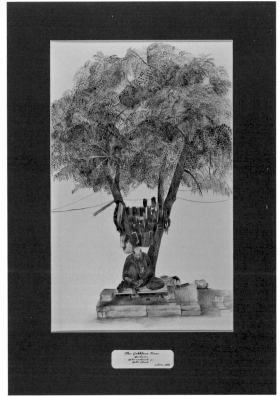

The Cobbler Tree
Roadside
Hazra underneath 2,
Jutti Church
Lahore 2010

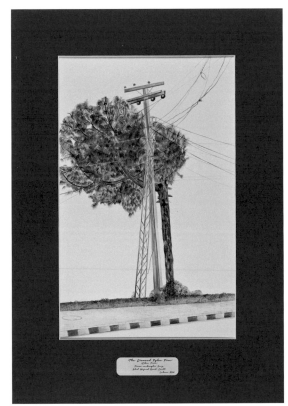

The Diamond Pylon Tree
Peace man
Peace underneath Guy,
Shell Dagood Souls Jawde
Lahore 2010

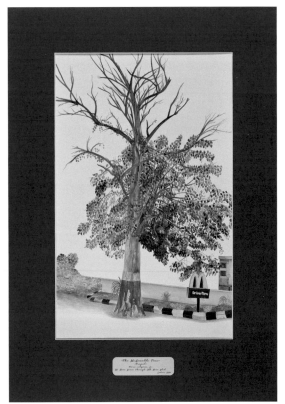

The No-Grumble Tree
Forgeth
Henro Enquires 2,
Di Hira Tree Through the Hira Shd.
Lahore 2010

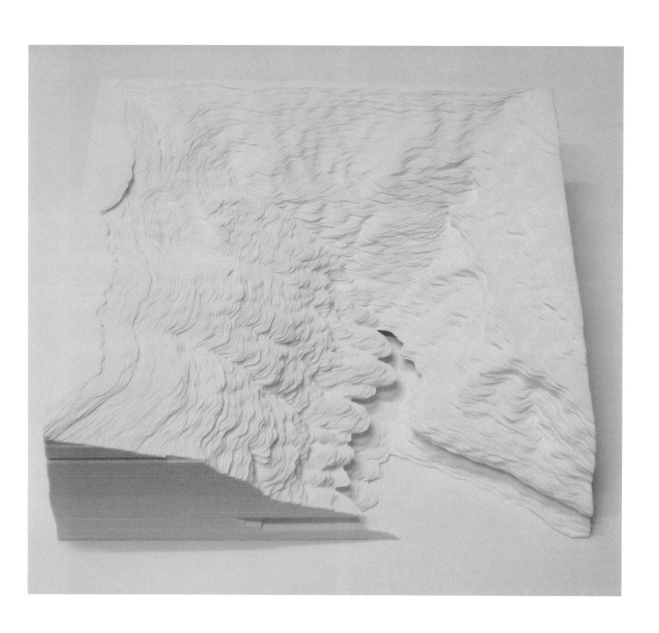

13. Noriko Ambe, *A Piece of Flat Globe Vol. 12*, 2010

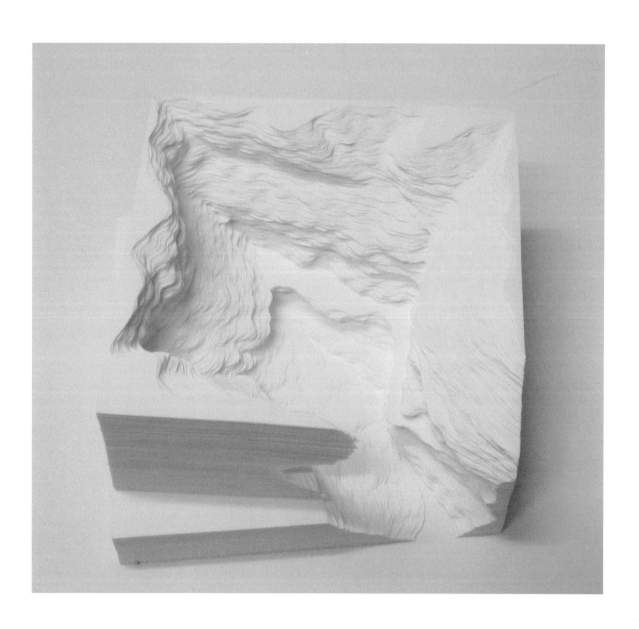

14. Noriko Ambe, *A Piece of Flat Globe Vol. 22*, 2010

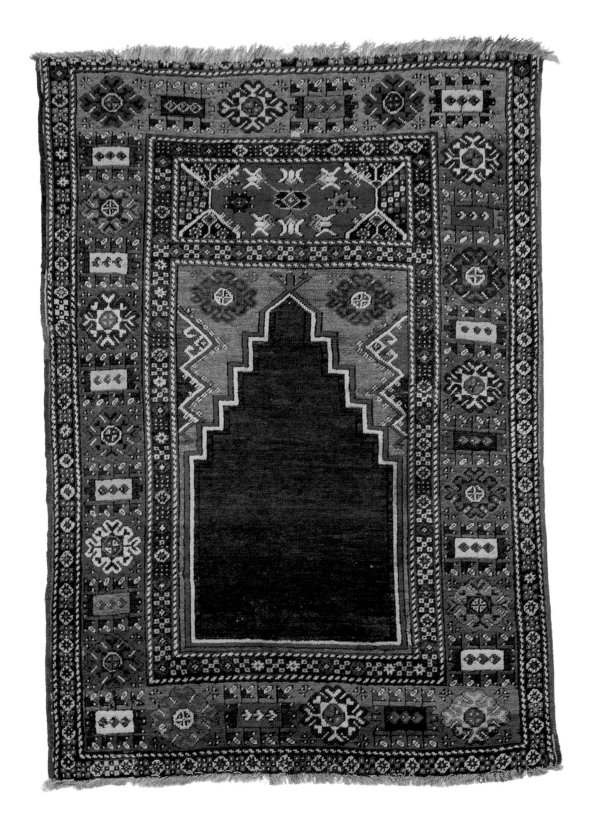

15. Anatolia (Konya), Turkey, Prayer rug, n.d.

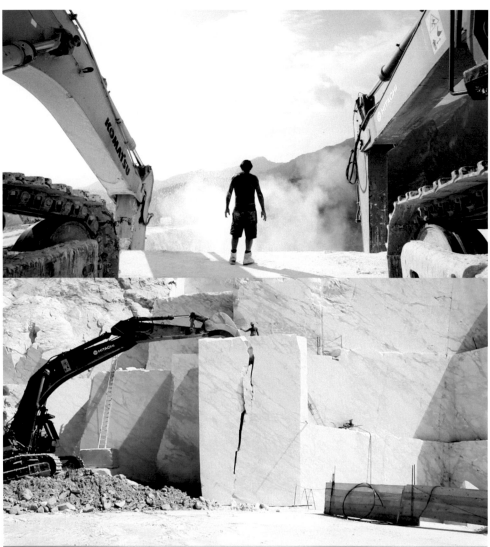

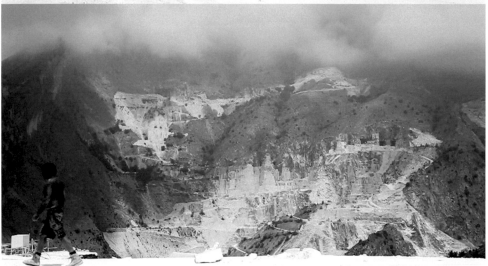

16. Yuri Ancarani, *Il capo*, from *La malattia del ferro (The Malady of Iron)*, 2010 (stills)

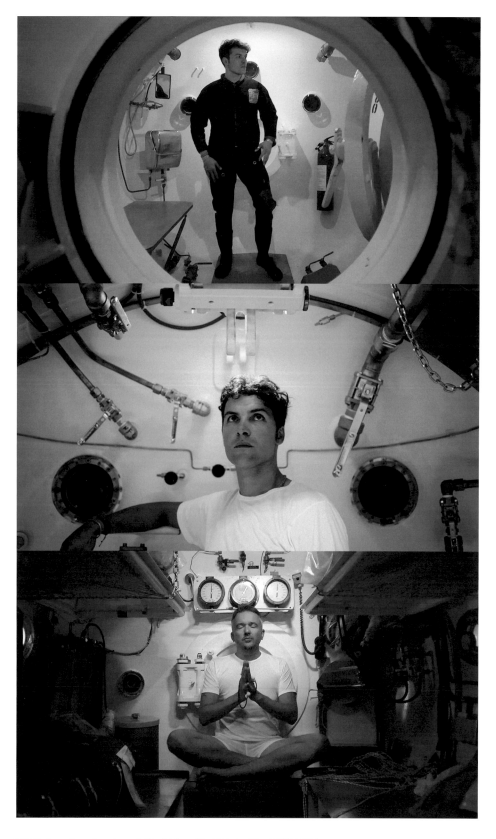

17. Yuri Ancarani, *Piattaforma luna*, from *La malattia del ferro (The Malady of Iron)*, 2011 (stills)

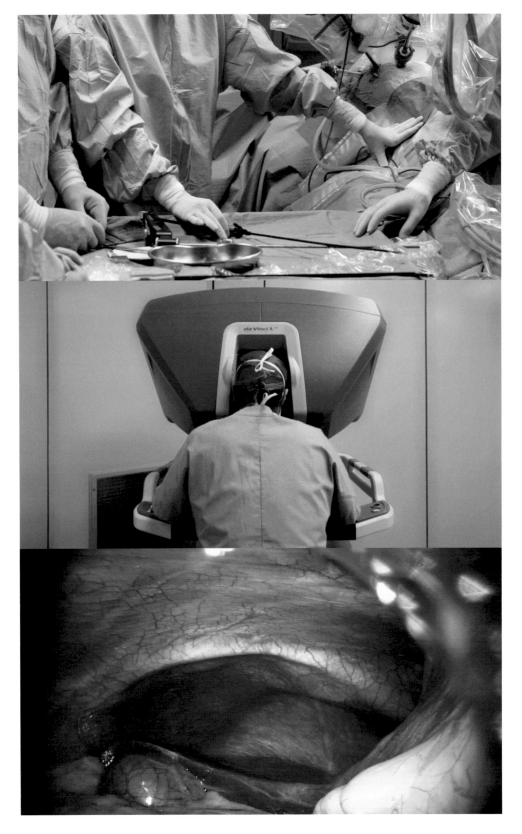

18. Yuri Ancarani, *Da Vinci*, from *La malattia del ferro (The Malady of Iron)*, 2012 (stills)

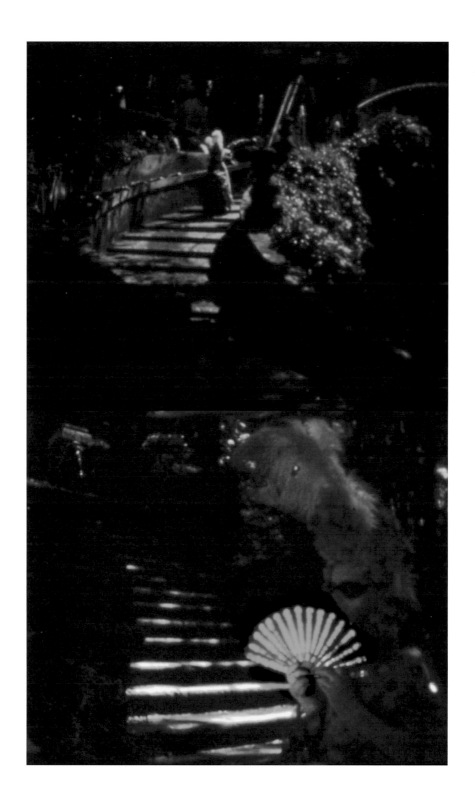

19. Kenneth Anger, *Eaux d'Artifice*, 1953 (stills)

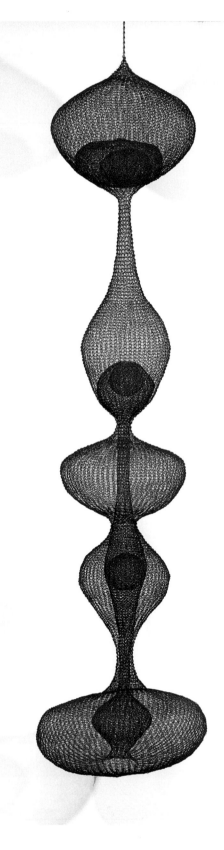

20. Ruth Asawa, *Untitled (S.283)*, c. 1953

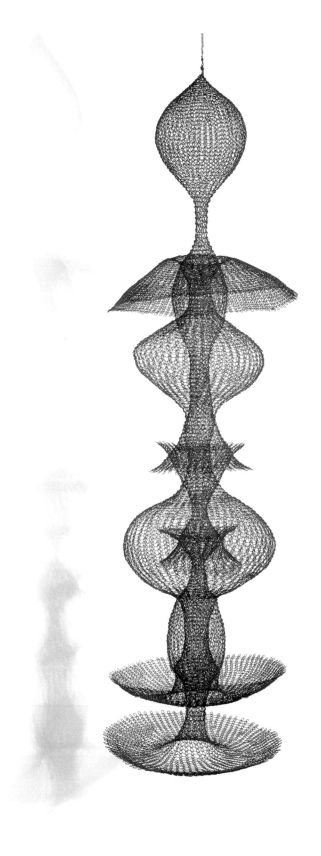

21. Ruth Asawa, *Untitled (S.573)*, c. 1953

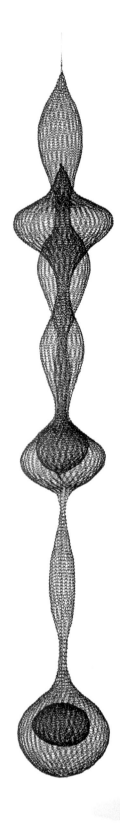

22. Ruth Asawa, *Untitled (S.550)*, late 1950s

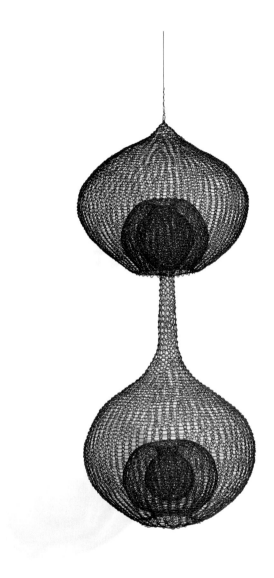

23. Ruth Asawa, *Untitled (S.157)*, c. 1958

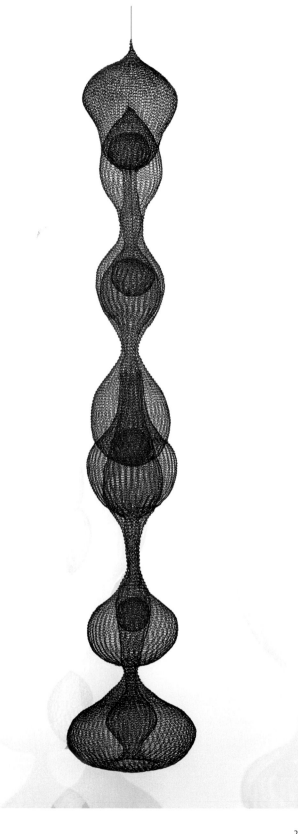

24. Ruth Asawa, *Untitled (S.065)*, 1962

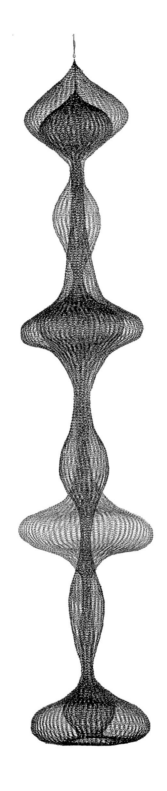

25. Ruth Asawa, *Untitled (S.266)*, c. 1965

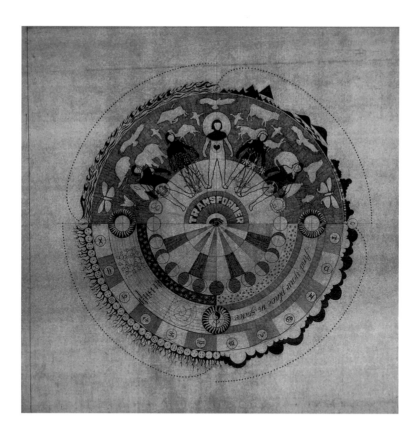

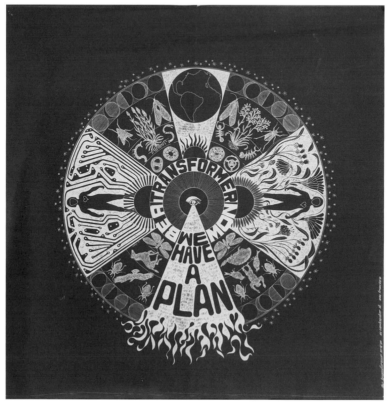

26. Gordon R. Ashby, *Transformer*, 1969

27. Gordon R. Ashby, *The Transformer No. 2*, 1970

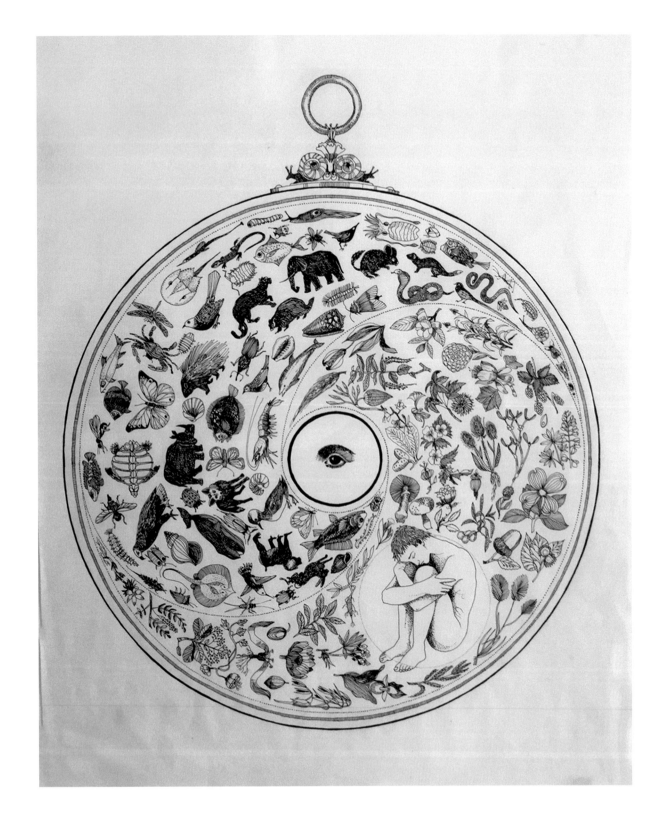

28. Gordon R. Ashby, *Untitled*, 1971

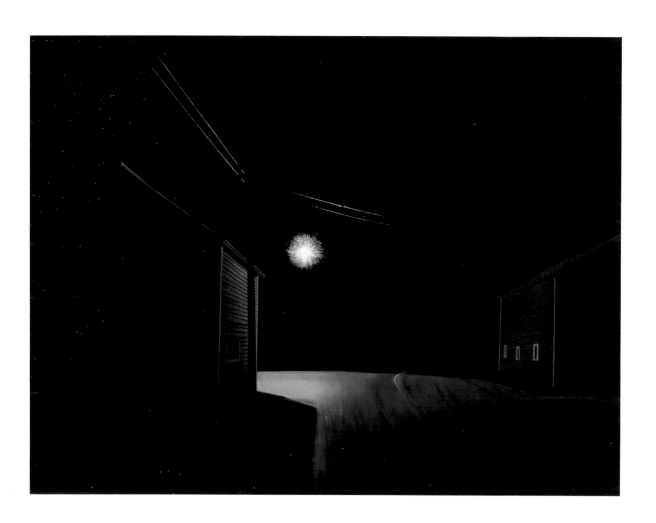

29. George Copeland Ault, *August Night at Russell's Corners*, 1948

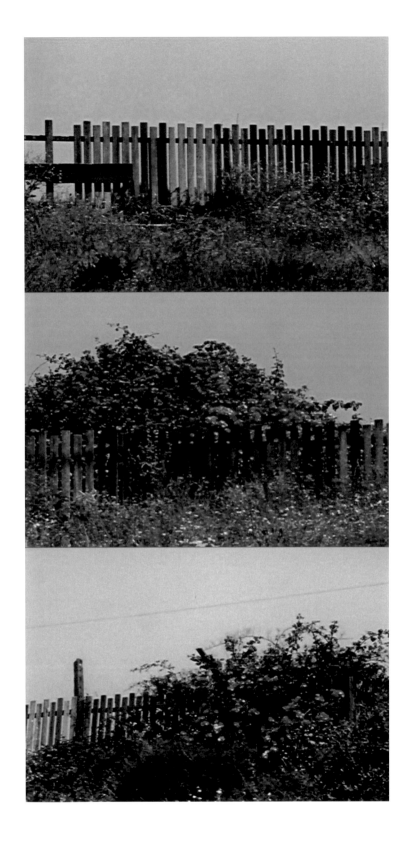

30. Bruce Baillie, *All My Life*, 1966 (stills)

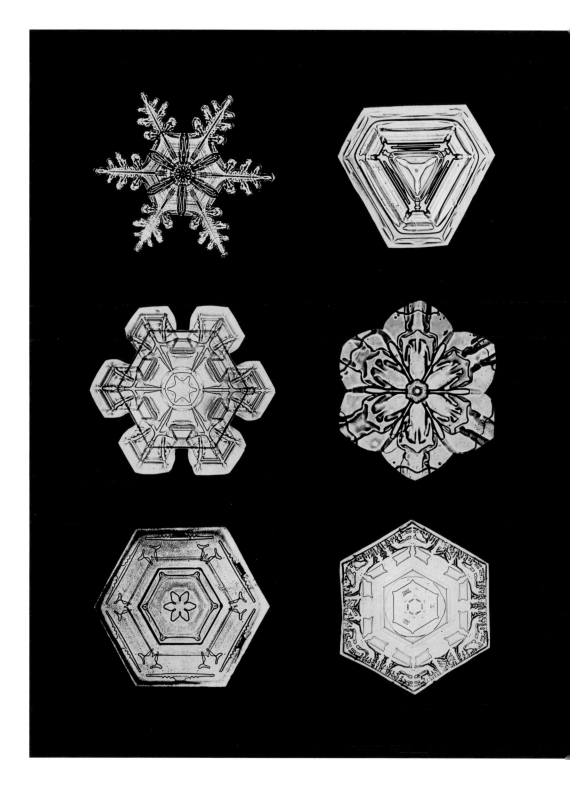

Wilson Bentley
All works c. 1920

31. *Untitled (Snowflake #2)*

32. *Untitled (Snowflake #5)*

33. *Untitled (Snowflake #6)*

34. *Untitled (Snowflake #7)*

35. *Untitled (Snowflake #10)*

36. *Untitled (Snowflake #11)*

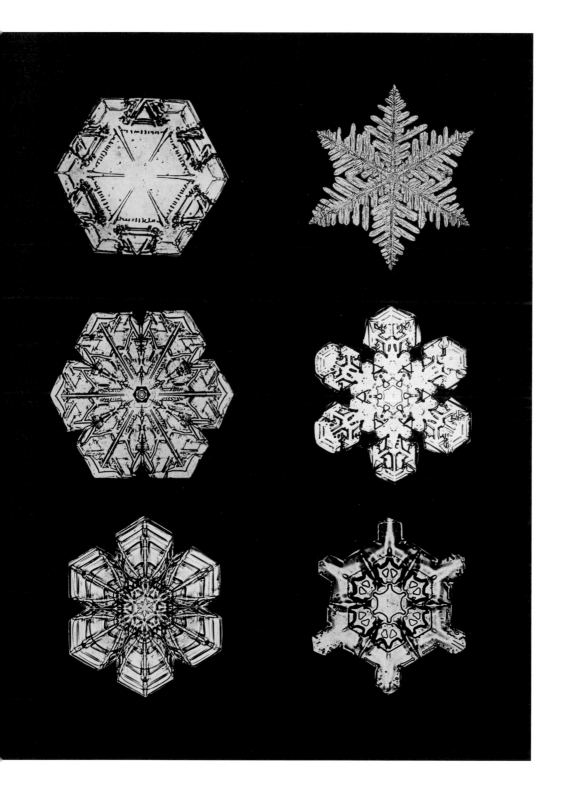

37. *Untitled (Snowflake #12)*
38. *Untitled (Snowflake #13)*
39. *Untitled (Snowflake #15)*

40. *Untitled (Snowflake #18)*
41. *Untitled (Snowflake #20)*
42. *Untitled (Snowflake #22)*

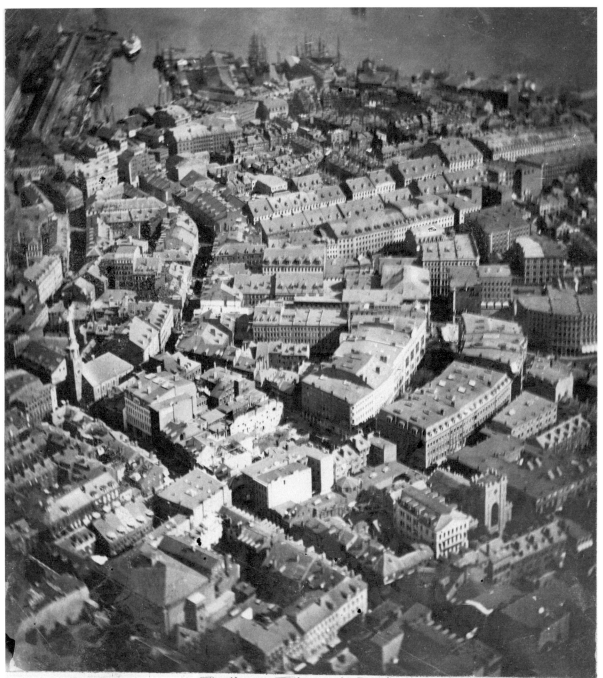

Balloon View of Boston Taken October 13, 1860
By J. W. Black
(*...*)

43. James Wallace Black, *Boston, as the Eagle and the Wild Goose See It*, 1860

44. Karl Blossfeldt, *Achillea filipendulina (Yarrow)*, c. 1928

45. Karl Blossfeldt, *Tremastelma palaestinum (seed from a scabious)*, c. 1928

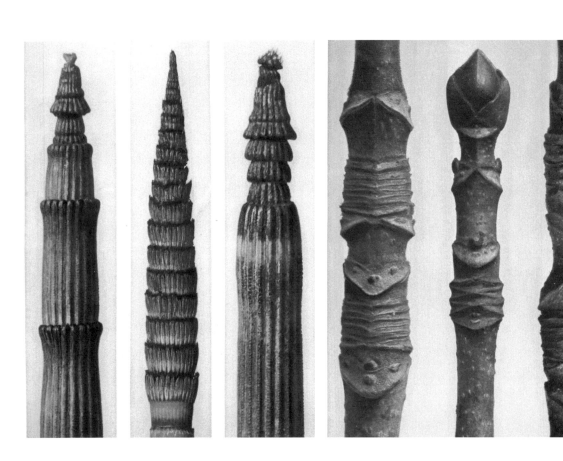

46. Karl Blossfeldt, *Equisetum hyemale (Rough Horsetail)*, *Equisetum telmateia
 (Great Horsetail)*, *Equisetum hyemale (Rough Horsetail)*, c. 1928

47. Karl Blossfeldt, *Maple Tree*, c. 1928

 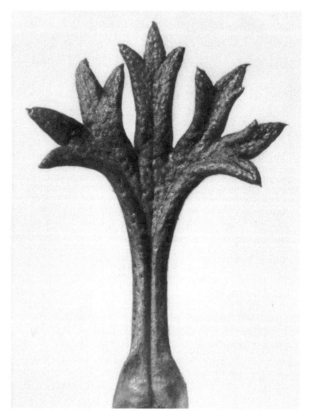

48. Karl Blossfeldt, *Sanguisorba canadensis (Canadian Burnet),*
 Vincentoxicum fuscatum (Mosquito Trap), c. 1928

49. Karl Blossfeldt, *Saxifraga willkommiana (Willkomm's Sacifrage),* c. 1928

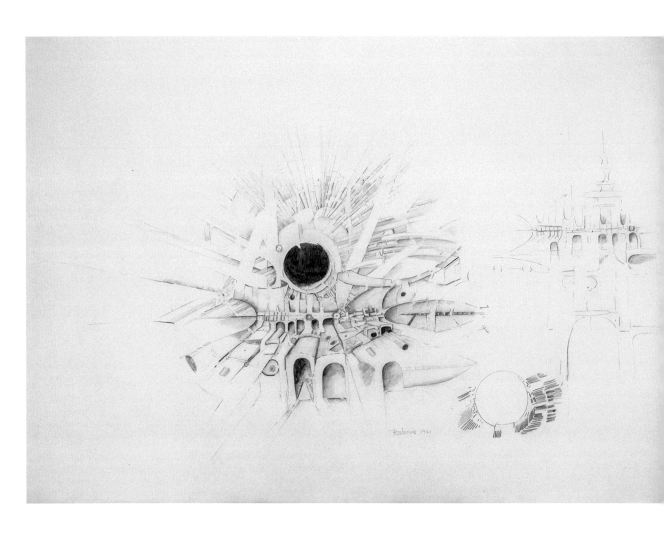

50. Lee Bontecou, *Untitled*, 1961

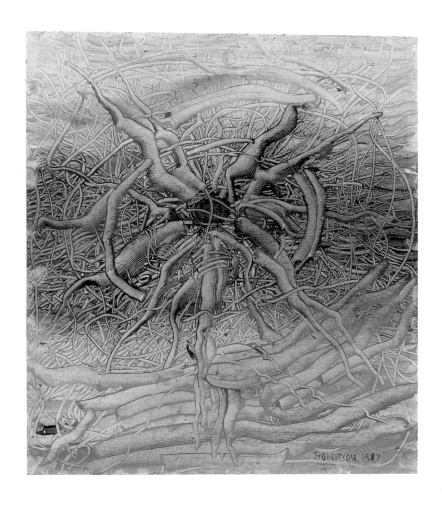

51. Lee Bontecou, *Untitled*, 1987

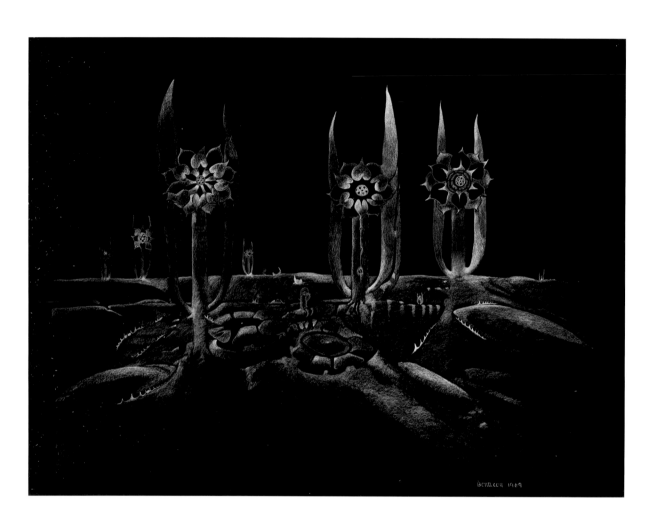

52. Lee Bontecou, *Untitled*, 1969

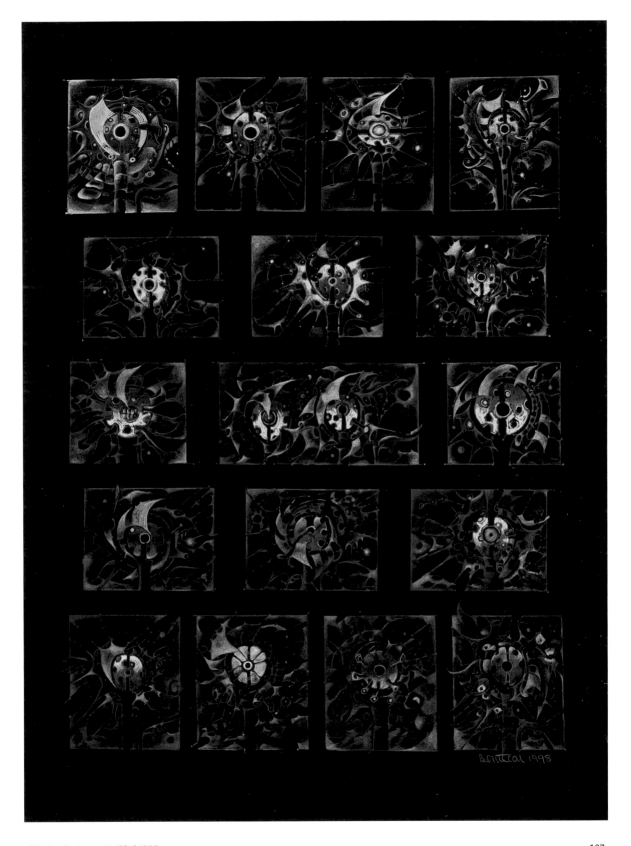

53. Lee Bontecou, *Untitled*, 1998

54. Louise Bourgeois, *Fée Couturière*, 1963

55. Louise Bourgeois, *The Quartered One*, 1964–65

56. Louise Bourgeois, *Untitled*, 1988

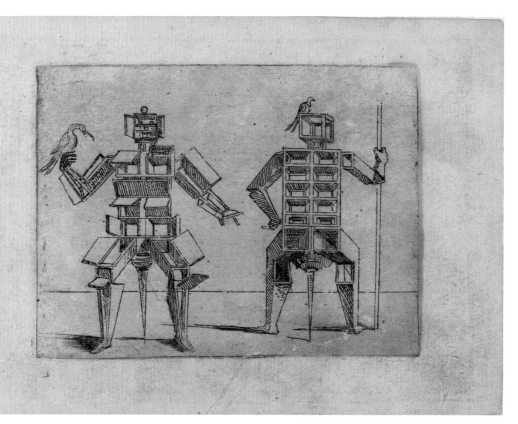

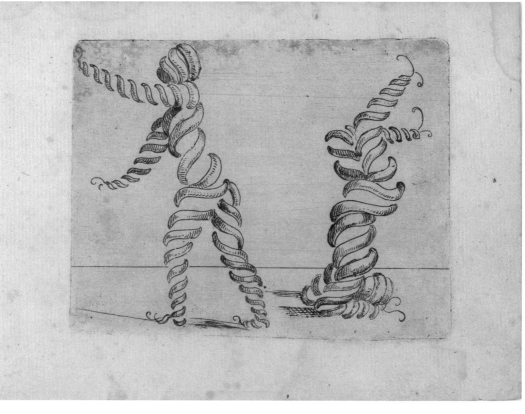

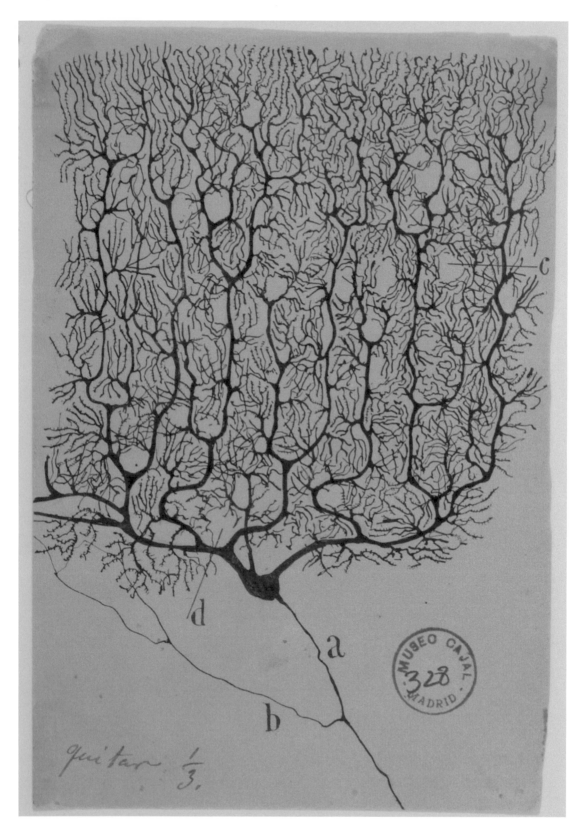

61. Santiago Ramón y Cajal, *Purkinje cell of the human cerebellum*, 1899

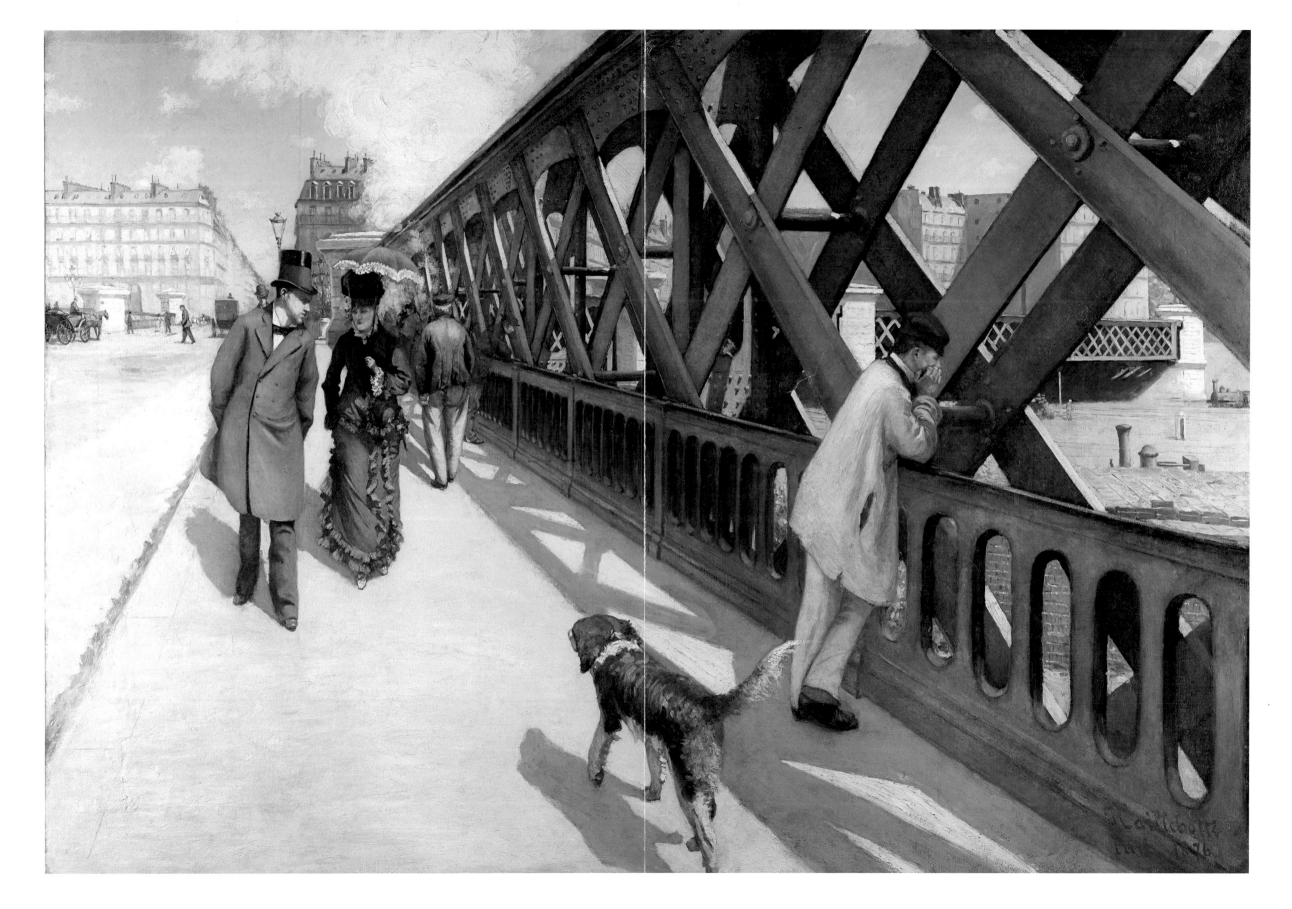

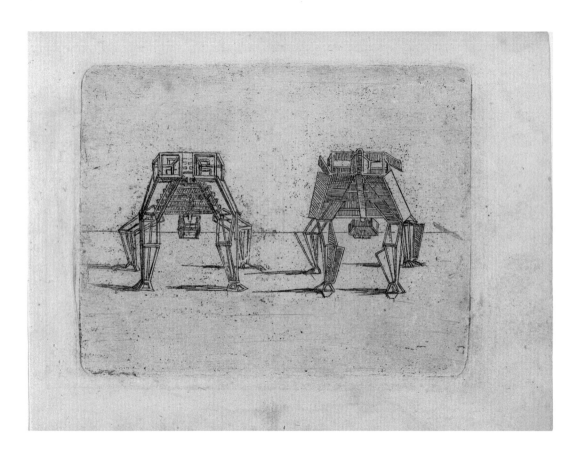

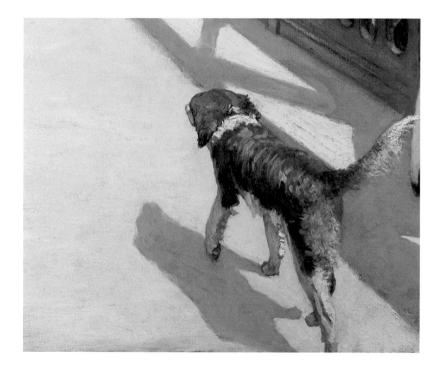

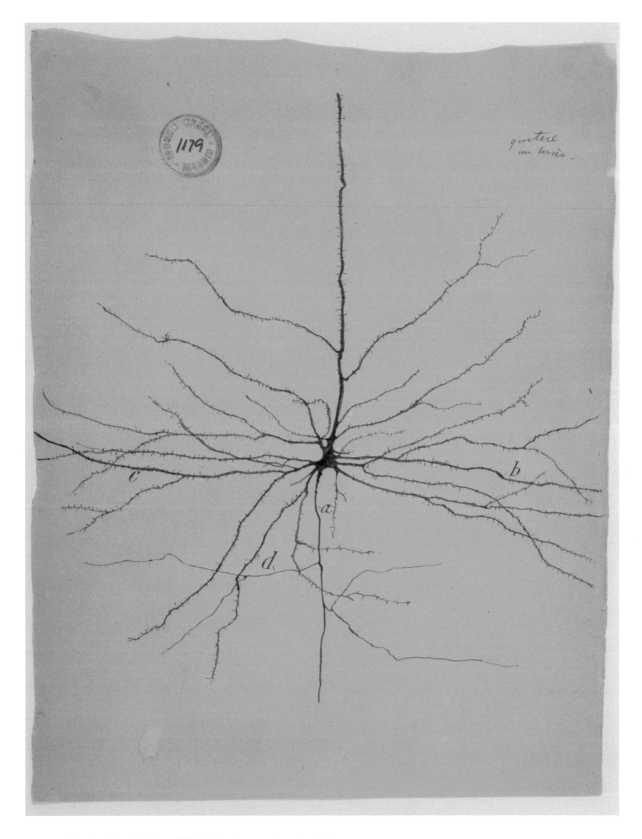

62. Santiago Ramón y Cajal, *Pyramidal cell of the human motor cortex*, 1899

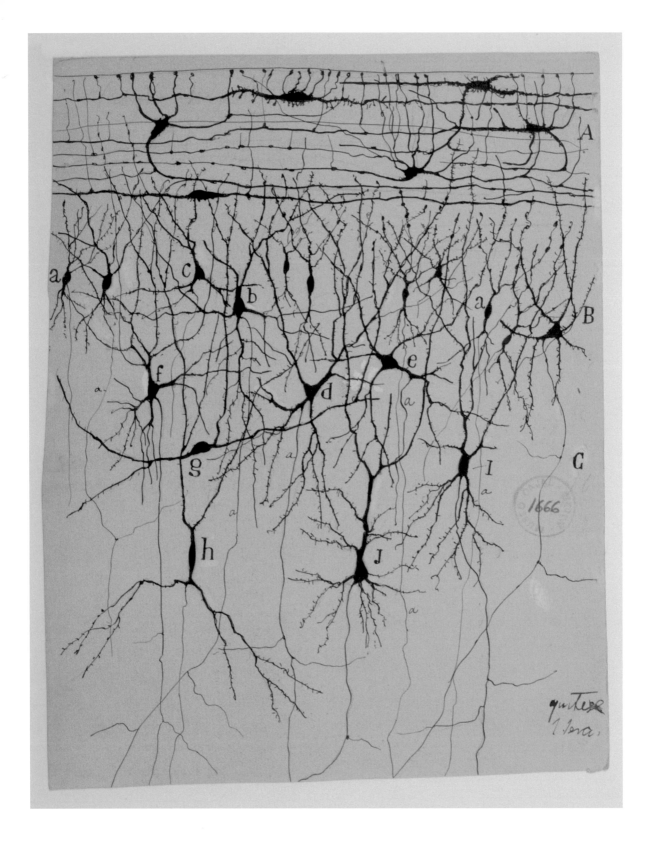

63. Santiago Ramón y Cajal, *Olfactory cortex*, 1901

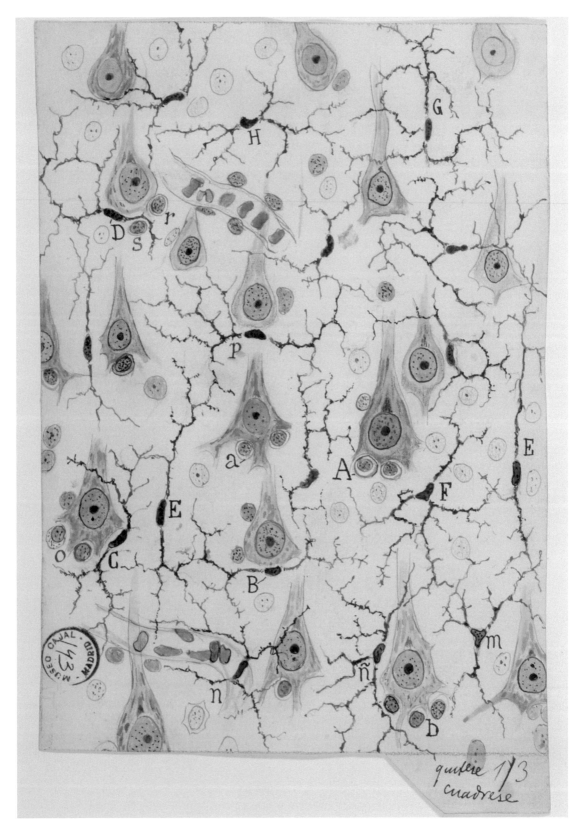

64. Santiago Ramón y Cajal, *Microglia in the grey matter of the cerebral cortex*, 1920

121

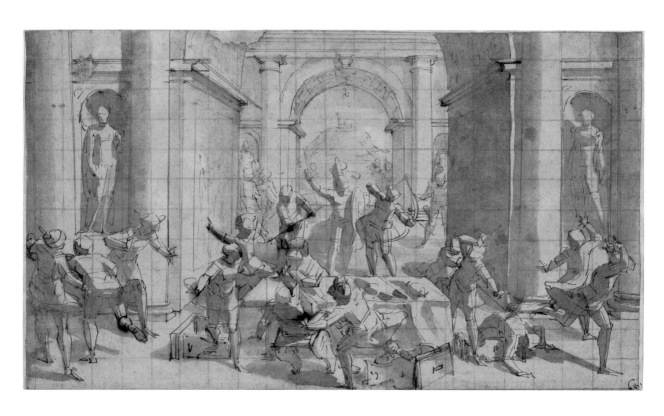

65. Luca Cambiaso, *Study for the Return of Ulysses*, c. 1565

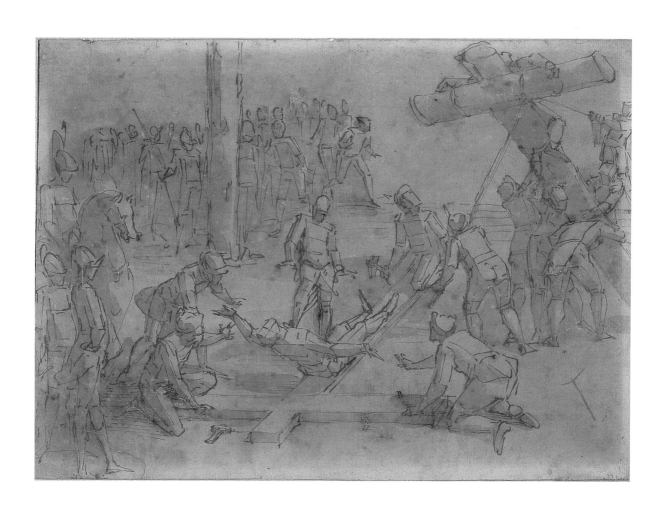

66. Luca Cambiaso, *Christ Nailed to the Cross*, early 1580s

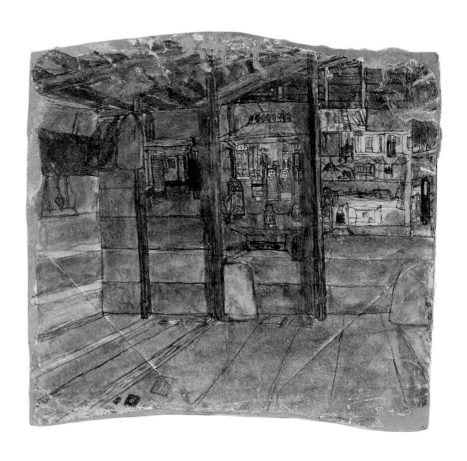

67, 68, 69. James Castle, *Untitled*, n.d.

70. Diller Scofidio + Renfro, *Hand holding a model for BAMPFA*, 2012

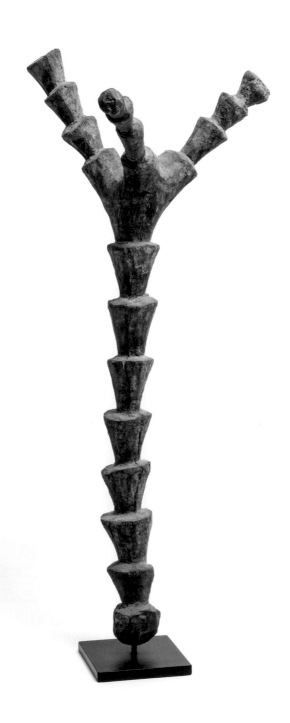

71. Dogon, Mali, Ritual altar ladder, late 19th–early 20th century

72. Marcel Duchamp, *Boîte*, 1966

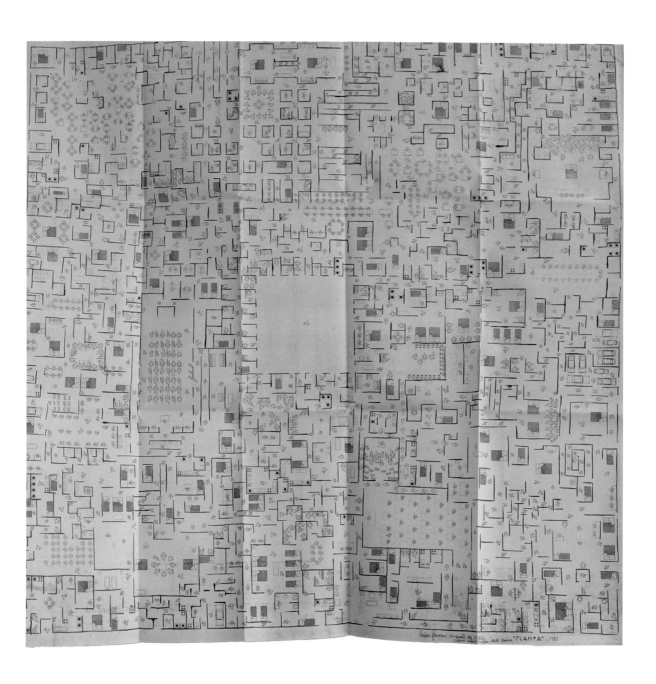

73. León Ferrari, *Planta*, 1980/2008

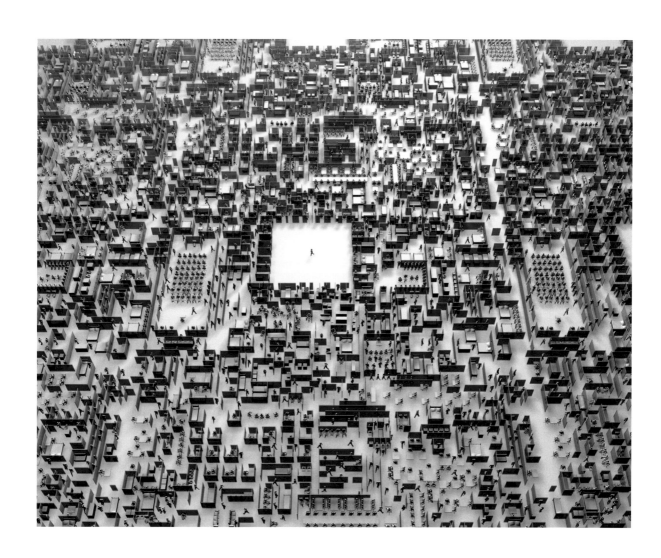

74. León Ferrari and Gabriel Rud, *Planta*, 2005 (still)

75. Suzan Frecon, *untitled*, n.d.

76. Suzan Frecon, *plan for a place (multiple red structural study)*, 1991

77. Suzan Frecon, *long strokes*, 1994

78. Suzan Frecon, *untitled*, 1994

135

79. Suzan Frecon, *untitled*, 1995

80. Suzan Frecon, *vertical red earths*, 2002

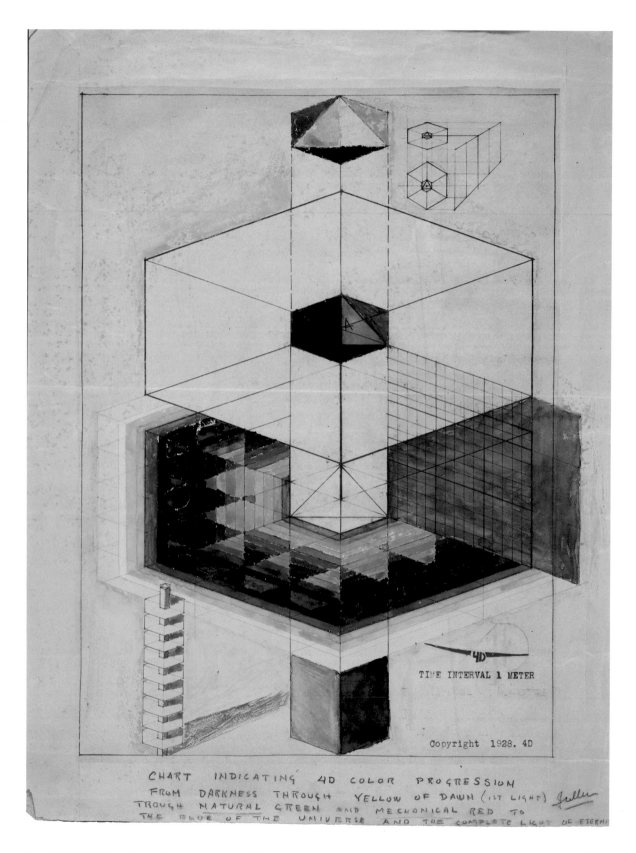

CHART INDICATING 4D COLOR PROGRESSION
FROM DARKNESS THROUGH YELLOW OF DAWN (1ST LIGHT)
TROUGH NATURAL GREEN AND MECHANICAL RED TO
THE BLUE OF THE UNIVERSE AND THE COMPLETE LIGHT OF ETERNI

TIME INTERVAL **1** METER

Copyright 1928. 4D

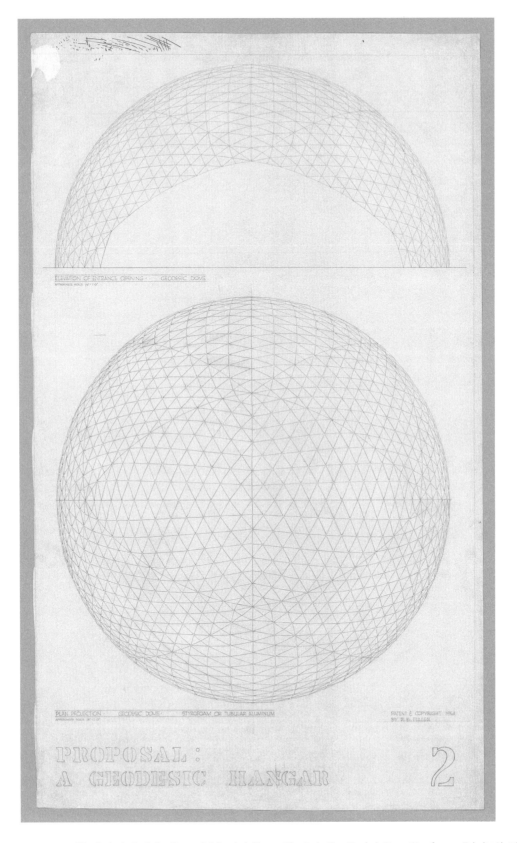

ELEVATION OF ENTRANCE OPENING · GEODESIC DOME
APPROXIMATE SCALE 1/16" = 1'-0"

PLAN PROJECTION · GEODESIC DOME · STYROFOAM OR TUBULAR ALUMINUM
APPROXIMATE SCALE 1/16" = 1'-0"

PATENT & COPYRIGHT 1954
BY R. B. FULLER

PROPOSAL:
A GEODESIC HANGAR

2

82. Buckminster Fuller, *Proposal: A Geodesic Hangar, Plan Projection, Geodesic Dome, Styrofoam or Tubular Aluminum*, 1951

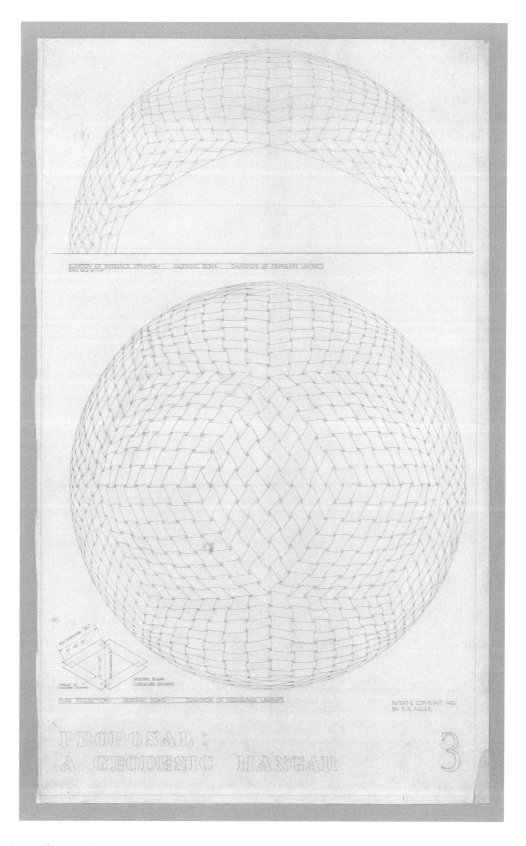

ELEVATION OF ENTRANCE OPENING: GEODESIC DOME: DIAMONDS OF FIBERGLASS LAMINATE

MASTER BLANK
CURVATURE DIAMOND

PLAN PROJECTION: GEODESIC DOME: DIAMONDS OF FIBERGLASS LAMINATE

PATENT & COPYRIGHT 1951
BY R.B. FULLER

PROPOSAL:
A GEODESIC HANGAR

3

83. Buckminster Fuller, *Proposal: A Geodesic Hangar, Plan Projection, Geodesic Dome, Diamonds of Fiberglass Laminate*, 1951 141

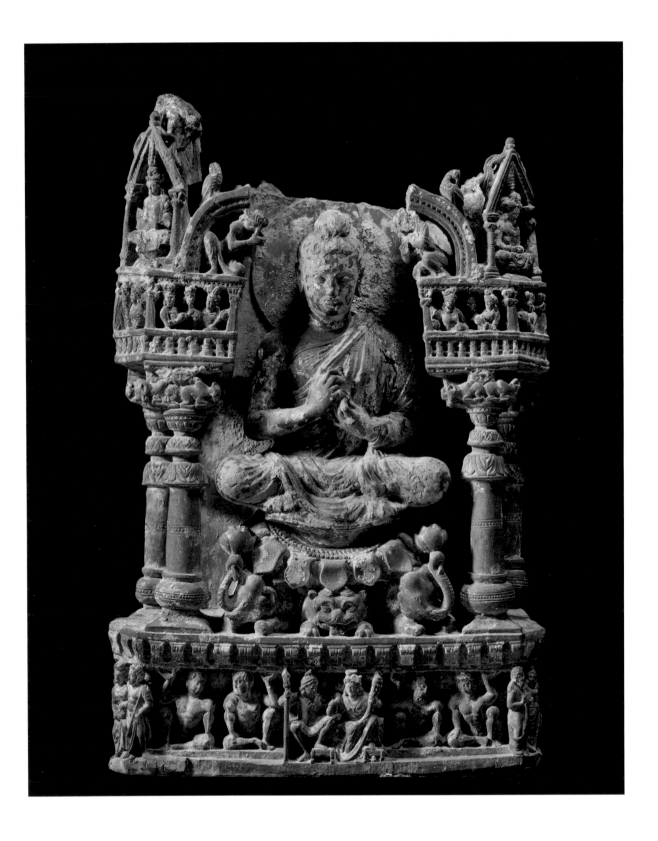

142 Gandhara, Pakistan, *Teaching Buddha*, 2nd–3rd century

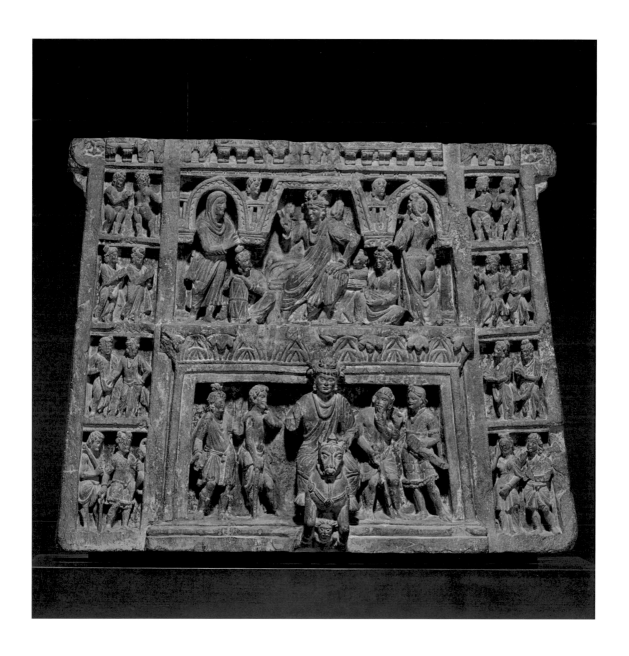

85. Gandhara, Pakistan, *The Great Departure*, 2nd–3rd century 143

86. Laeh Glenn, *Untitled*, 2013

87. Brent Green, *Gravity Was Everywhere Back Then*, 2010 (stills)

Rhiz. rad. Thalasicolla nucleata A. M. 27. 10. 57.

Fig. 186.

88. Ernst Haeckel, *Thalassicolla nucleata*, 1859

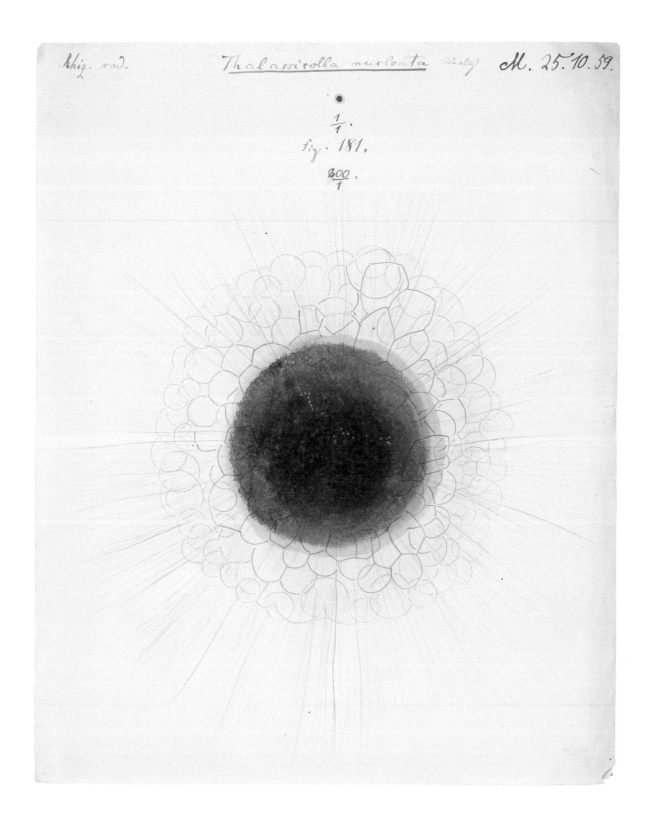

89. Ernst Haeckel, *Thalassicolla nucleata*, 1859

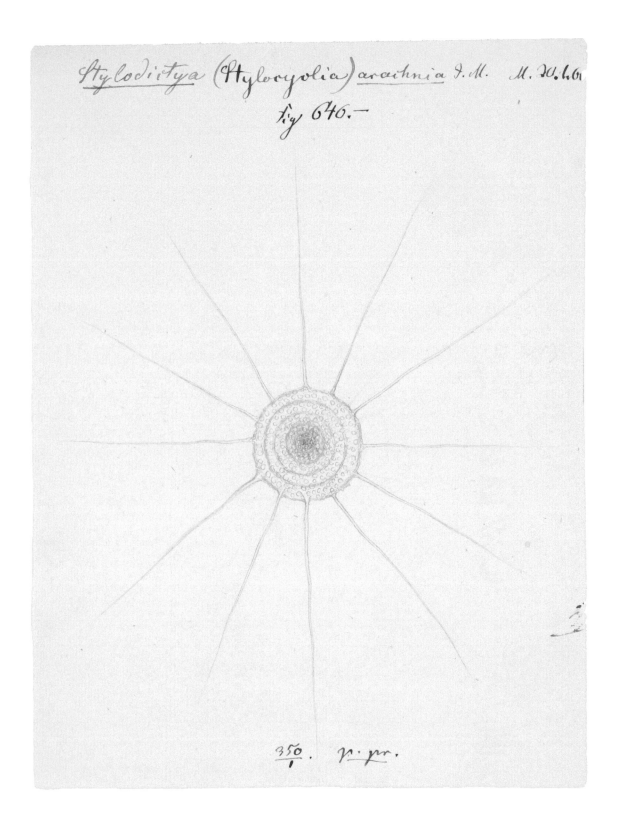

90. Ernst Haeckel, *Stylodictya (Stylocyolia) arachnia*, 1860

Dictyosphaera tenerrima Messina 2. 2. 60.

Heliosphaera tenuissima

fig 715.

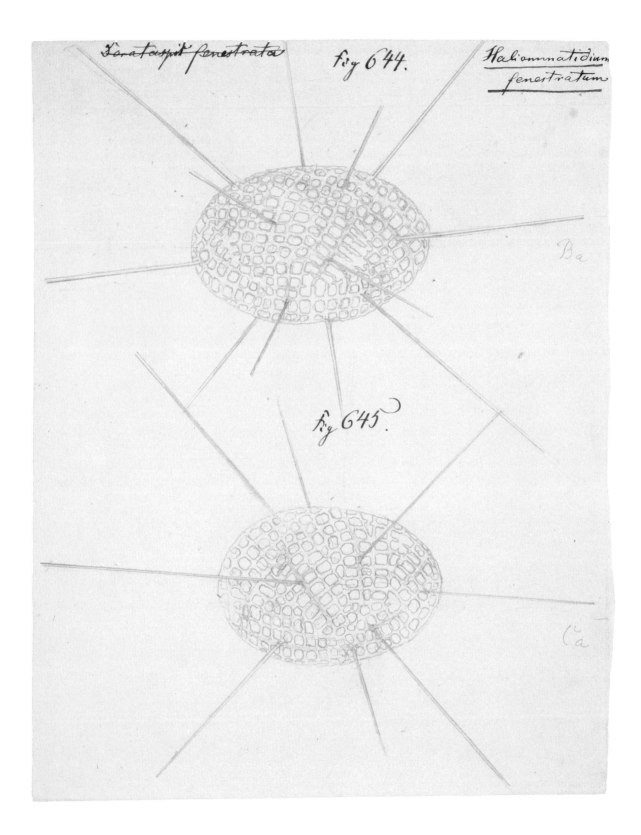

Ceratospis fenestrata

fig 644.

Haliommatidium fenestratum

Ba

fig 645.

Ca

92. Ernst Haeckel, *Haliommatidium fenestratum*, c. 1860

$$\frac{606}{1}$$

p:fr.

93. Ernst Haeckel, *Rhaphidococcus acufer*, 1860 151

94. Ganesh Haloi, *Untitled*, 1997

95. Ganesh Haloi, *Untitled*, 1999

96. Ganesh Haloi, *Untitled*, 2004

153

97. Ganesh Haloi, *Untitled*, 1998

98. Ganesh Haloi, *Untitled*, 1998

99. Ganesh Haloi, *Untitled*, 1999

100. Ganesh Haloi, *Untitled*, 1999

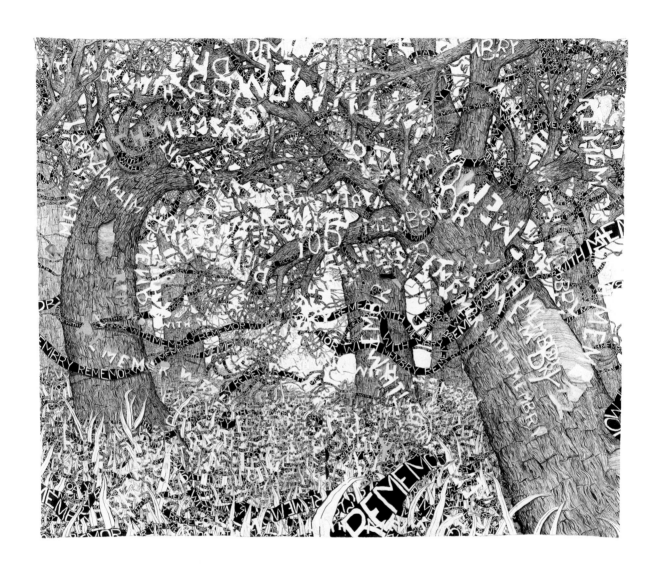

101. Trenton Doyle Hancock, *Rememor with Membry*, 2001

102. Toyo Ito, Kumiko Inui, Sou Fujimoto, Akihisa Hirata, 1:10 scale model, "Home-for-All" in Rikuzentakata, 2012

103. Sou Fujimoto, Study model, "Home-for-All" in Rikuzentakata, December 22, 2011

104. Akihisa Hirata, Study model, "Home-for-All" in Rikuzentakata, December 27, 2011

105. Sou Fujimoto, Study model, "Home-for-All" in Rikuzentakata, January 28, 2012

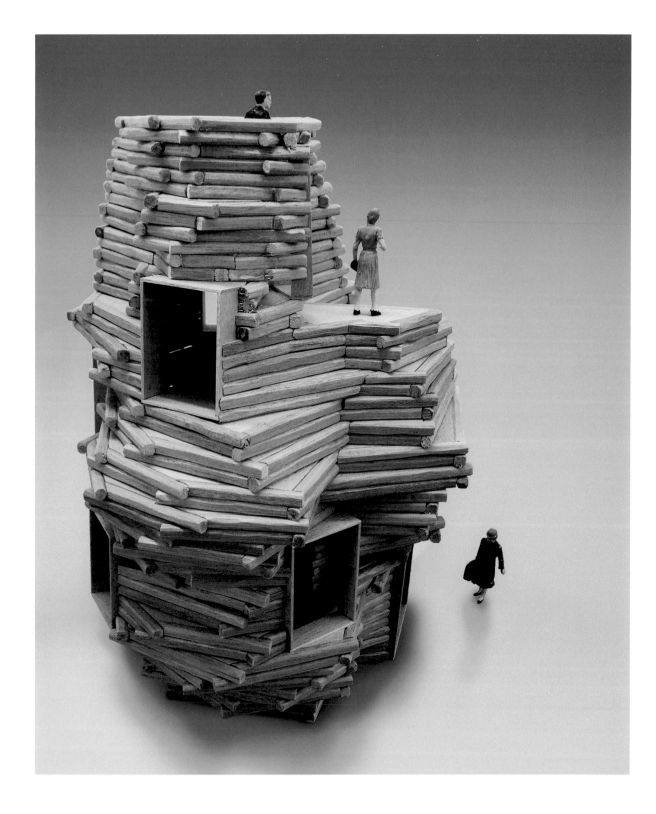

106. Akihisa Hirata, Study model, "Home-for-All" in Rikuzentakata, February 10, 2012

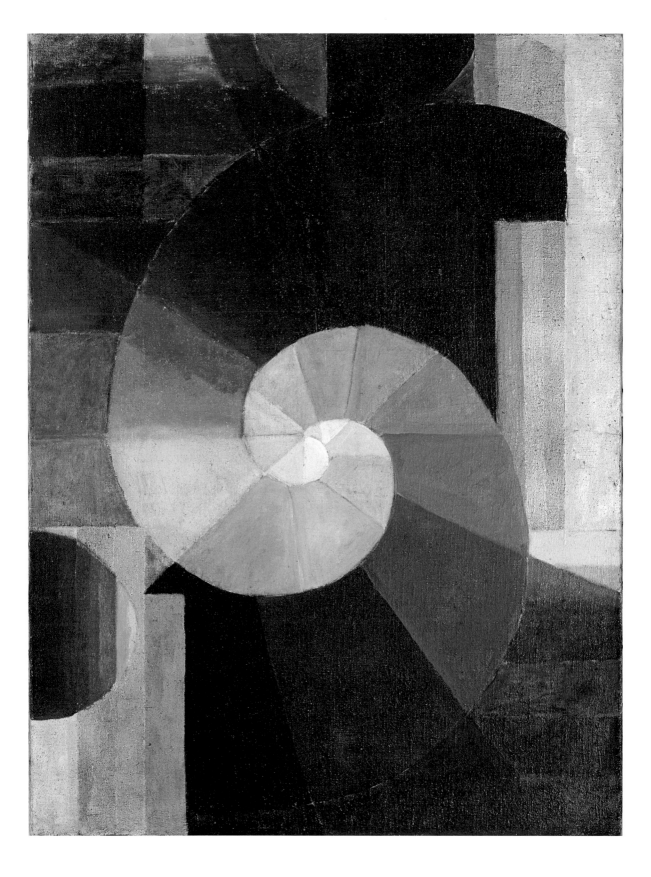

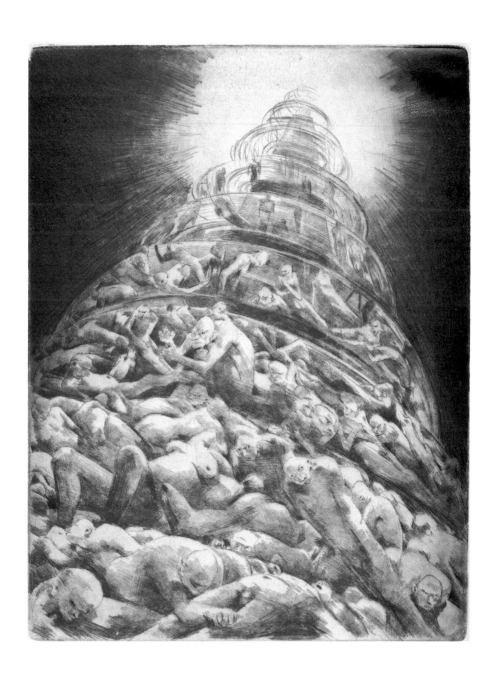

107. Johannes Itten, *Encounter*, 1916

108. Willy Jaeckel, *The Tower of Babel*, 1920

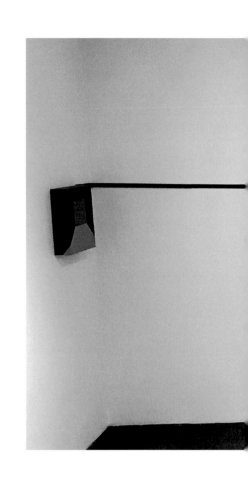

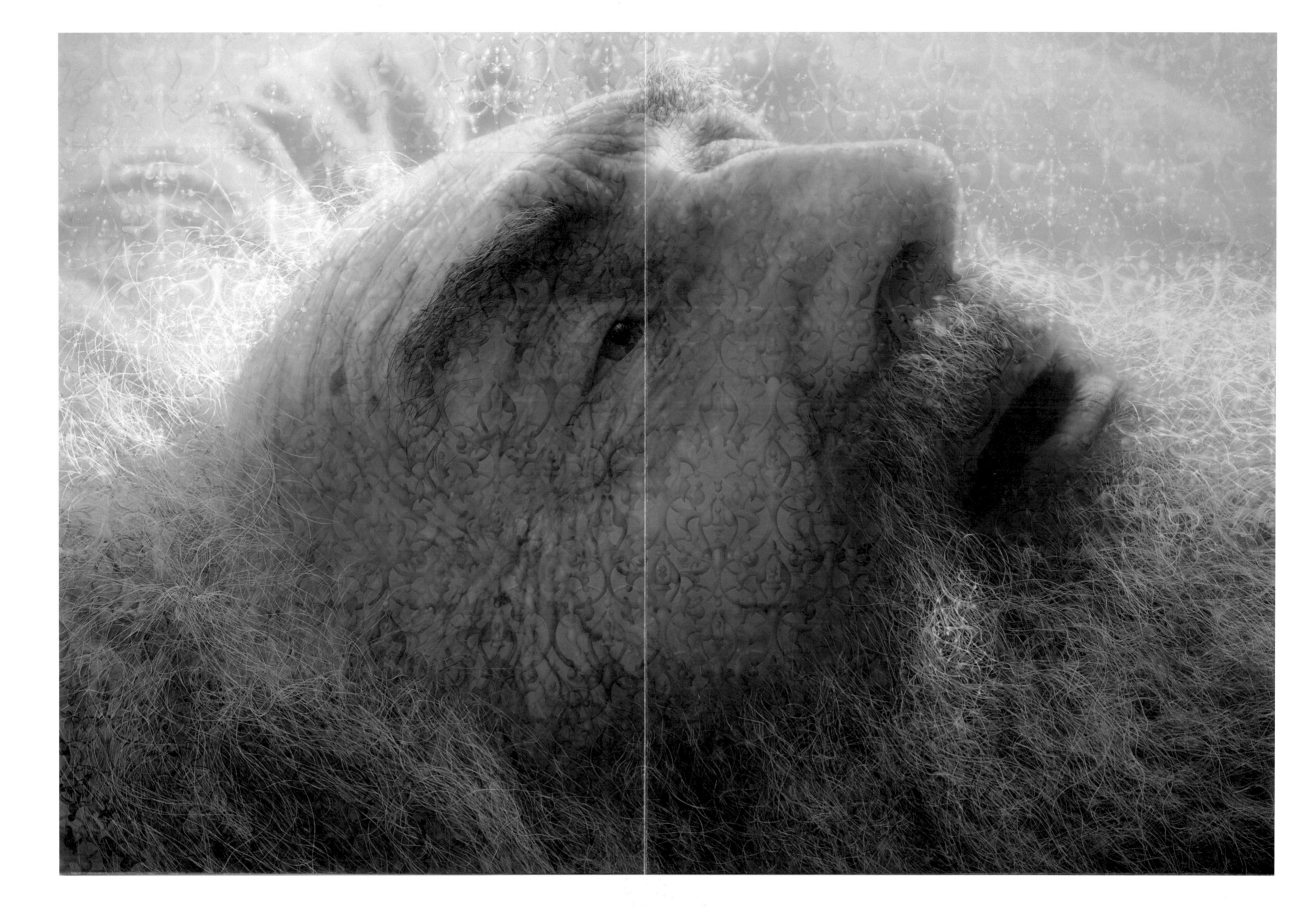

109. Chris Johanson, *Cityscape with House & Gray Energy*, 2003

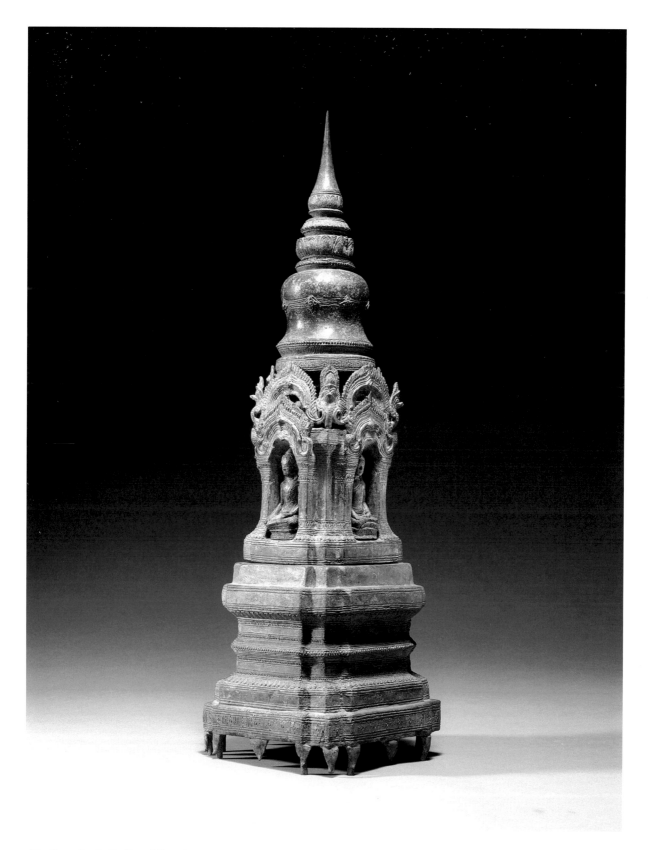

111. Khmer, Cambodia, Stupa, 13th century

112. Frederick Kiesler, Study for Endless House, "Paris Endless," 1947

113. Frederick Kiesler, Study for Endless House, "Paris Endless," 1947

114. Frederick Kiesler, Study for Tooth House, 1948

115. Frederick Kiesler, Study for Endless House, 1951–52

116. Frederick Kiesler, Study for Endless House, 1959

117. Frederick Kiesler, Model of Endless House, 1959

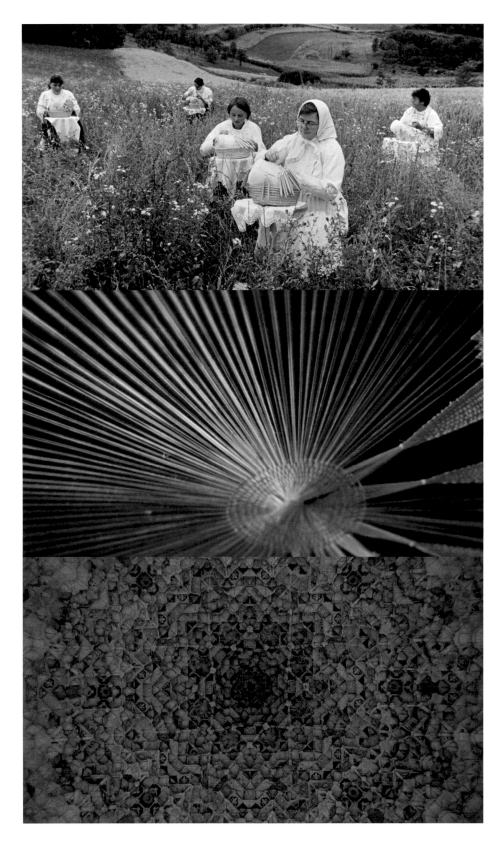

118. Kimsooja, *Thread Routes — Chapter II*, 2011 (stills)

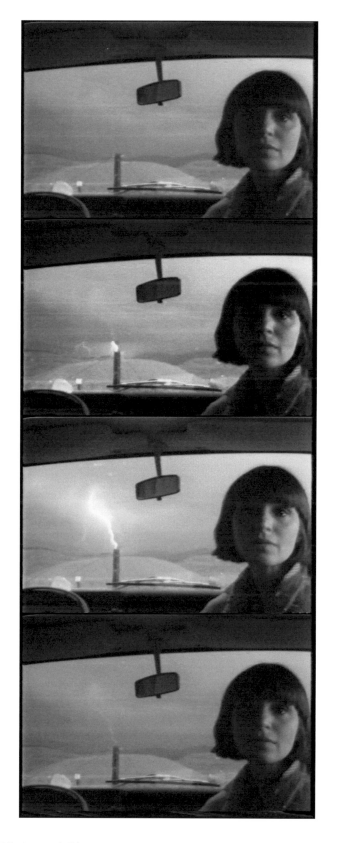

119. Paul Kos and Marlene Kos, *Lightning*, 1976 (stills)

120. Lace: Bestiary or Dream of Nebuchadnezzar, early 16th century

121. Lace: Coraline fragment, 16th century

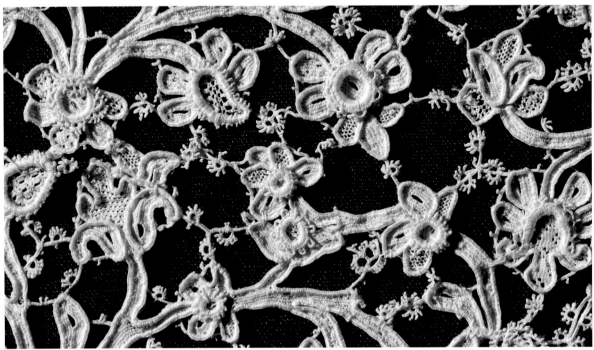

122. Lace: Venetian Rose Point bertha, 17th century (full view and detail)

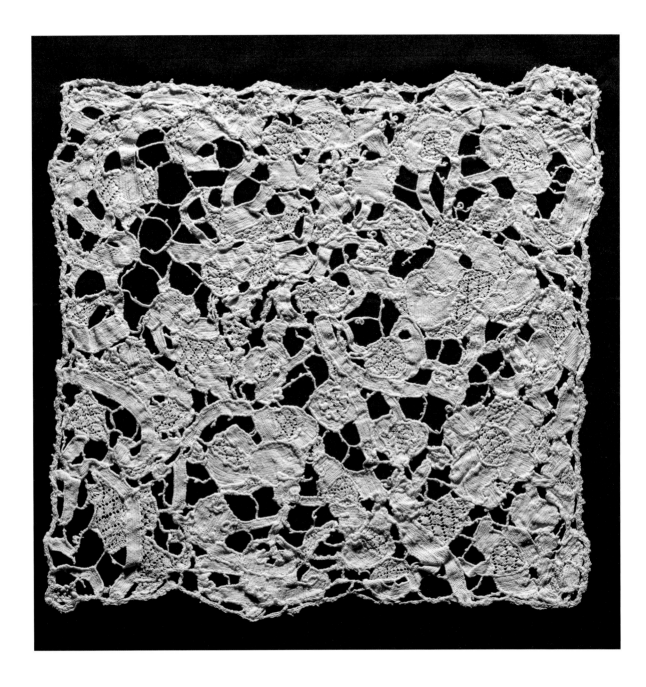

123. Lace: Point Plat de Venise fragment, 17th century

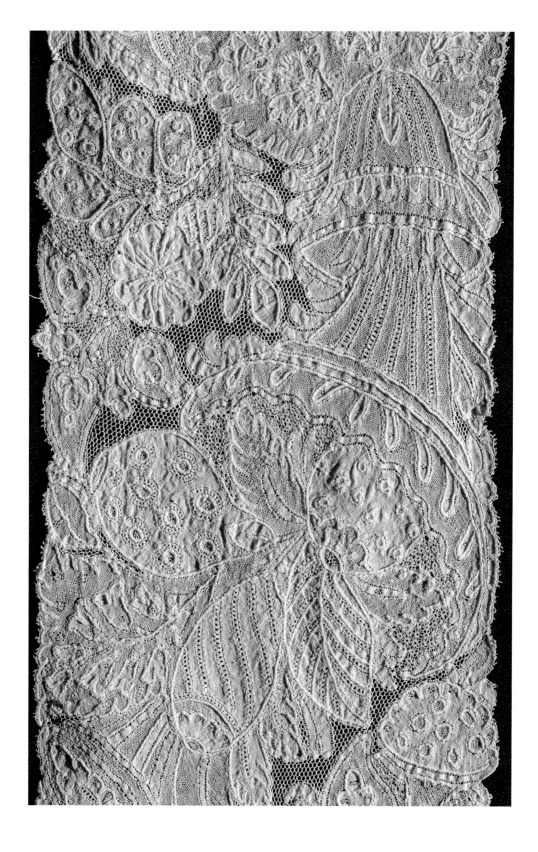

124. Lace: Brussels lappet, 18th century

127. Otto Lehmann, Microscopic view of liquid crystals, c. 1888–89

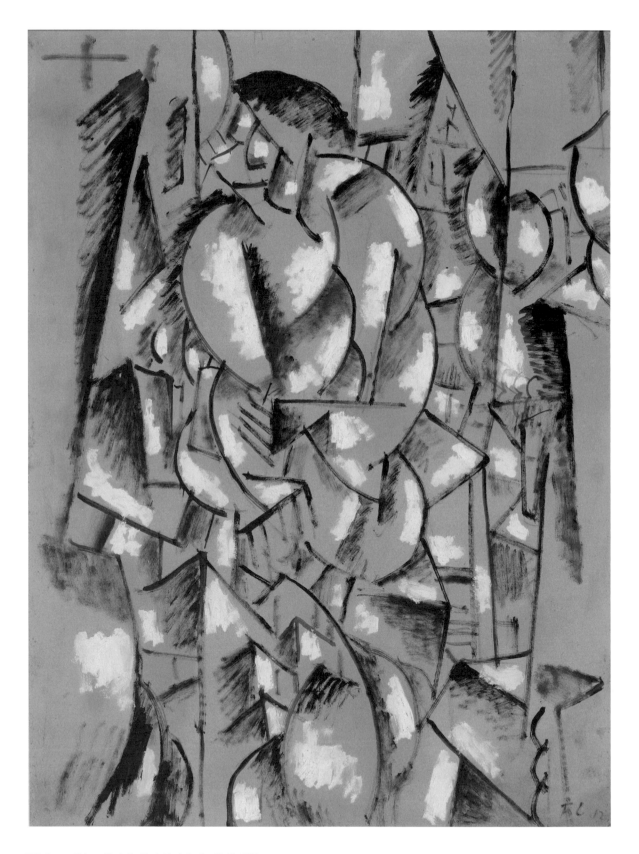

126. Fernand Léger, Study for *Nude Model in the Studio*, 1912

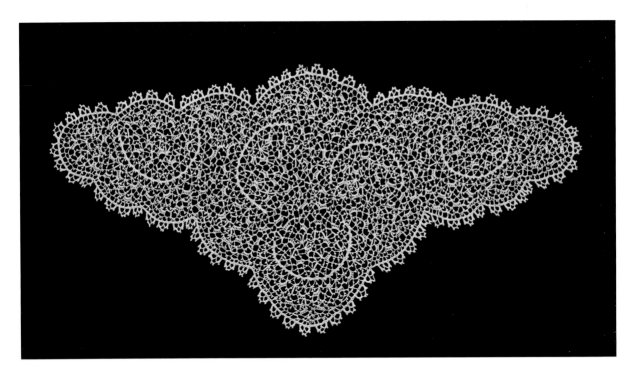

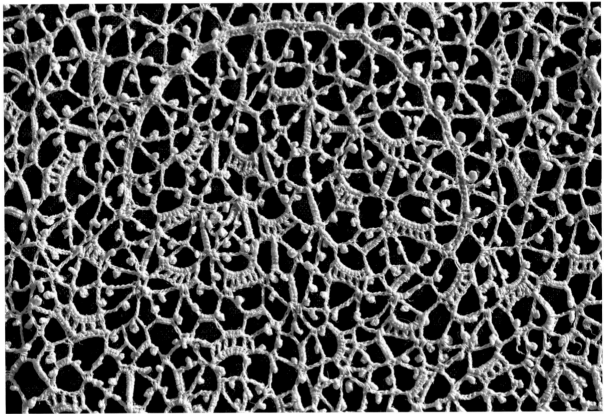

125. Lace: Orvieto crochet, 19th century (full view and detail)

128. Otto Lehmann, Microscopic view of liquid crystals, c. 1888–89 (recto and verso)

129. Otto Lehmann, Microscopic view of liquid crystals, c. 1888–89 (recto and verso)

130. Otto Lehmann, Microscopic views of liquid crystals, c. 1907 (stills)

131. Ed Loftus, *Untitled*, 2011

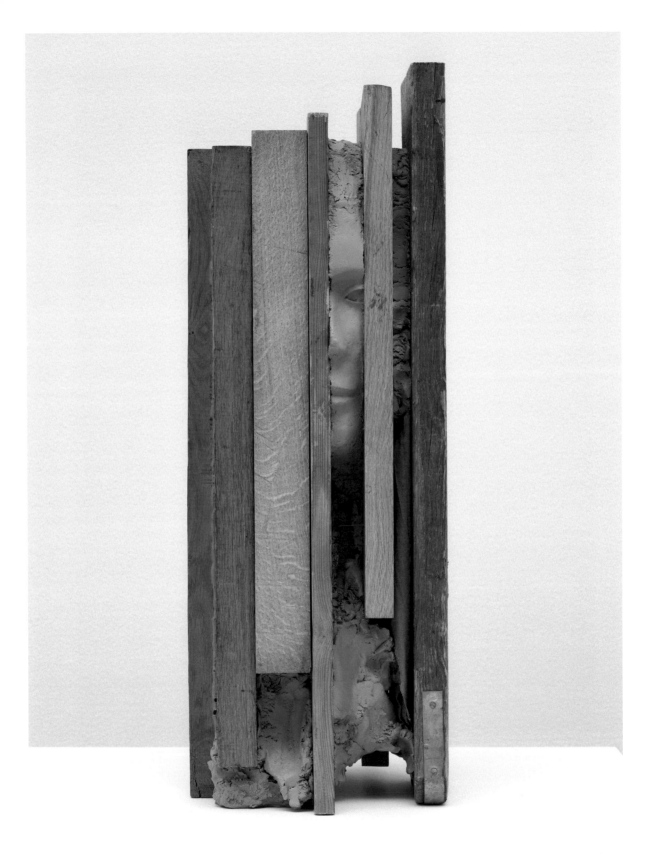

132. Mark Manders, *Obtrusive Head*, 2010

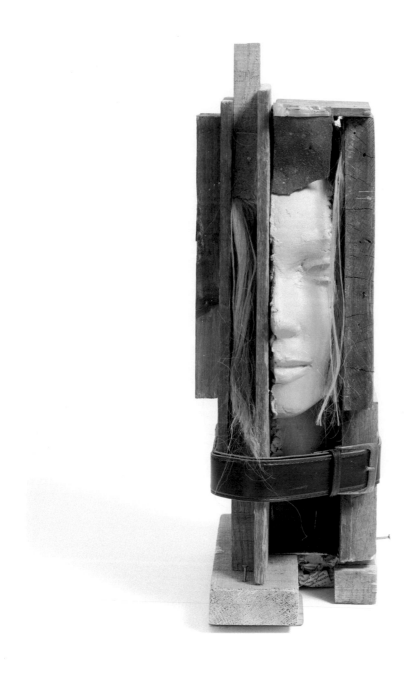

133. Mark Manders, *Girl Study*, 2013

134. Gordon Matta-Clark, *Window Blow-Out*, 1976

 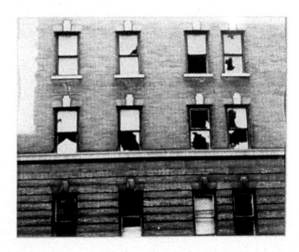

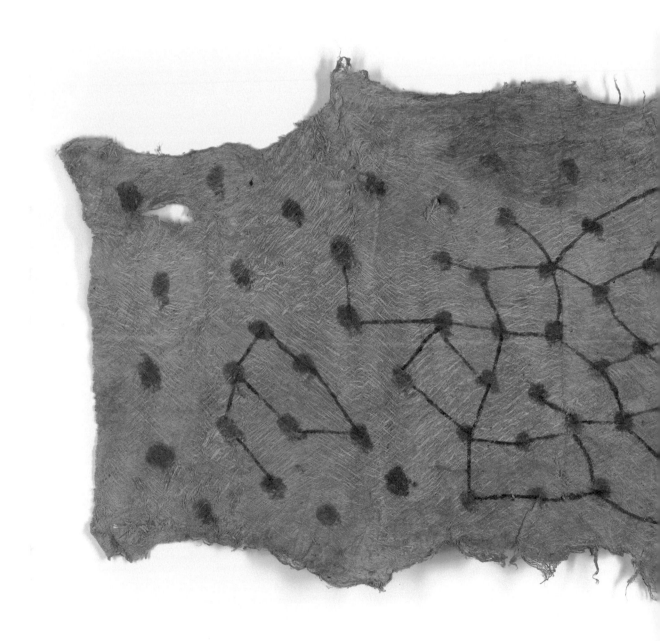

135. Mbuti, Congo, Barkcloth drawing, 1970s

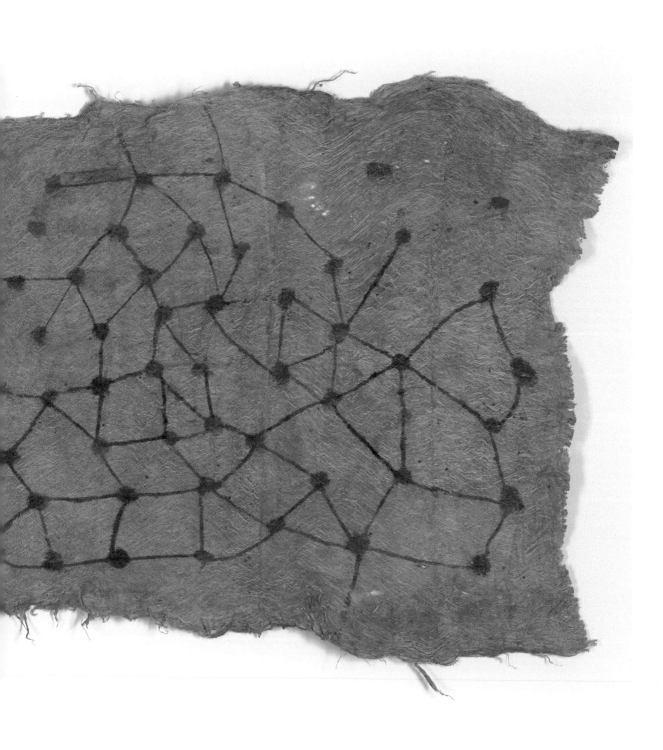

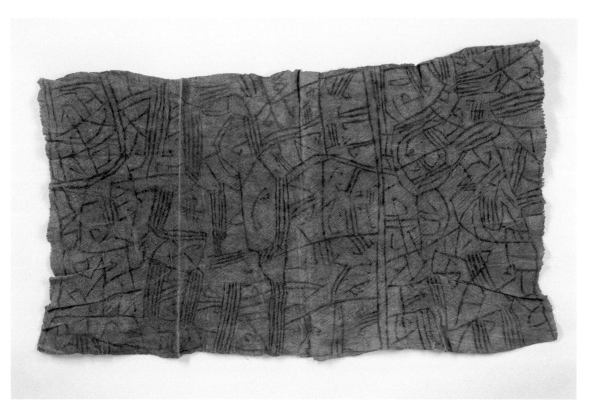

136. Mbuti, Congo, Barkcloth drawing, c. 1975–2000

137. Mbuti, Congo, Barkcloth drawing, 1970s

138. Mbuti, Congo, Barkcloth drawing, 1970s

139. Mbuti, Congo, Barkcloth drawing, 1970s

140. Mbuti, Congo, Barkcloth drawing, c. 1975–2000

141. Julie Mehretu, *Unclosed*, 2007

142. Micronesia (Marshall Islands), Navigational chart, n.d.

143. Micronesia (Marshall Islands), Navigational chart, n.d.

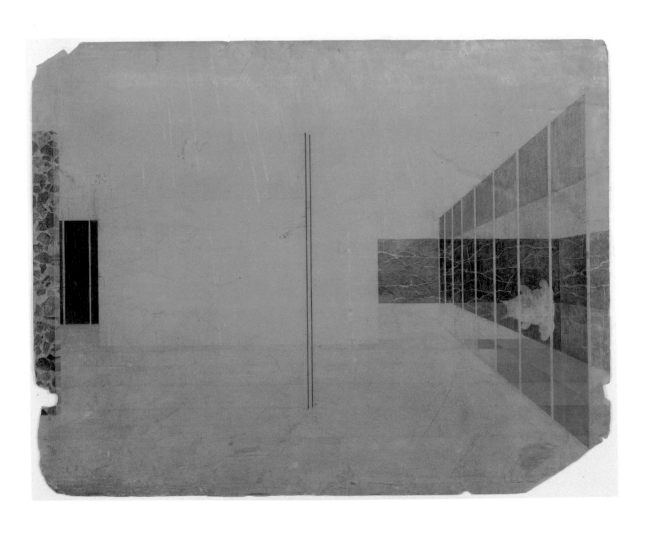

144. Ludwig Mies van der Rohe, *German Pavilion, International Exposition, Barcelona, Spain, Interior Perspective*, c. 1928–29

145. Jay Nelson, *The Goodbye Ranch*, 2007—9

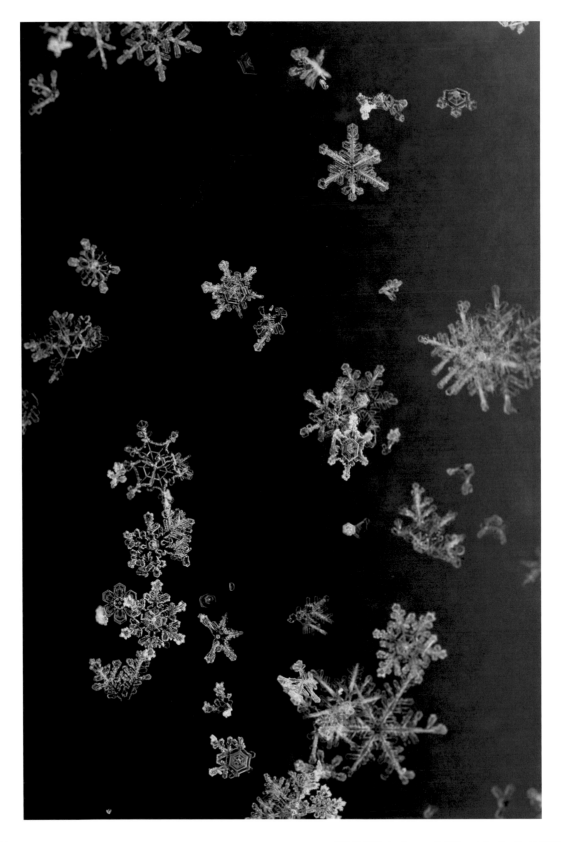

146. Yuji Obata, *Homage to Wilson A. Bentley No. 12*, 2005–6

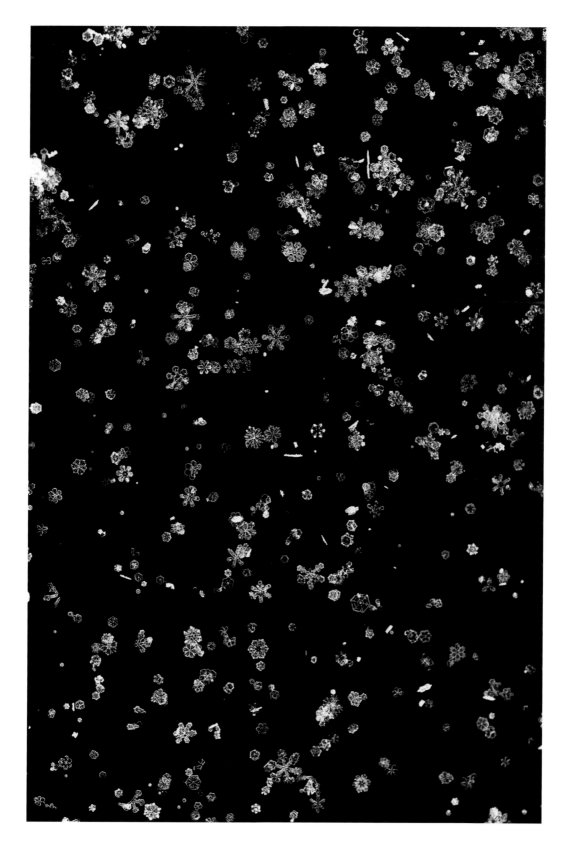

147. Yuji Obata, *Homage to Wilson A. Bentley No. 1*, 2005–6

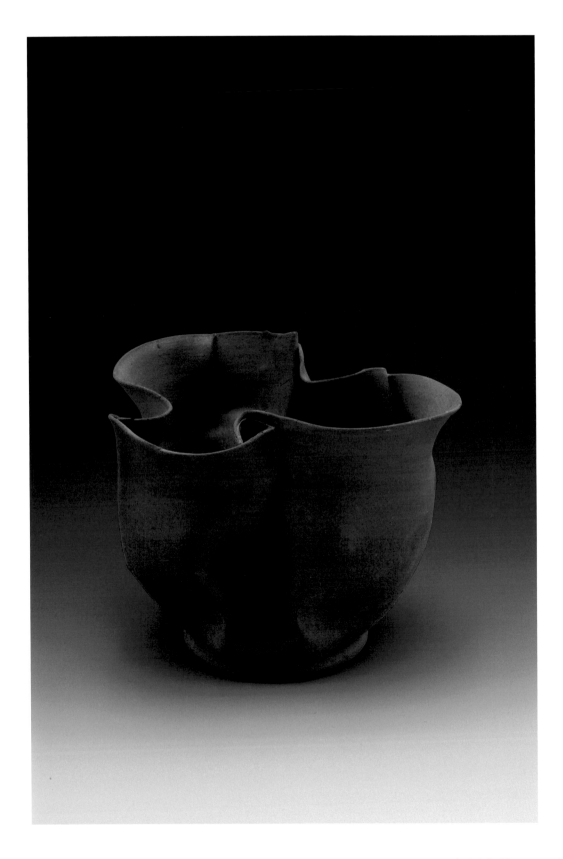

148. George Ohr, Red clay bisque vase, c. 1903–7

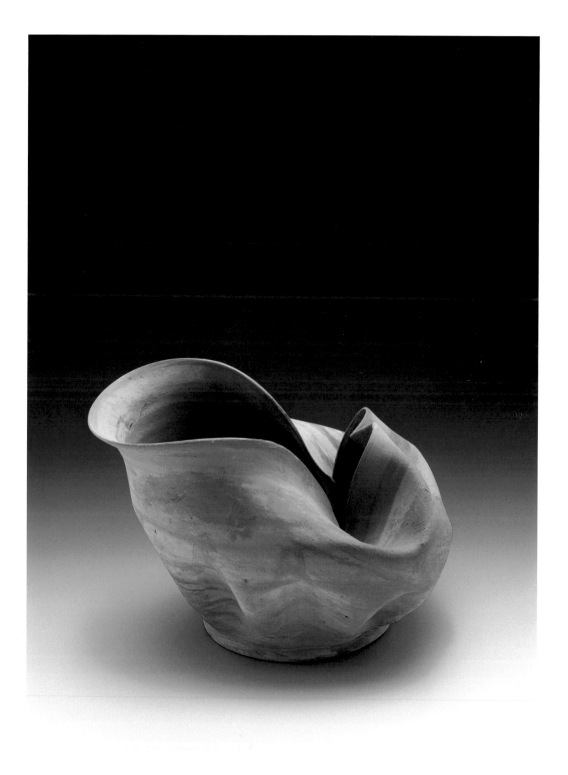

149. George Ohr, Tan clay bisque pitcher, c. 1903–7

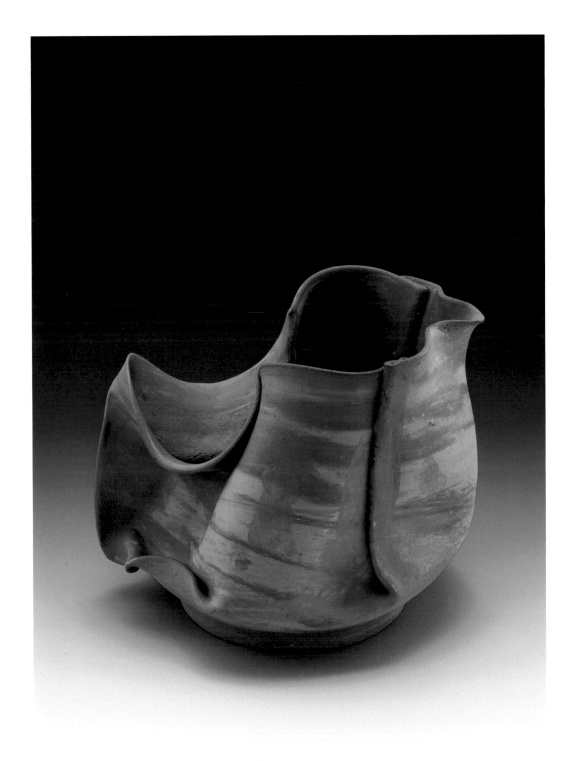

150. George Ohr, Bisque pitcher with terra-cotta slip streaks, c. 1903–7

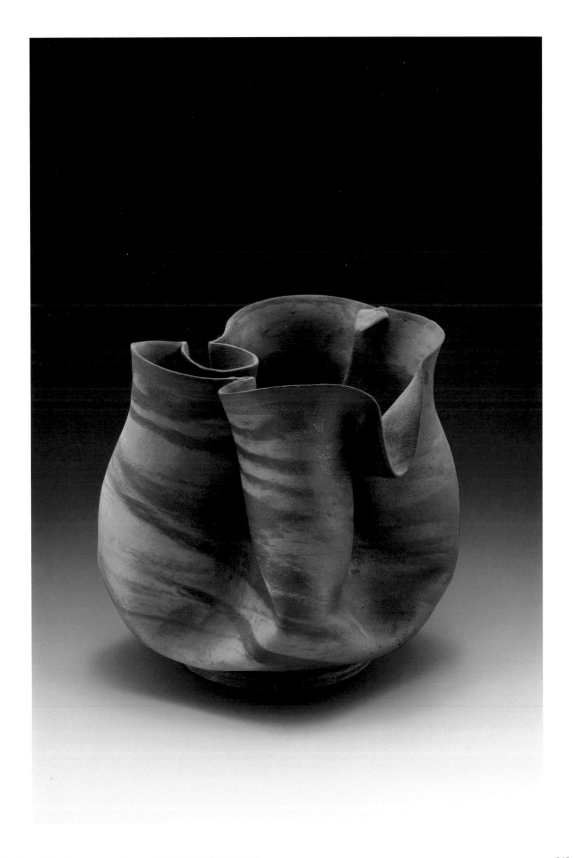

151. George Ohr, Bisque vase with terra-cotta slip streaks, c. 1903–7

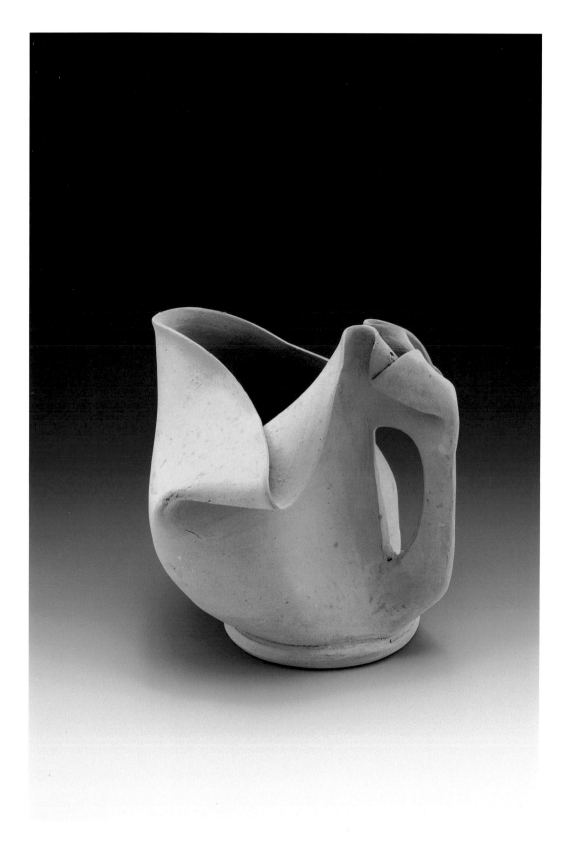

152. George Ohr, Tan clay bisque pitcher with cutout handle, c. 1903–7

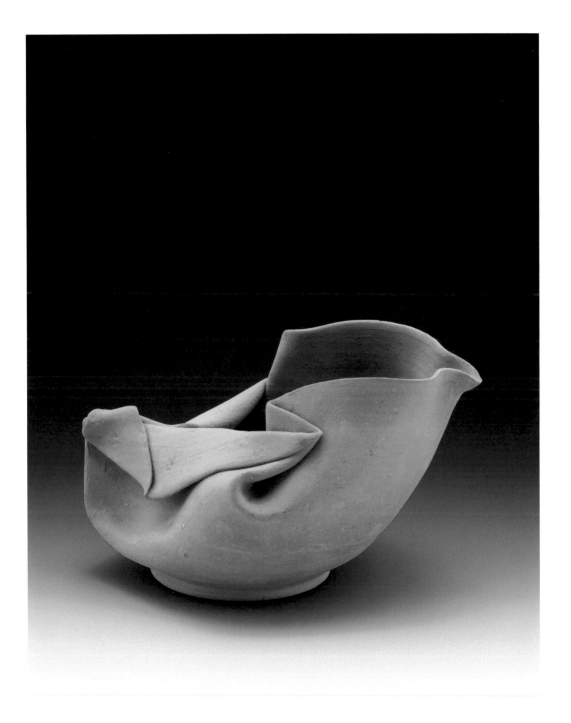

153. George Ohr, Tan clay bisque pitcher, c. 1903–7

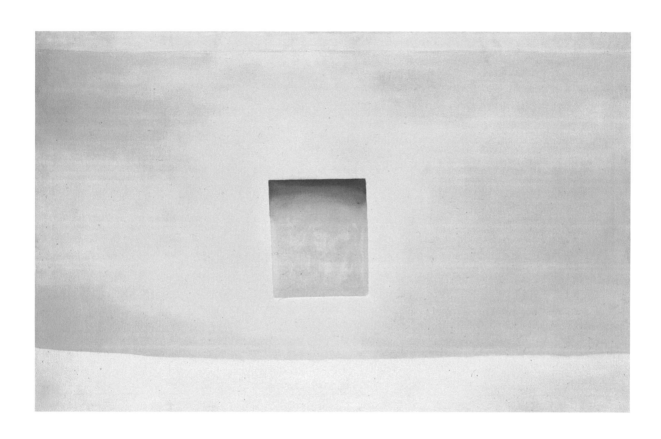

154. Georgia O'Keeffe, *Wall with Green Door*, 1953

155. Robert Overby, *Broken Window Maps*, 1972

156. Bernard Palissy, Plate decorated with rustic figures, 1550–1600

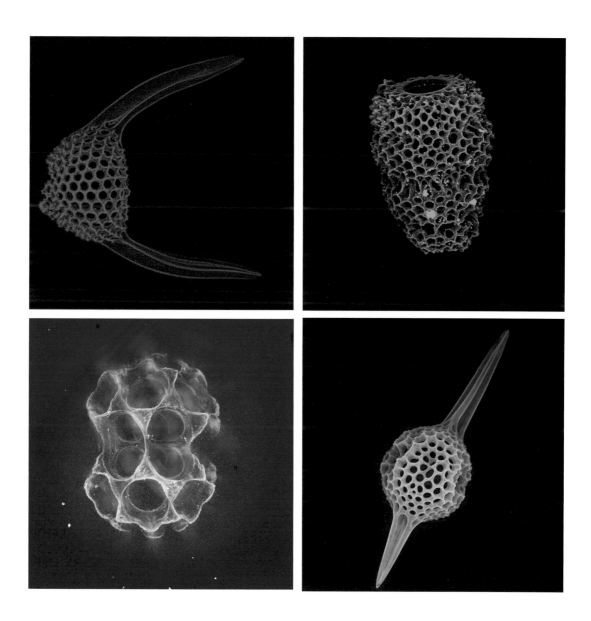

157. Nipam Patel, Radiolarian confocals, 2015 (clockwise from top left: 1x, 8x, 9x, 6x)

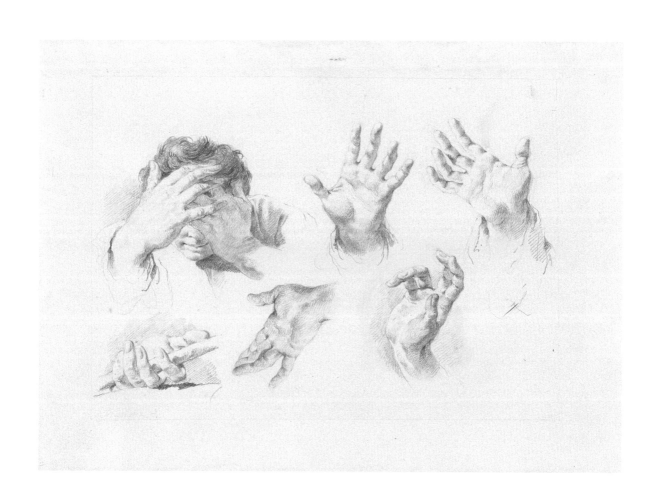

158. Giovanni Battista Piazzetta, *Six Studies of Hands, with a Pair Held Before a Boy's Face*, 18th century

159. Pomo, Northern California, Coiled basket miniature, n.d.

160. Pomo, Northern California, Twined burden basket, n.d.

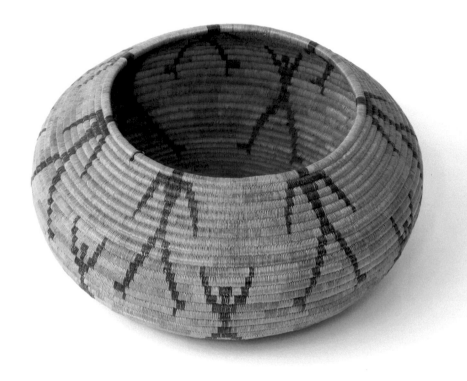

161. Pomo, Northern California, Coiled storage basket, n.d.

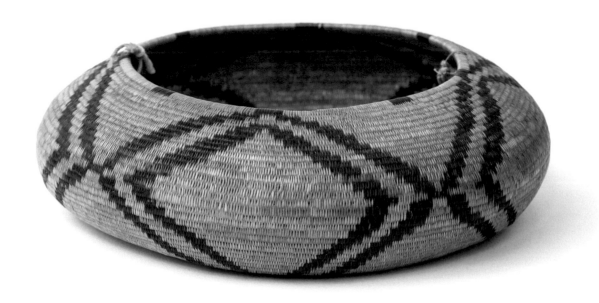

162. Pomo, Northern California, Coiled basket, n.d.

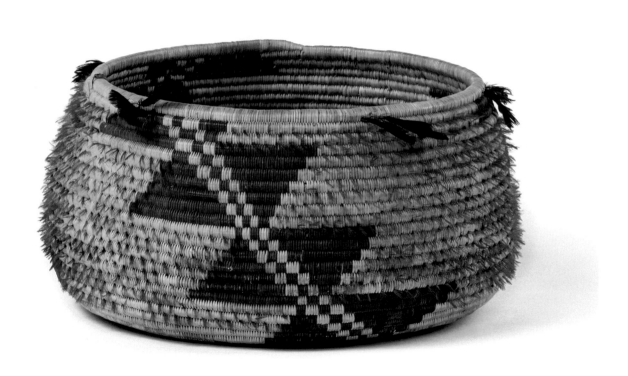

163. Pomo, Northern California, Coiled basket with quail crests and feathers, n.d.

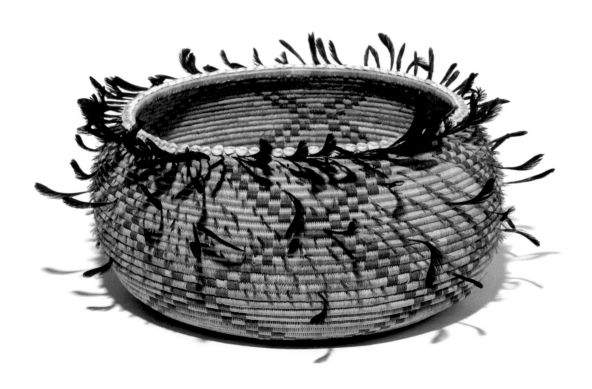

164. Pomo, Northern California, Coiled basket with feathers and shell beads, n.d.

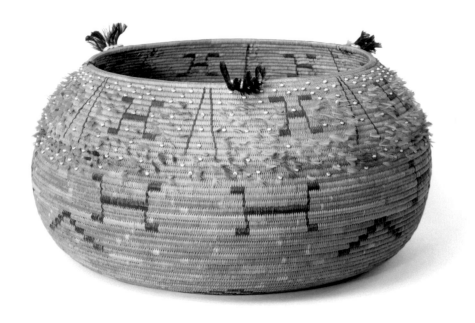

165. Pomo, Northern California, Coiled basket with feathers and beads, n.d.

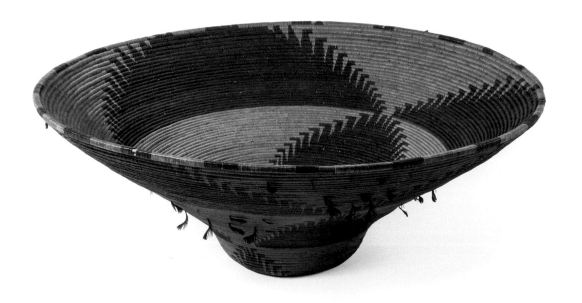

166. Pomo, Northern California, Coiled basket with quail crests, n.d.

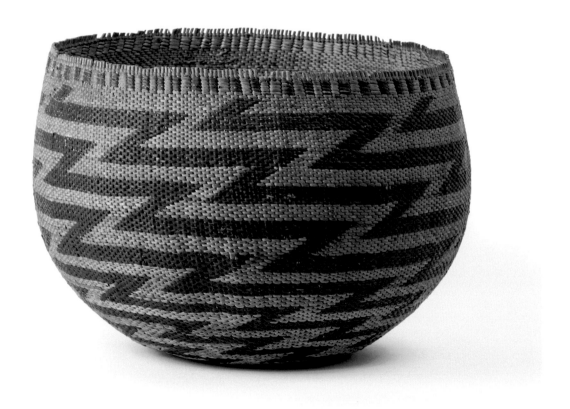

167. Pomo, Northern California, Twined cooking and food storage basket, n.d.

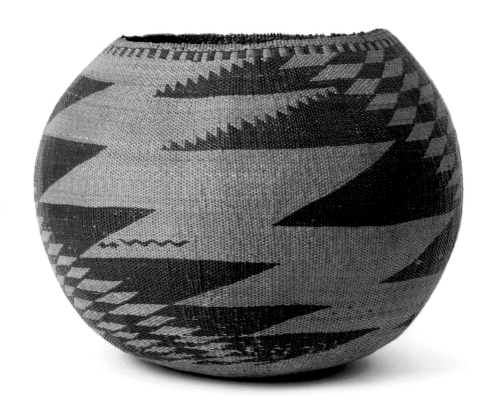

168. Pomo, Northern California, Twined cooking and food storage basket, n.d.

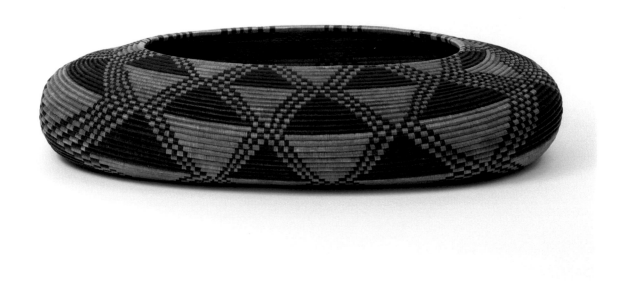

169. Pomo, Northern California, Coiled doctor's basket, n.d.

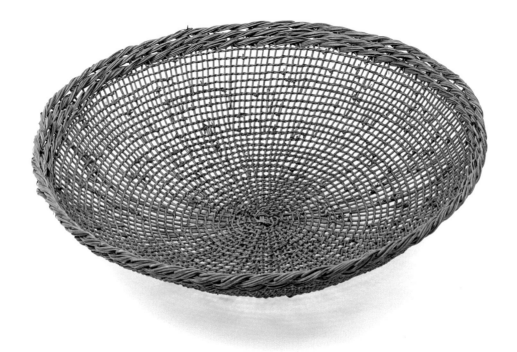

170. Pomo, Northern California, Openwork twined food preparation basket, n.d. 235

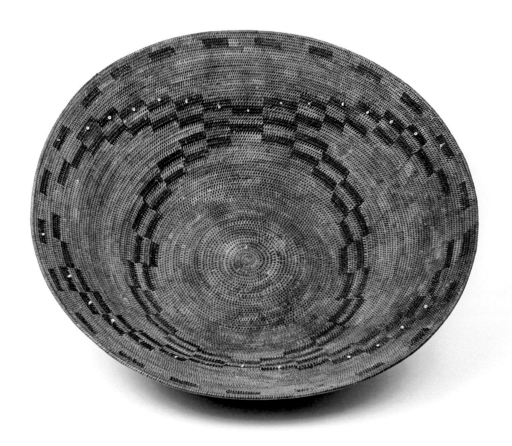

171. Pomo, Northern California, Coiled serving basket with beads, n.d.

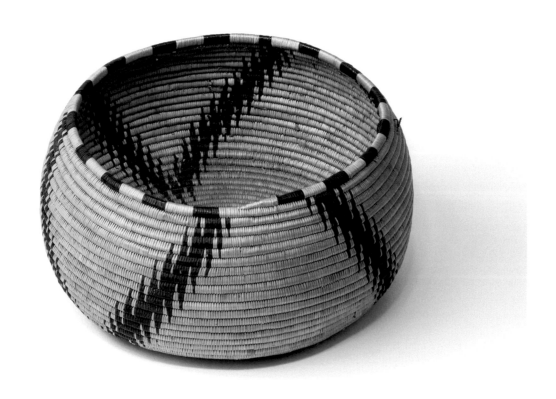

172. Pomo, Northern California, Coiled storage basket, n.d.

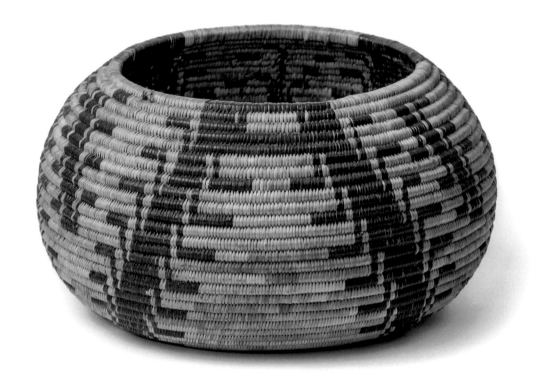

173. Pomo, Northern California, Coiled storage basket, n.d.

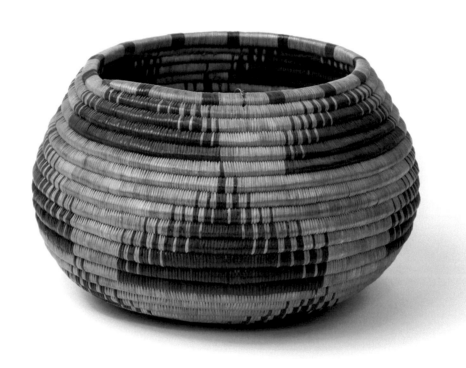

174. Pomo, Northern California, Coiled storage basket, n.d.

175. Avery Preesman, *Untitled, Last Silver Painting, Hang II (voor Noorden/for North)*, 2006

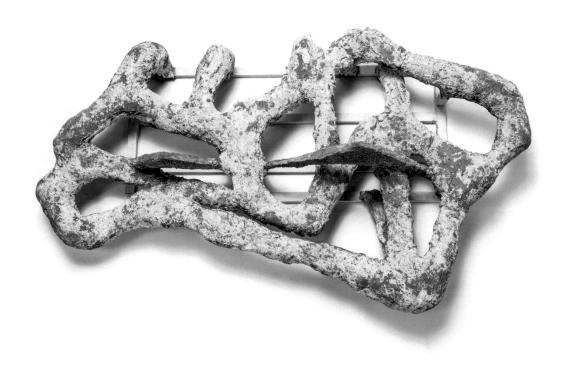

176. Avery Preesman, *Within, S.W.S.*, 2008–9

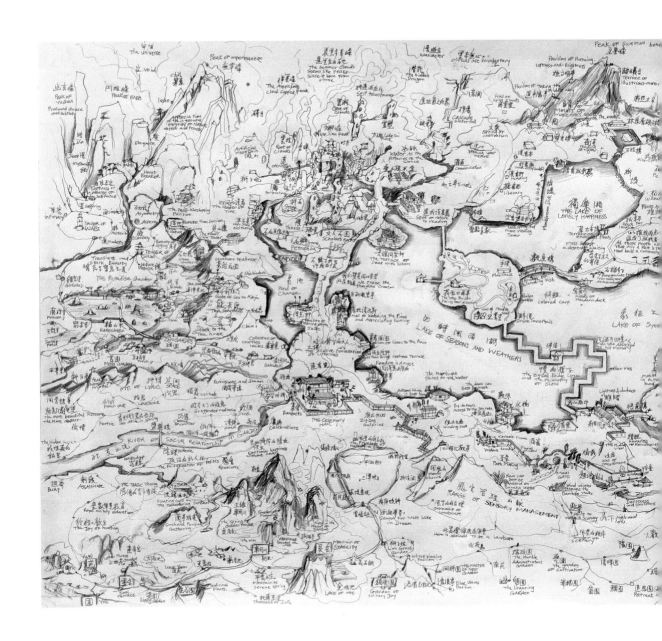

177. Qiu Zhijie, Sketch for *The World Garden*, 2015

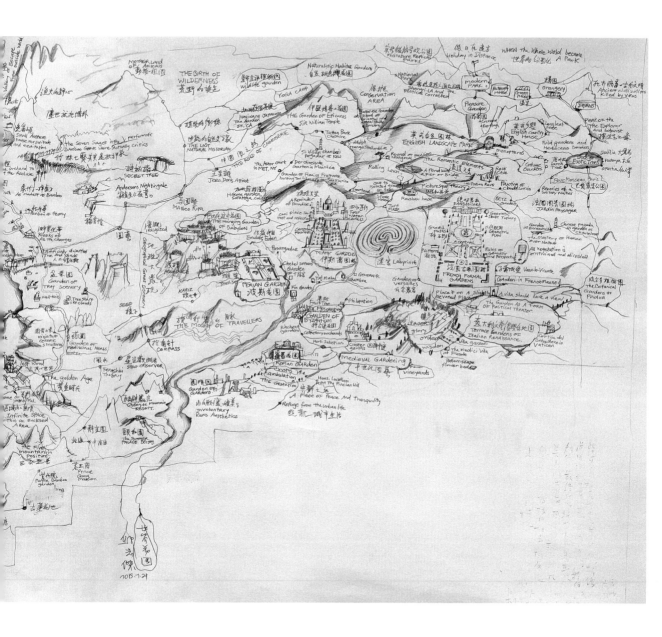

243

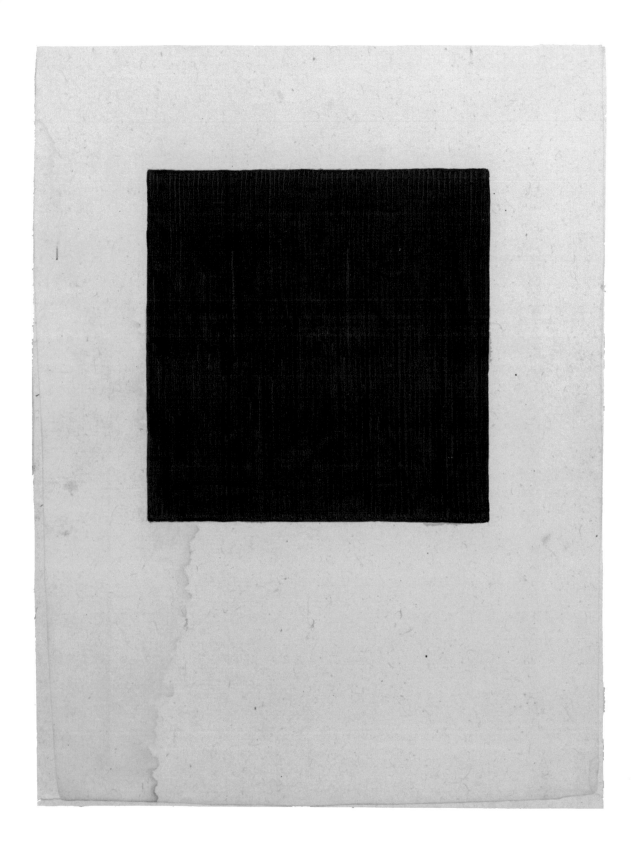

178. Rajasthan, India, *Untitled (Legend: A Meditation on the Four Directions)*, 1998

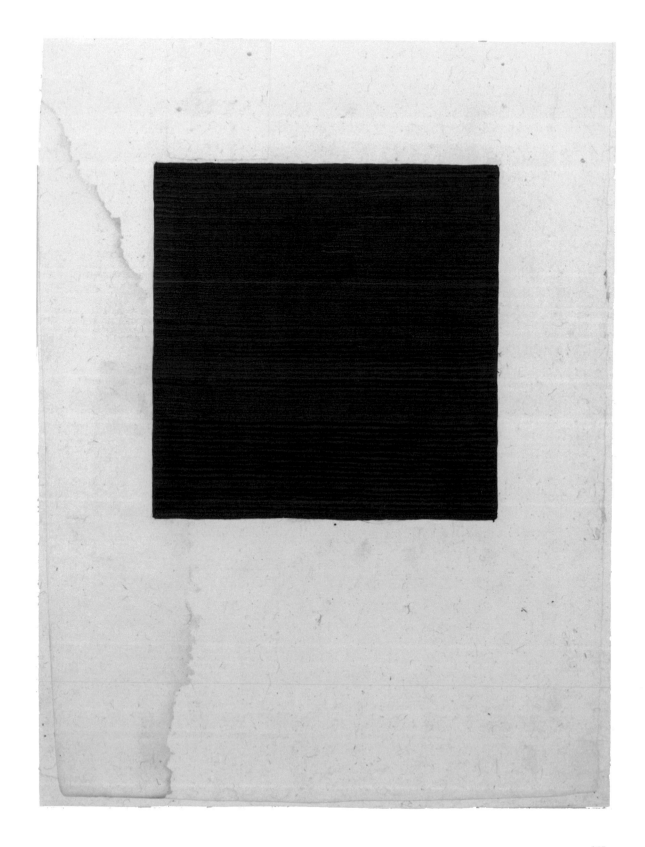

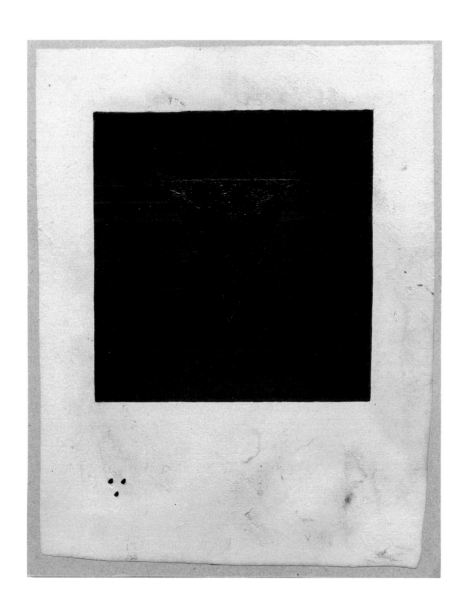

179. Rajasthan, India, *Untitled (Portrait of Kali, the Goddess, the "Black One")*, 2007

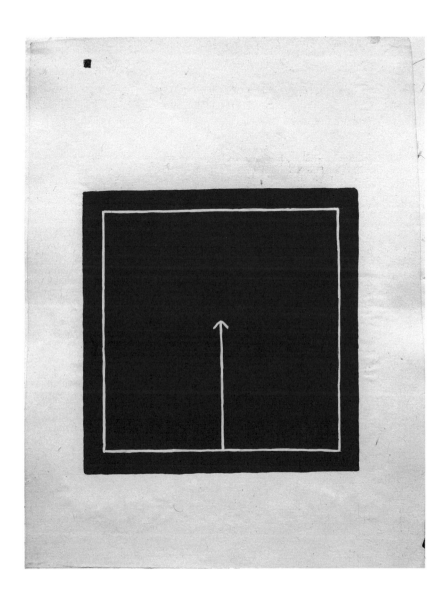

180. Rajasthan, India, *Untitled (The Goddess, Having Journeyed Through the Blue of Consciousness, at Her Source, Her Center)*, 2008 247

181. Ad Reinhardt, *Abstract Painting*, 1960–65

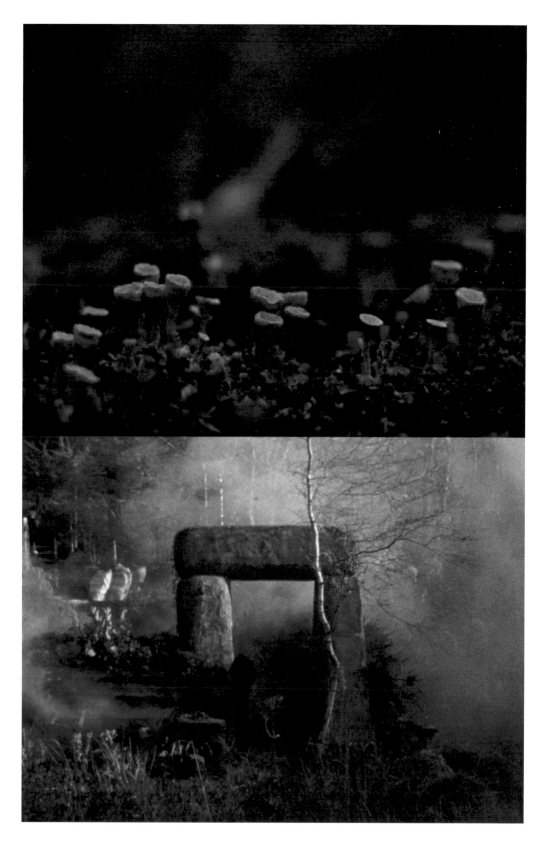

182. Ben Rivers, *Origin of the Species*, 2008 (stills)

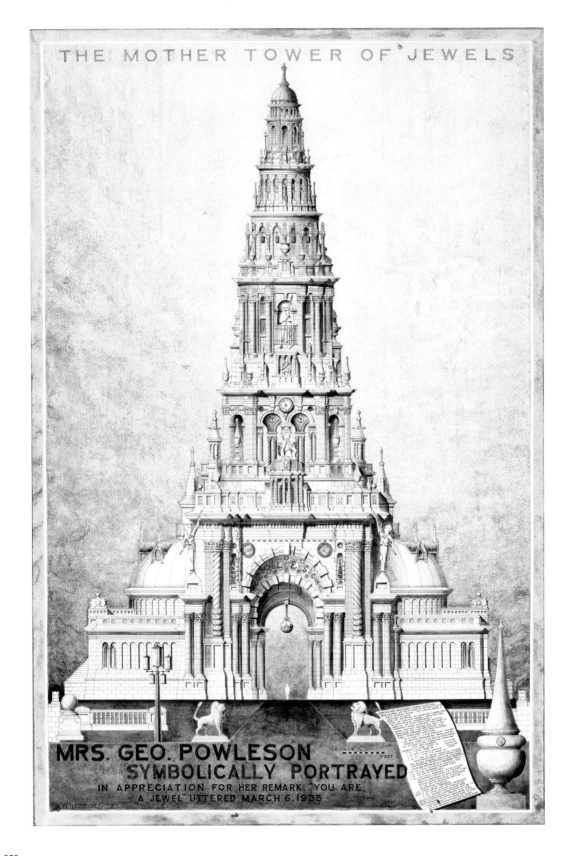

THE MOTHER TOWER OF JEWELS

MRS. GEO. POWLESON
SYMBOLICALLY PORTRAYED
IN APPRECIATION FOR HER REMARK, "YOU ARE
A JEWEL" UTTERED MARCH 6, 1935

A.G.RIZZOLI, DEL.

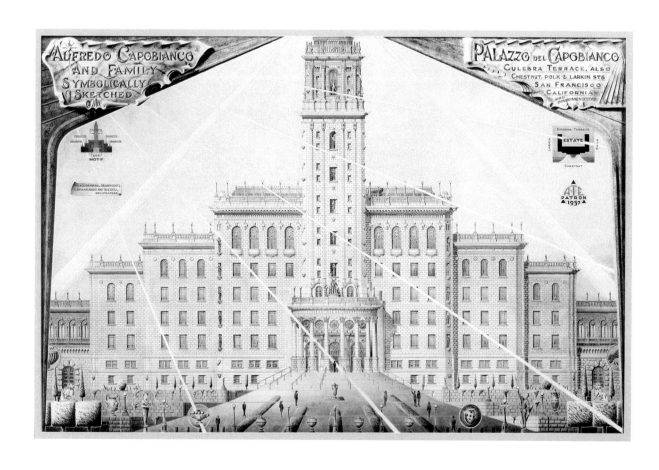

183. A. G. Rizzoli, *Mrs. Geo. Powleson Symbolically Portrayed / The Mother Tower of Jewels*, 1935

184. A. G. Rizzoli, *Alfredo Capobianco and Family Symbolically Sketched / Palazzo del Capobianco*, 1937

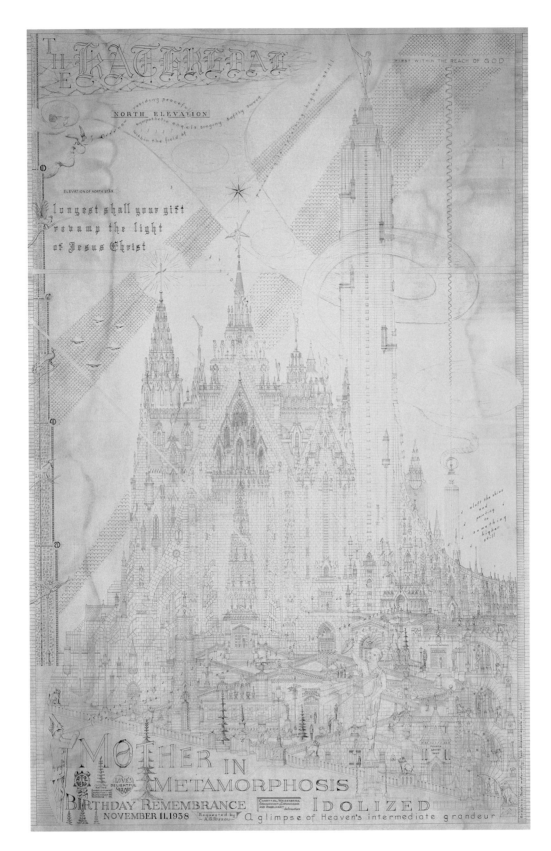

THE KATHEDRAL

FIRST WITHIN THE REACH OF GOD

NORTH ELEVATION

ELEVATION OF NORTH STAR

longest shall your gift
revamp the light
of Jesus Christ

MOTHER IN METAMORPHOSIS IDOLIZED

BIRTHDAY REMEMBRANCE
NOVEMBER 11, 1938

A glimpse of Heaven's intermediate grandeur

254

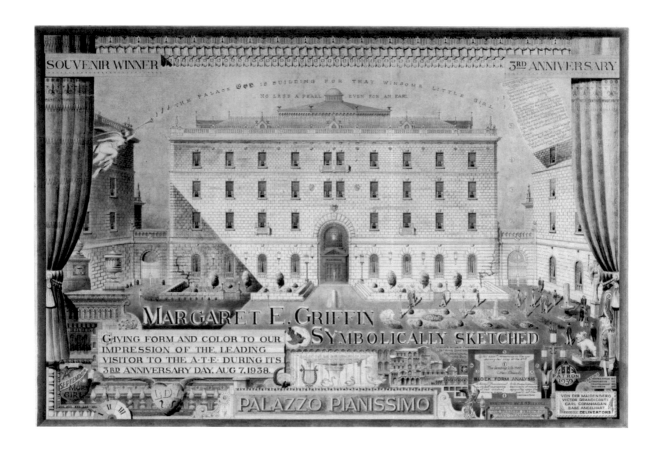

185. A. G. Rizzoli, *Mother in Metamorphosis Idolized / The Kathredal (A glimpse of Heaven's intermediate grandeur)*, 1938

186. A. G. Rizzoli, *Margaret E. Griffin Symbolically Sketched / Palazzo Pianissimo*, 1939

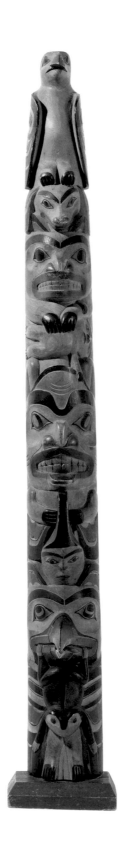
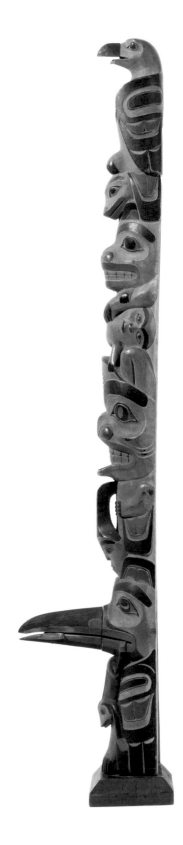

187. John Robson (Gyaawhllns), Model crest pole, 1875

188. Till Roeskens, *Videomappings: Aida, Palestine*, 2009 (stills)

189. Dieter Roth, *At Home*, 1970

190. Fred Sandback, *Untitled*, 1989

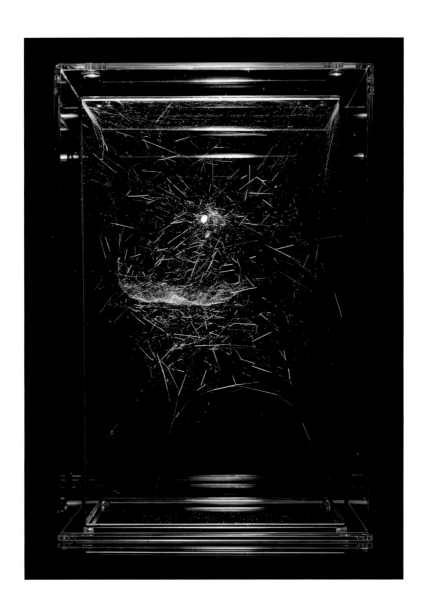

191. Tomás Saraceno, *Hybrid solitary semi-social musical instrument Ophiuchus: built by Parasteatoda lunata—two weeks—and a Cyrtophora citricola—two weeks*, 2015

192. Tomás Saraceno, *Hybrid semi-social musical instrument Arp87: built by a couple of Cyrtophora citricola—one month—one Agelena labirintica—two months—one Cyrtophora moluccensis—two weeks—and one Tegenria domestica—four months—(turned four times 180 degrees on Z axis)*, 2015

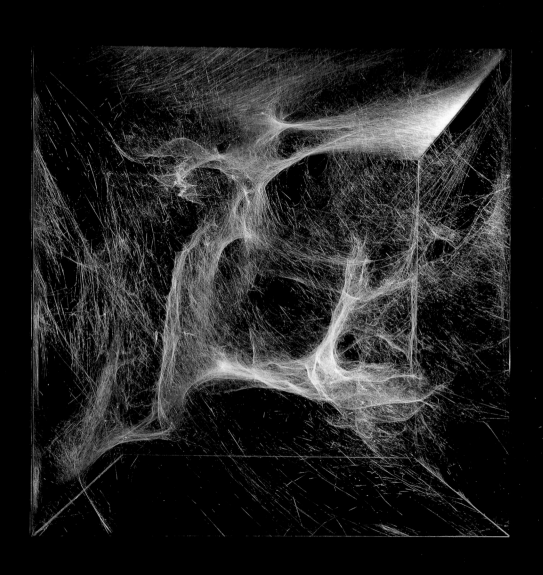

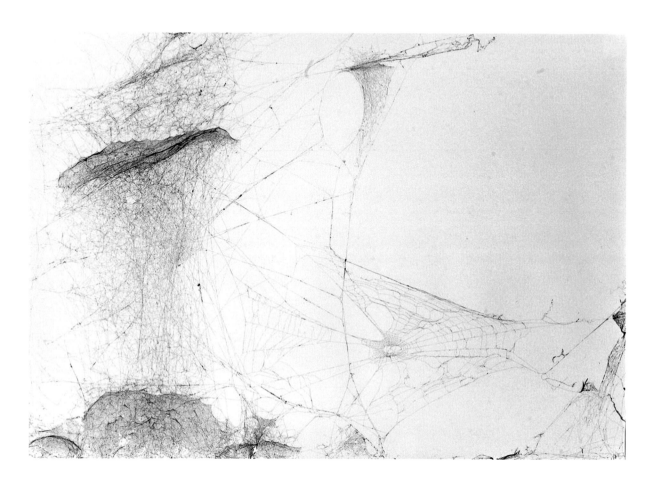

193. Tomás Saraceno, *Solitary, semi-social mapping of ESO-510 613 connected with intergalactic dust by one Nephila clavipes—one week—and three Cyrtophora citricola—three weeks*, 2015

194. Viktor Schauberger, *Detail of a water turbine*, late 1940s

195. Viktor Schauberger, *Detail of a water turbine*, late 1940s

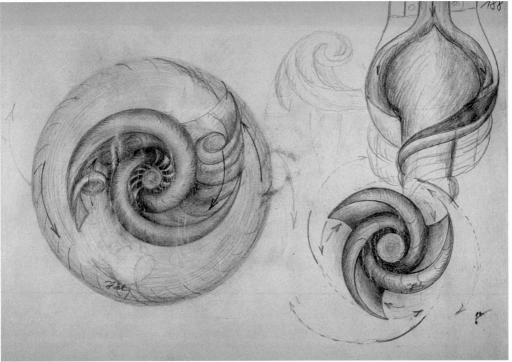

196. Viktor Schauberger, *Detail of a bio-plough and a water impeller,* late 1940s

197. Viktor Schauberger, *Studies for water impellers,* late 1940s

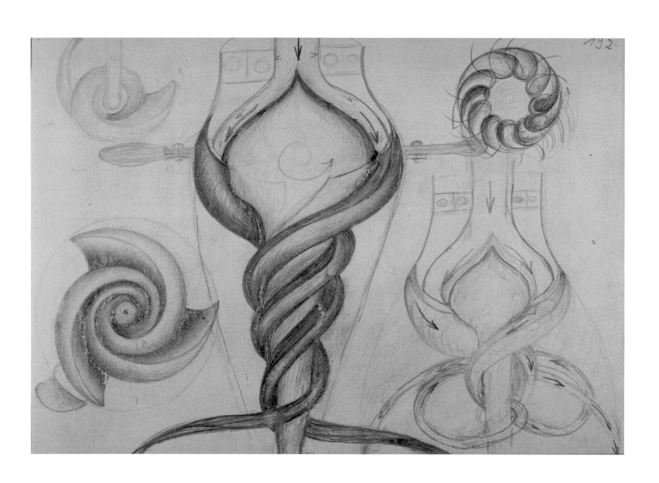

198. Viktor Schauberger, *Studies for a suction turbine*, late 1940s

199. Viktor Schauberger, *Study of twisted water pipes*, c. 1950

200. Viktor Schauberger, *Water impeller*, c. 1950

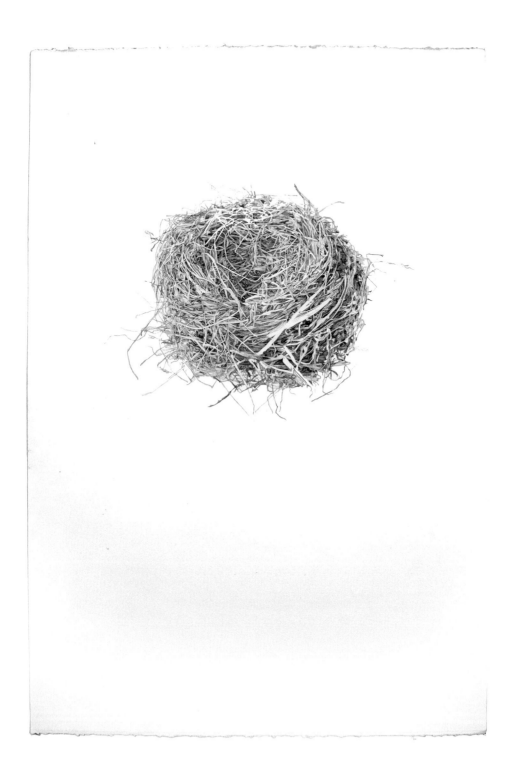

201. Jesse Schlesinger, *Construct III (to forget the name)*, 2009

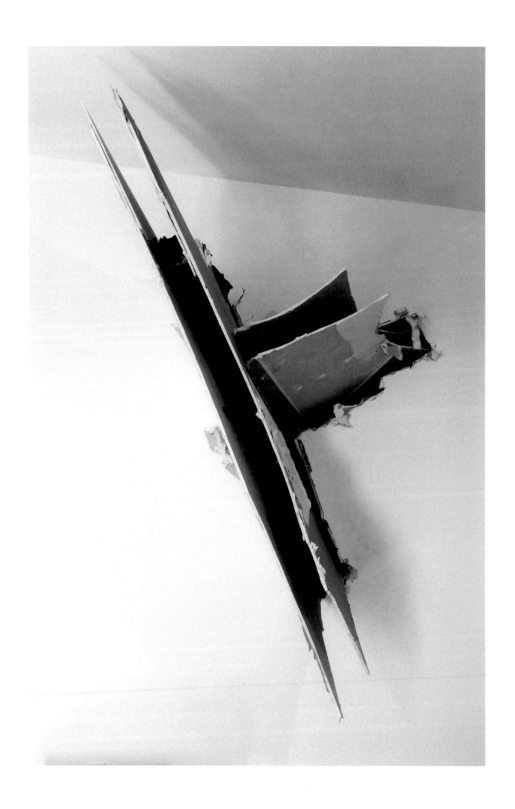

202. Felix Schramm, *Untitled*, 2008

203. June Schwarcz, *2485*, 2009

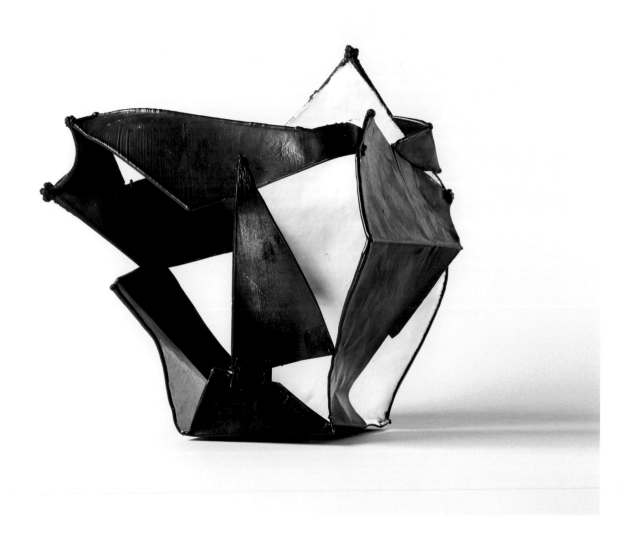

204. June Schwarcz, *2425*, 2011

205. June Schwarcz, *2492*, 2013

206. June Schwarcz, *2493*, 2013

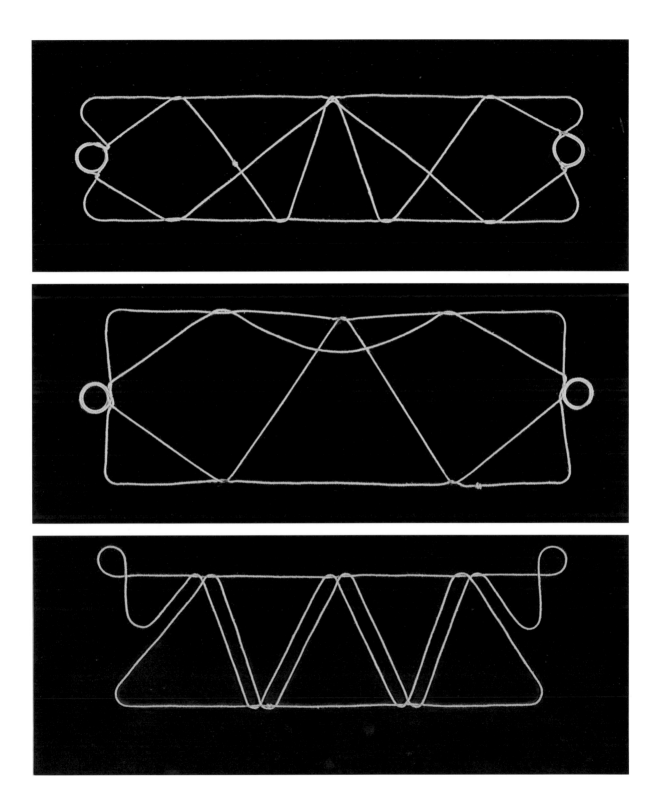

207. Harry Smith, String figures, c. 1970

208. Hyun-Sook Song, *4 Brushstrokes over Figure*, 2012

209. Hyun-Sook Song, *21 Brushstrokes*, 2007

210. Hyun-Sook Song, *2 Brushstrokes*, 2013

211. Hedda Sterne, *Untitled (November 14, 2001)*, 2001

212. Hedda Sterne, *Untitled (March 21, 2002)*, 2002

213. Hedda Sterne, *Untitled (July 22, 2002)*, 2002

214. Hedda Sterne, *Untitled (August 15, 2002)*, 2002

215. Hedda Sterne, *Untitled (August 12, 2002)*, 2002

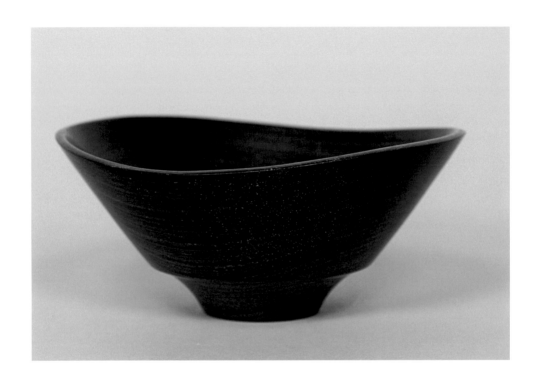

216. Bob Stocksdale, Oval bowl, mid-20th century

217. Bob Stocksdale, Bowl, mid- to late 20th century

218. Bob Stocksdale, Bowl, 1983

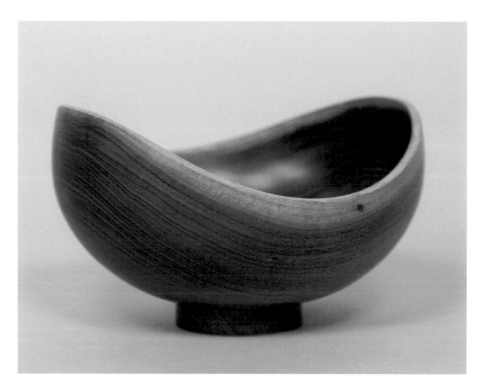

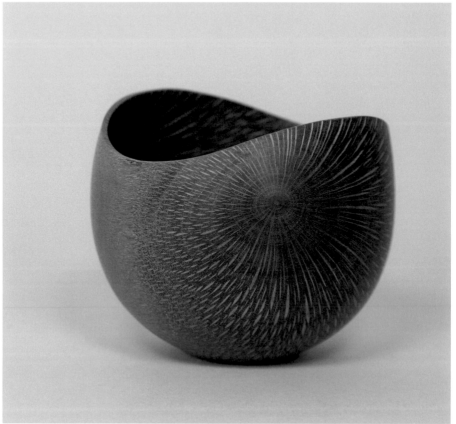

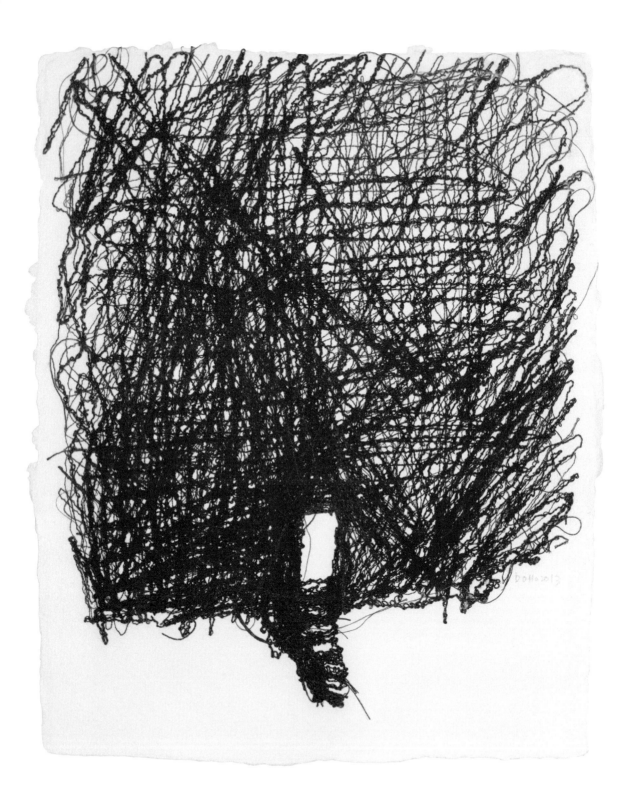

219. Do Ho Suh, *Staircase*, 2013

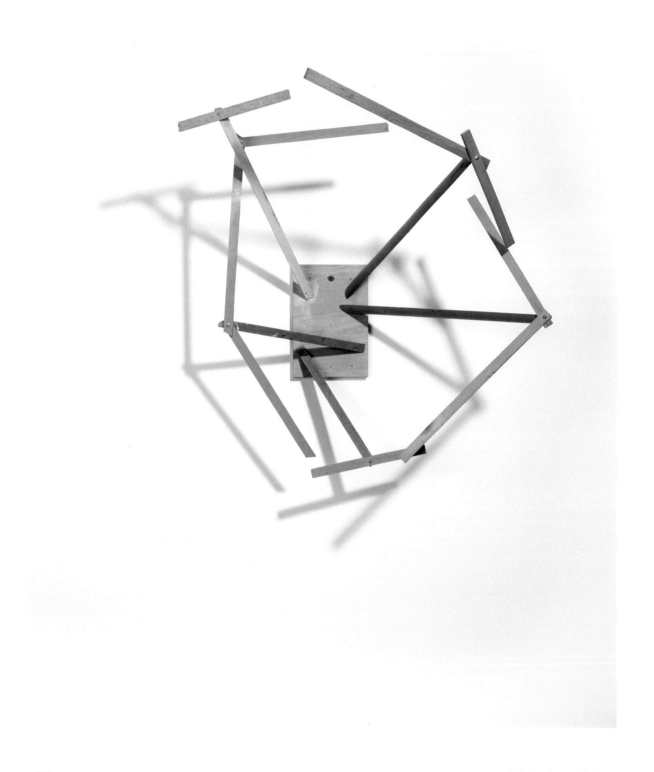

220. Al Taylor, *Untitled*, 1985

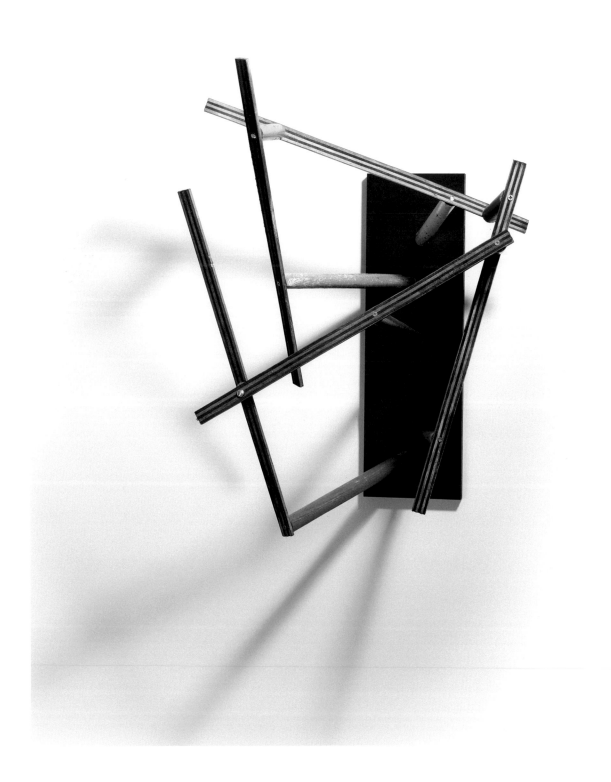

221. Al Taylor, *Untitled (Latin Studies)*, 1985

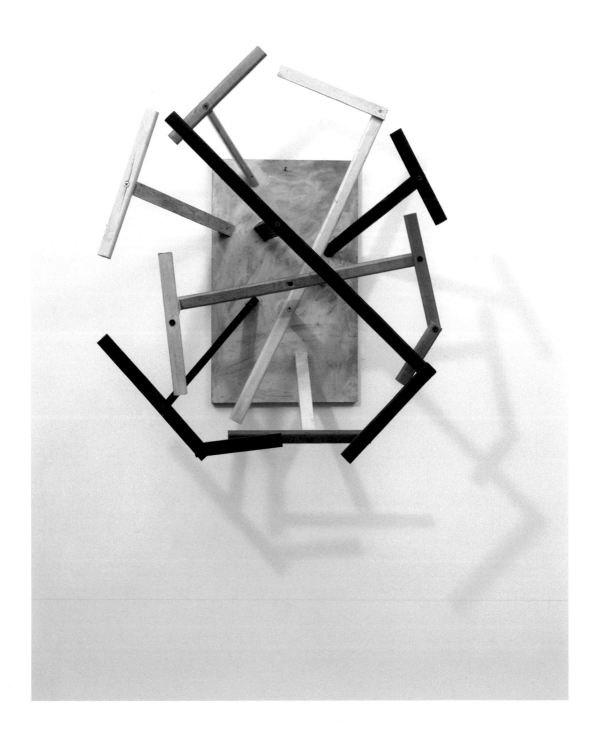

222. Al Taylor, *Untitled (Latin Study)*, 1985

223. Pavel Tchelitchew, *Tree into Double-Hand (Study for "Hide and Seek")*, 1939

224. Pavel Tchelitchew, *Interior Landscape*, c. 1947

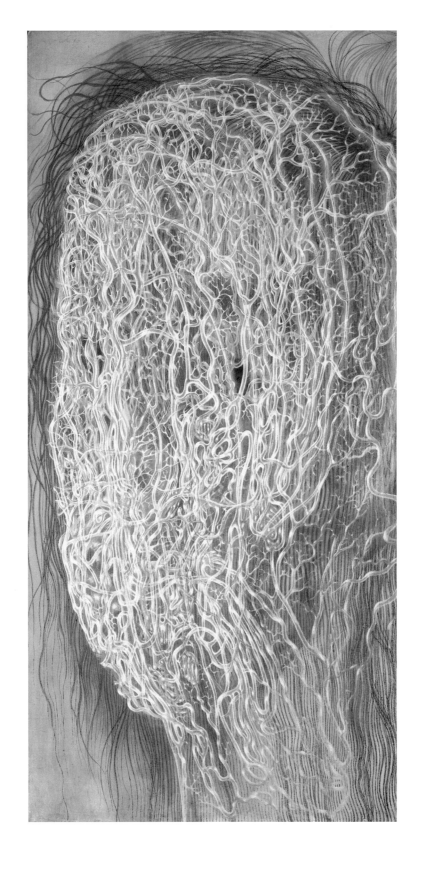

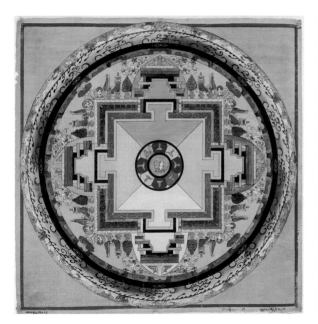

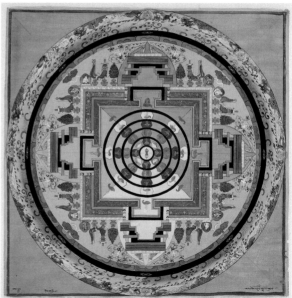

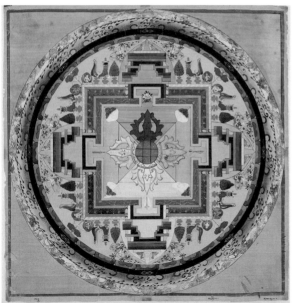

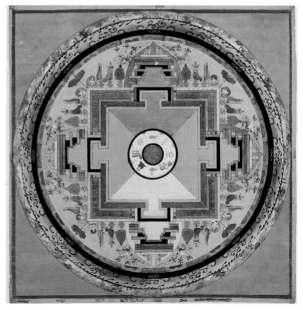

Tibet
All works 19th–20th century

225. *Mandala of Buddhakapala*

226. *Mandala of Krsnari*

227. *Mandala of Nila Varahi*

228. *Mandala of Trikayavajra*

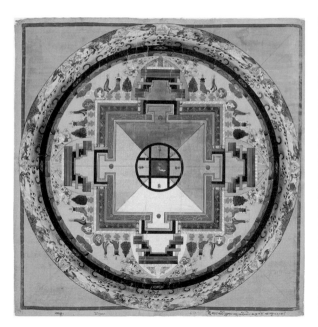

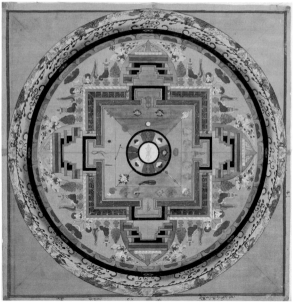

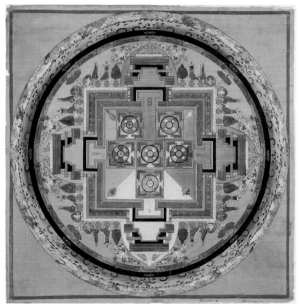

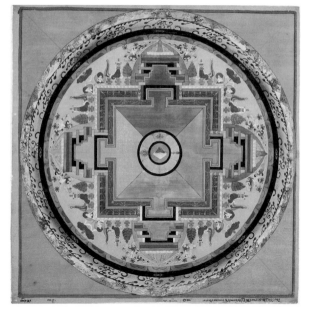

229. *Mandala of Jnana Dakini*

230. *Mandala of the Cakravartin of the Six Realms*

231. *Mandala of Vajra Humkara*

232. *Mandala of Mahamaya*

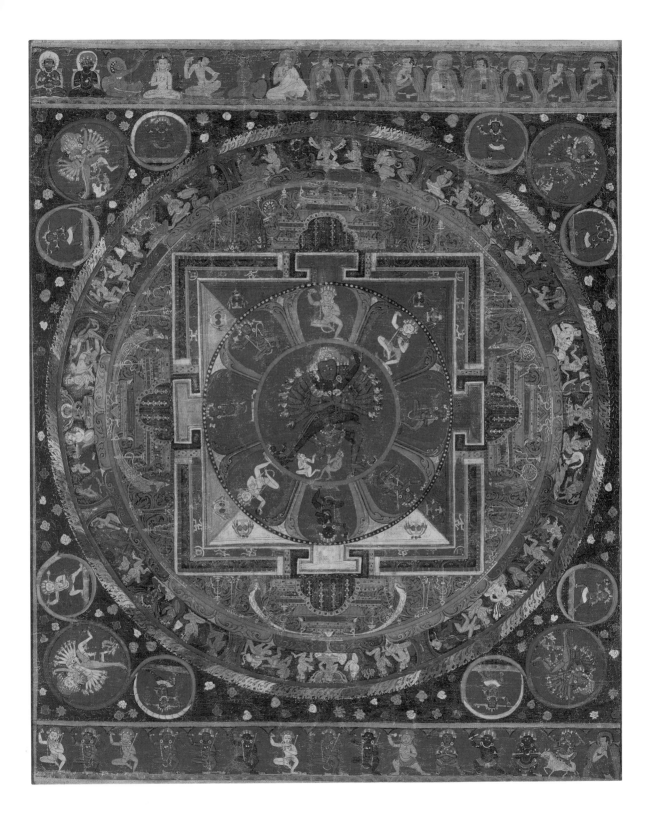

233. Tibet, *Hevajra Mandala*, 14th century

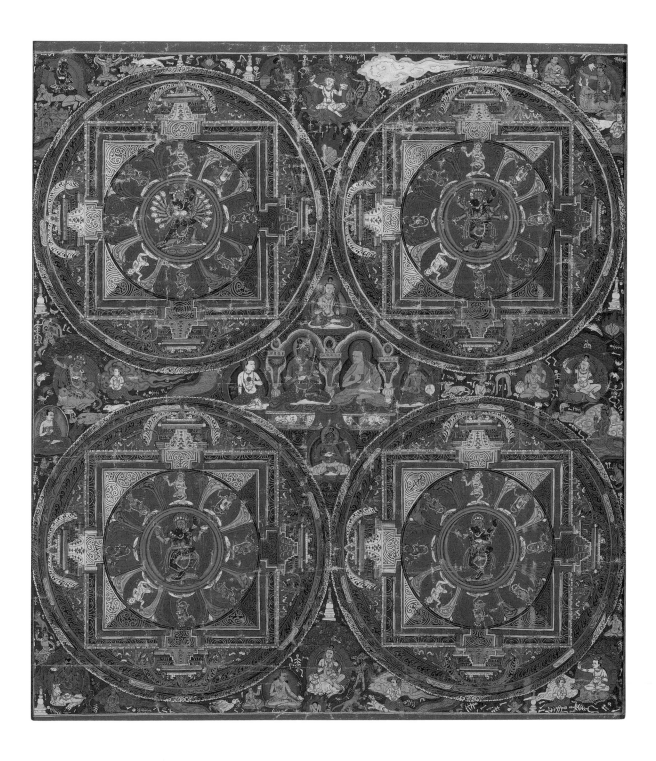

234. Tibet, *Four Mandalas of Hevajra*, 16th century

303

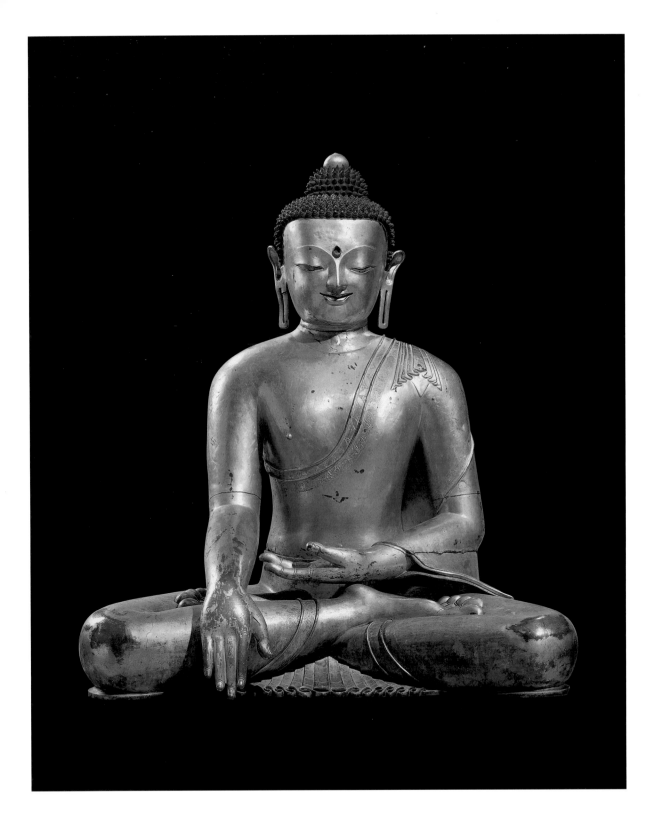

235. Tibet, *Seated Buddha*, 14th century

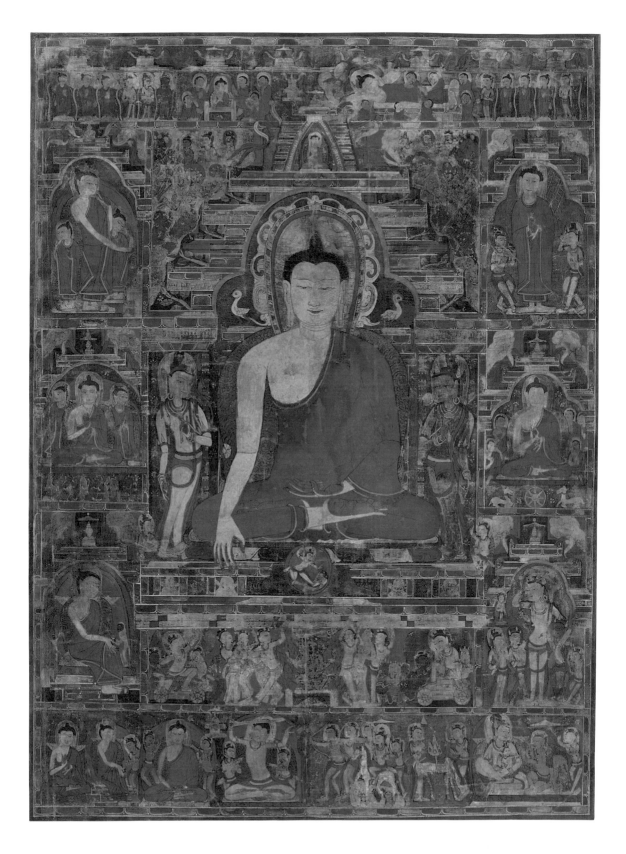

236. Tibet, *Scenes from the Life of Buddha Shakyamuni*, 12th century

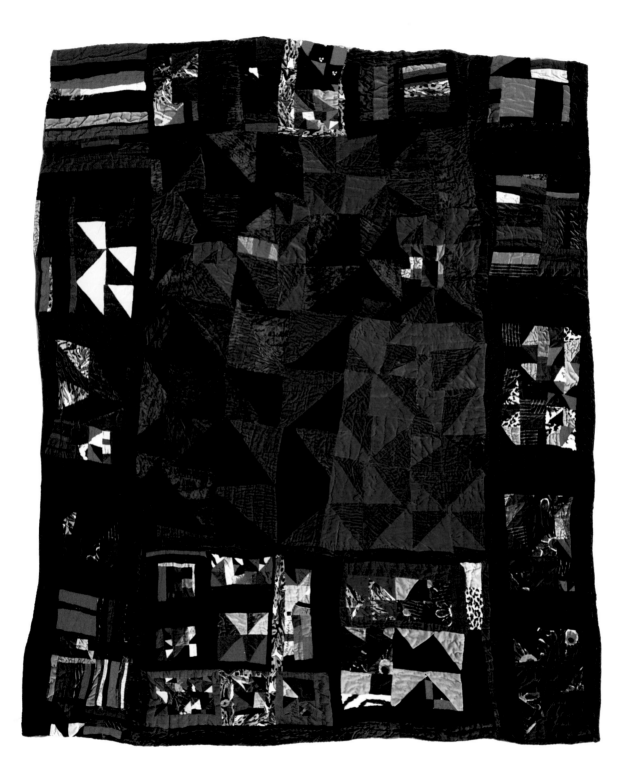

237. Rosie Lee Tompkins, *Blue Medallion*, 1986

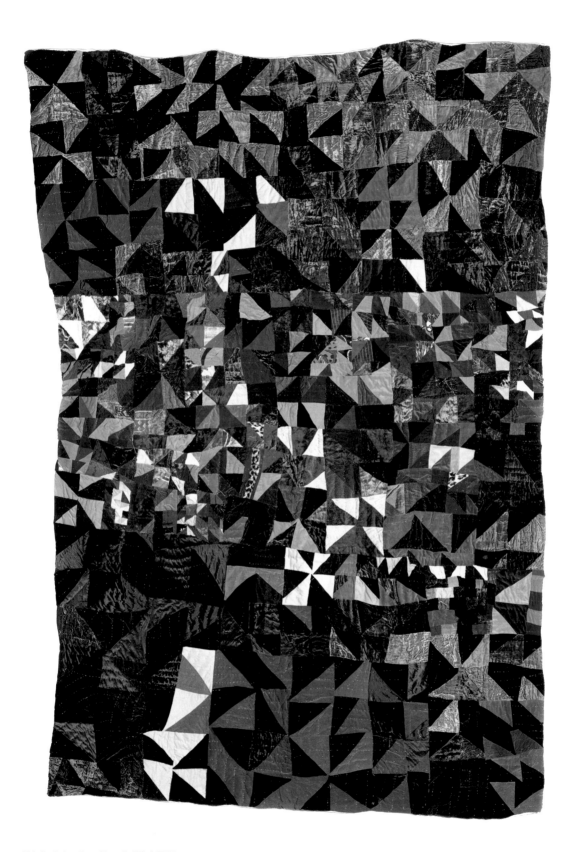

238. Rosie Lee Tompkins, *Untitled*, 1987

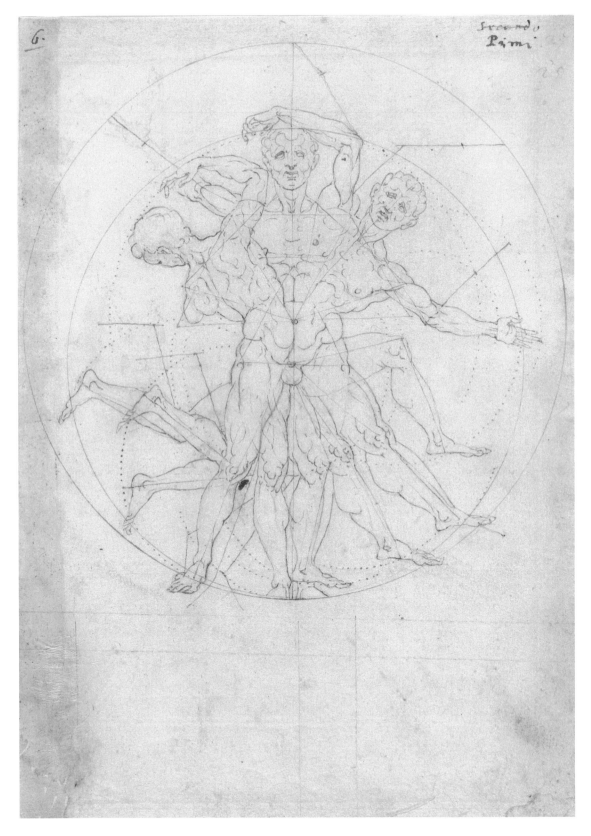

239. Carlo Urbino, "Primi," from *Codex Huygens* (Urbino codex), fol. 6, 16th century

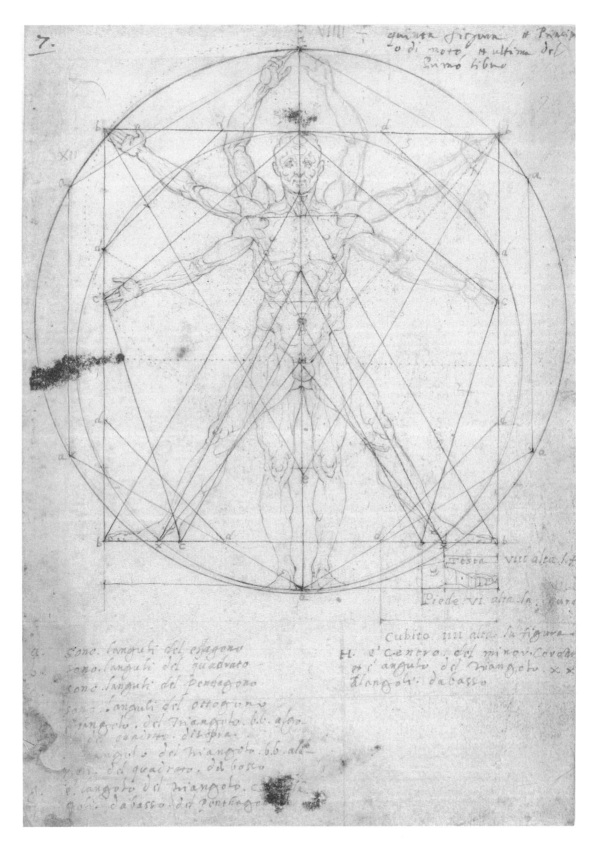

240. Carlo Urbino,"Quinta figura et principio di moto et ultima del primo libro," from *Codex Huygens* (Urbino codex), fol. 7, 16th century

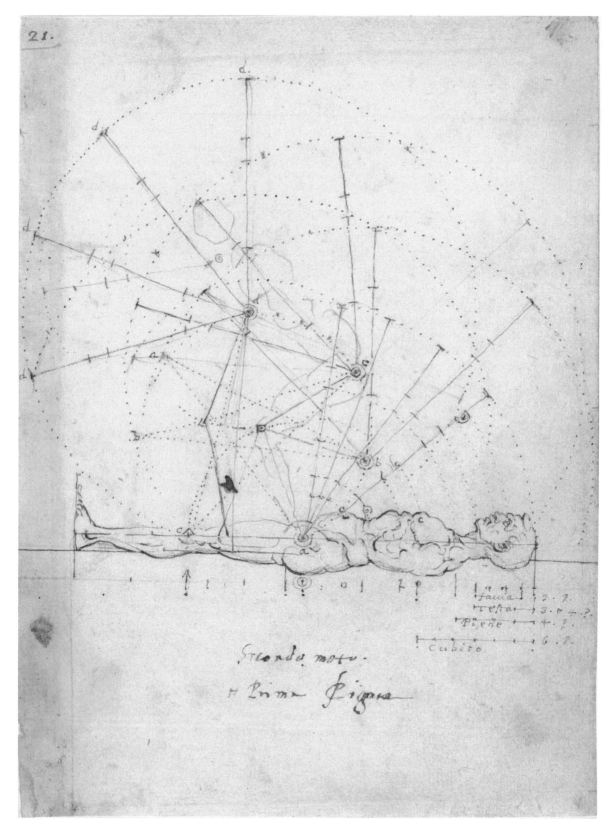

241. Carlo Urbino, "Secondo moto. Prima figura," from *Codex Huygens* (Urbino codex), fol. 21, 16th century

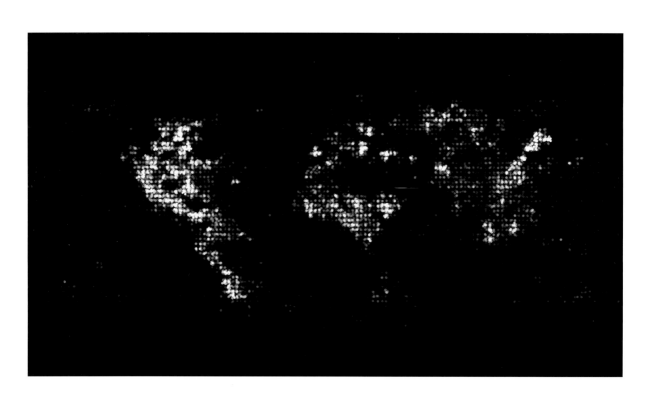

242. Muhammad Hafiz Wan Rosli, *Point Cloud*, 2015 (still)

243. James Whitney, *Yantra*, 1957 (stills) 313

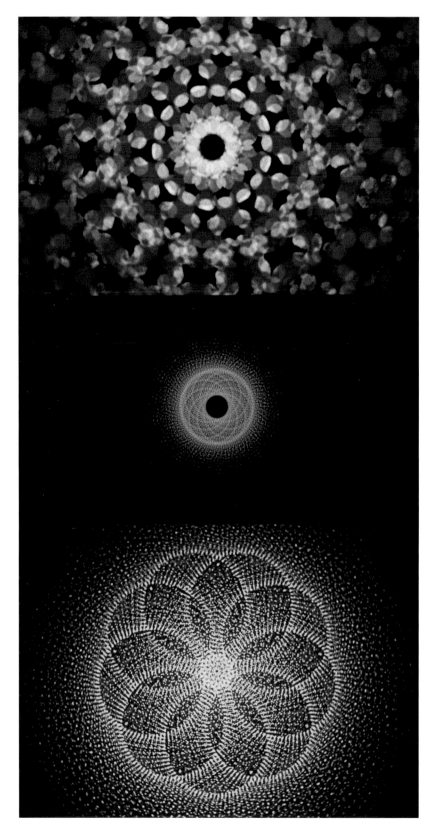

244. James Whitney, *Lapis*, 1966 (stills)

245. John Whitney, *Arabesque*, 1975 (stills)

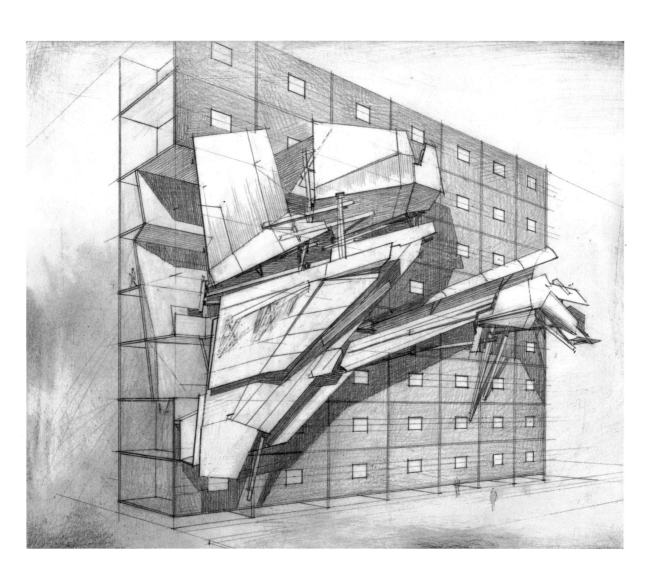

246. Lebbeus Woods, *Sarajevo*, 1993

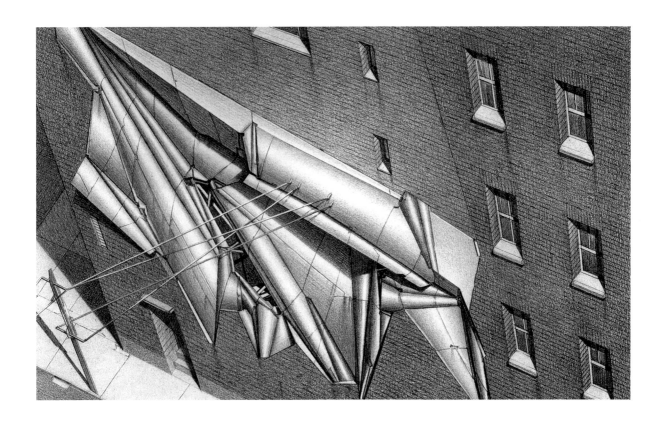

247. Lebbeus Woods, *SCAR Construction*, 1993

248. Lebbeus Woods, *Bosnia Free State: The Wall, or Defense by Absorption*, 1993–94

249. Lebbeus Woods, *Bosnia Free State: The Wall, or Defense by Absorption*, 1993–94

250. Lebbeus Woods, *Bosnia Free State: Segment of the Wall*, 1993–94

251. Lebbeus Woods, *Bosnia Free State: Segment of the Wall*, 1993–94

252. Wow! signal, 11:16 p.m. EDST, August 15, 1977

253. Iannis Xenakis, Initial studies of musical rhythm for *Metastasis*, 1953

254. Iannis Xenakis, Diastematic calculations and intervals for *Metastasis*, 1954

→ page 11

(295)

325

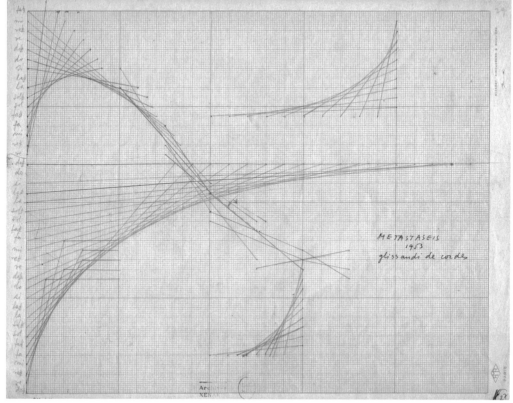

255. Iannis Xenakis, Sketch for west facade of Convent of Sainte Marie de La Tourette, "Pans de verre ondulatoire," 1954

256. Iannis Xenakis, Graphic score for *Metastasis*, glissandi of chords, 1954

257. Iannis Xenakis, Preparatory studies for the Philips Pavilion, 1956

258. Iannis Xenakis, "Sounds as lightning," sketch describing the acoustic qualities of the Philips Pavilion, 1958

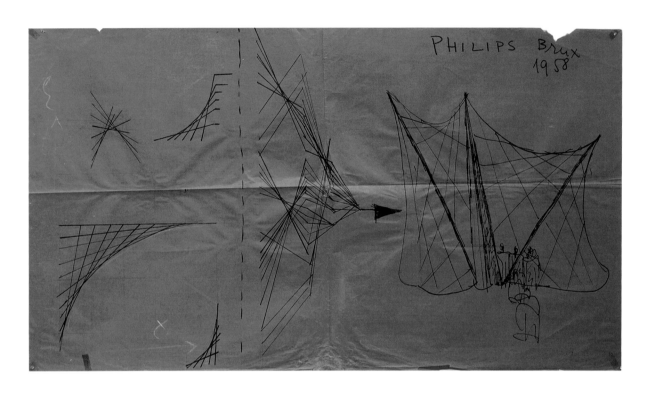

PHILIPS BRUX
1958

259. Iannis Xenakis, Sketch showing the link between *Metastasis* and the Philips Pavilion, 1958

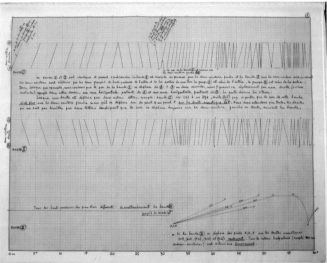

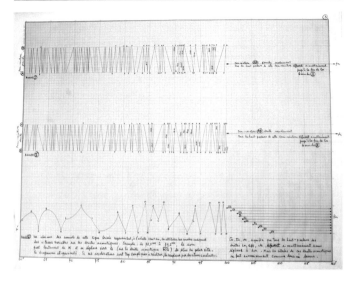

260. Iannis Xenakis, Score for *Concret PH*, electronic music composed for the entrance and exit of the Philips Pavilion, 1958

261. Will Yackulic, *Trait Family A*, 2013

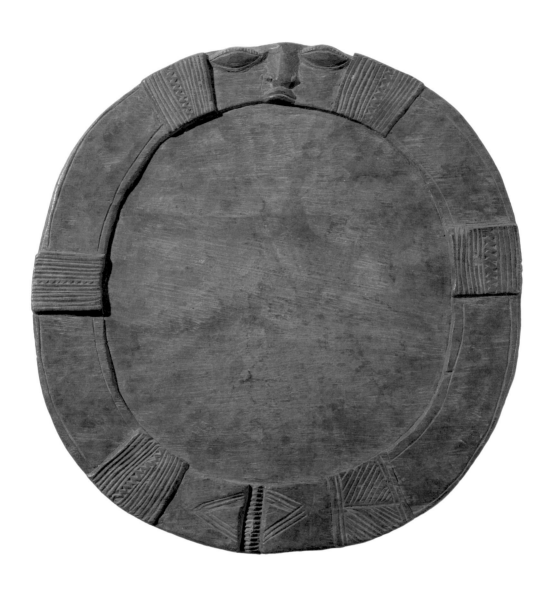

262. Yoruba, Nigeria, Divining tray, n.d.

Works in the Exhibition

Works without known artists are organized by culture, region, or medium.

David Chalmers Alesworth
United Kingdom/Pakistan, born 1957
Selections from the series *The Trees of Pakistan*, 2004–14
Watercolor and ink on wasli paper, mat board;
24 × 17 ¼ in. each
Courtesy of the artist, Commissioned and produced by
the 8th Berlin Biennale

"The Striped Eucalypt" (Safeda), *Eucalyptus camaldulensis* Dehnh., Dr. Ziauddin Ahmed Rd., Karachi, 2004 (pl. 1)

"The Bottle Palm in Black and White" (Royal Palm), *Roystonea regia* (Kunth) O.F. Cook, Nr. Karsarz, Karachi, 2005 (pl. 2)

"The Fortress Sniper Tree" (Arjun), *Terminalia arjuna* (Roxb. ex DC.) Wight & Arn., Fortress Check-Post, Nr. Mian Mir Bridge, Lahore, 2010 (pl. 3)

"The Political Tiger Tree" (Devil's Tree, Blackboard Tree), *Alstonia scholaris* L. R. Br., Neela Gumbad, Lahore, 2013 (pl. 4)

"The Tyre Shop Tree" (Neem), *Azadarachta indica* A. Juss., Ravi Bridge Stop, Lahore, 2013 (pl. 5)

"The Two Barbers' Tree" (Kubabhal, Babul), *Leucaena leucocephala* (Lam.) de Wit, Railway Underpass, Nr. Seven-up, Lahore, 2013 (pl. 6)

"The Bells and Baskets Tree" (Gul e Nishtar), *Erythrina suberosa* Roxb., D-Block, Model Town, Lahore, 2013 (pl. 7)

"The Bird Boxes Eucalypt" (Safeda), *Corymbia maculata* (hook.) K.D. Hill & L.A.S. Johnson, E-Block, Model Town, Lahore, 2013 (pl. 8)

"The Main Mkt. Barber Shop Tree" (Maulsary), *Mimusops elengi* L., Main Mkt., Lahore, 2013 (pl. 9)

"The Disused Pylon Pine" (Chir Pine), *Pinus roxburghii* Sarg., Abid Majeed Road, Cantt., Lahore, 2014 (pl. 10)

"The Cobbler's Tree" (Bachain), *Melia azedarach* L., Batti Chawkh, Lahore, 2014 (pl. 11)

"The McDonald's Tree" (Peepal), *Ficus religiosa* L., 63-Main Drive Through, Off Main Blvd., Lahore, 2014 (pl. 12)

Noriko Ambe
United States, born Japan 1967

A Piece of Flat Globe Vol. 12, 2010 (pl. 13)
Cut YUPO; 2 ½ × 8 ½ × 8 ½ in.
Collection of Lea Weingarten, Houston

A Piece of Flat Globe Vol. 22, 2010 (pl. 14)
Cut YUPO; 3 ⅛ × 6 ¼ × 6 ¼ in.
Collection of Stephen Mills and Brent Hasty, Austin

Anatolia (Konya), Turkey

Prayer rug, n.d. (pl. 15)
Wool; 45 × 65 in.
Phoebe A. Hearst Museum of Anthropology,
University of California, Berkeley *9-337*

Yuri Ancarani
Italy, born 1972
La malattia del ferro (The Malady of Iron), 2010–12
35mm transferred to HD; color, sound
Courtesy of the artist and ZERO…, Milan

Il capo, 2010 (pl. 16)
15 mins

Piattaforma luna, 2011 (pl. 17)
25 mins

Da Vinci, 2012 (pl. 18)
25 mins

Kenneth Anger
United States, born 1927

Eaux d'Artifice, 1953 (pl. 19)
16mm transferred to HD; color, sound; 12 mins
University of California, Berkeley Art Museum and
Pacific Film Archive *0230-01-13166*

Ruth Asawa
United States, 1926–2013

Untitled (S.283), c. 1953 (pl. 20)
Iron and brass wire; 78 × 19 ½ × 19 ½ in.
Private collection, Richmond, CA

Untitled (S.573), c. 1953 (pl. 21)
Iron and enameled copper wire; 63 ½ × 20 × 20 in.
Collection of Deborah and Andy Rappaport, San Francisco

Untitled (S.550), late 1950s (pl. 22)
Steel and brass wire; 81 × 11 ½ × 11 ½ in.
Private collection, Albany, CA

Untitled (S.157), c. 1958 (pl. 23)
Copper wire; 41 × 19 × 19 in.
Private collection, San Francisco

Untitled (S.065), 1962 (pl. 24)
Copper and brass wire; 94 × 17 ½ × 17 ½ in.
Private collection, San Francisco

Untitled (S.266), c. 1965 (pl. 25)
Copper and brass wire; 111 × 22 ½ × 22 ½ in.
Collection of Snyder Family Living Trust, Santa Barbara

Gordon R. Ashby
United States, born 1934
Works from the University of California, Berkeley Art Museum and Pacific Film Archive, Gifts of the artist
2015.18.1–3

Transformer, 1969 (pl. 26)
Sepia print; 27 ½ × 27 ⅞ in.

The Transformer No. 2, 1970 (pl. 27)
Blueprint; 27 ½ × 27 ½ in.

Untitled, 1971 (pl. 28)
Ink on vellum; 19 ¼ × 15 ½ in.

George Copeland Ault
United States, 1891–1948

August Night at Russell's Corners, 1948 (pl. 29)
Oil on canvas; 18 × 24 in.
Joslyn Art Museum, Omaha, Museum purchase
1955.189

Bruce Baillie

United States, born 1931

All My Life, 1966 (pl. 30)
16mm transferred to DVD; color, sound; 3 mins
University of California, Berkeley Art Museum
and Pacific Film Archive *0230-01-16591*

Wilson Bentley

United States, 1865–1931
Untitled (Snowflakes), c. 1920
Gelatin silver prints
Santa Barbara Museum of Art, Museum purchase
with funds provided by JGS, Inc. *2008.16.1–20*

Untitled (Snowflake #2), 2 ⅝ × 2 ⅞ in. (pl. 31)

Untitled (Snowflake #5), 2 ¼ × 2 ⅝ in. (pl. 32)

Untitled (Snowflake #6), 2 ½ × 2 ⅞ in. (pl. 33)

Untitled (Snowflake #7), 2 ⅜ × 2 ¾ in. (pl. 34)

Untitled (Snowflake #10), 2 ⅝ × 2 ¾ in. (pl. 35)

Untitled (Snowflake #11), 2 ¼ × 2 ½ in. (pl. 36)

Untitled (Snowflake #12), 2 ⅞ × 2 ⅝ in. (pl. 37)

Untitled (Snowflake #13), 2 ⅞ × 2 ⅜ in. (pl. 38)

Untitled (Snowflake #15), 2 ½ × 3 in. (pl. 39)

Untitled (Snowflake #18), 2 ¾ × 3 in. (pl. 40)

Untitled (Snowflake #20), 2 ½ × 2 ¾ in. (pl. 41)

Untitled (Snowflake #22), 3 × 2 ⅞ in. (pl. 42)

Untitled (Snowflake #3), 2 ¾ × 3 in.

Untitled (Snowflake #8), 2 ⅛ × 1 ⅞ in.

Untitled (Snowflake #9), 3 × 2 ⅝ in.

Untitled (Snowflake #14), 3 × 2 ⅞ in.

Untitled (Snowflake #16), 2 ¾ × 2 ½ in.

Untitled (Snowflake #17), 2 ½ × 2 ¾ in.

Untitled (Snowflake #19), 2 ¾ × 3 in.

Untitled (Snowflake #21), 2 ½ × 2 ⅞ in.

James Wallace Black

United States, 1825–1896

Boston, as the Eagle and the Wild Goose See It,
1860 (pl. 43)
Albumen silver print; 7 ⁵⁄₁₆ × 6 ⁹⁄₁₆ in.
The Metropolitan Museum of Art, Gilman Collection,
Purchase, Ann Tenenbaum and Thomas H. Lee Gift, 2005
2005.100.87

Karl Blossfeldt

Germany, 1865–1932
Works from the Minneapolis Institute of Arts,
Gift of Elaine Dines Cox and Kris Cox
98.265.21; 98.265.15; 98.265.16A–C; 98.265.20; 98.265.18A,B; 98.265.11

Achillea filipendulina (Yarrow), c. 1928 (pl. 44)
Photogravure; 12 ⁵⁄₁₆ × 9 ⁹⁄₁₆ in.

Tremastelma palaestinum
(seed from a scabious), c. 1928 (pl. 45)
Photogravure; 12 ⁵⁄₁₆ × 9 ⅝ in.

Equisetum hyemale (Rough Horsetail),
Equisetum telmateia (Great Horsetail),
Equisetum hyemale (Rough Horsetail), c. 1928 (pl. 46)
Photogravure; 12 ⁵⁄₁₆ × 9 ⅝ in.

Maple Tree, c. 1928 (pl. 47)
Photogravure; 12 ⁵⁄₁₆ × 9 ⁹⁄₁₆ in.

Sanguisorba canadensis (Canadian Burnet),
Vincentoxicum fuscatum (Mosquito Trap),
c. 1928 (pl. 48)
Photogravure; 12 ⁵⁄₁₆ × 9 ⅜ in.

Saxifraga willkommiana (Willkomm's Sacifrage),
c. 1928 (pl. 49)
Photogravure; 12 ⁵⁄₁₆ × 9 ⅜ in.

Lee Bontecou

United States, born 1931

Untitled, 1961 (pl. 50)
Graphite on paper; 27 ¼ × 39 in.
The Menil Collection, Houston
1978-035 E

Untitled, 1969 (pl. 52)
White charcoal on paper; 18 × 24 in.
Collection of Halley K. Harrisburg and
Michael Rosenfeld Gallery, New York

Untitled, 1987 (pl. 51)
Printer's ink on prepared plastic paper; 11 ½ × 10 ⅜ in.
Private collection, New York

Untitled, 1998 (pl. 53)
Graphite and colored pencil on black paper; 24 × 18 in.
Collection of Halley K. Harrisburg and Michael Rosenfeld
Gallery, New York

Louise Bourgeois

United States, born France, 1911–2010

Fée Couturière, 1963 (pl. 54)
Painted bronze; 39 ½ × 22 ½ × 22 ½ in.
Courtesy of Cheim & Read, Los Angeles, and
Hauser & Wirth, New York

The Quartered One, 1964–65 (pl. 55)
Bronze, black patina; 62 ¼ × 24 × 20 in.
Courtesy of Cheim & Read, Los Angeles, and
Hauser & Wirth, New York

Untitled, 1988 (pl. 56)
Watercolor and pencil on paper; 11 ¾ × 9 in.
University of California, Berkeley Art Museum and
Pacific Film Archive, Gift of the artist and Jerry Gorovoy
1993.62

Giovanni Battista Bracelli

Italy, c. 1600–1650

Untitled, from the series *Bizzarie di varie figure*, 1624
(pls. 57–59)
Etchings on paper; 3 ¼ × 4 ¼ in. ea.
National Gallery of Art, Washington, DC,
Rosenwald Collection *1961.17.25, 1961.17.29, 1961.17.35*

Gustave Caillebotte
France, 1848–1894

Le Pont de l'Europe, 1876 (pl. 60)
Oil on canvas; 49 × 71 in.
Association des Amis du Petit Palais, Geneva

Santiago Ramón y Cajal
Spain, 1852–1934
Works from the Cajal Legacy, Instituto Cajal (csic), Madrid

Purkinje cell of the human cerebellum, 1899 (pl. 61)
India ink on paper; 6 3/32 × 4 3/16 in.

Pyramidal cell of the human motor cortex, 1899
(pl. 62)
India ink on paper; 8 3/4 × 7 in.

Olfactory cortex, 1901 (pl. 63)
India ink on paper; 8 × 6 5/16 in.

Microglia in the grey matter of the cerebral cortex,
1920 (pl. 64)
Chinese ink and graphite on paper; 9 5/16 × 6 5/32 in.

Luca Cambiaso
Italy, 1527–1585

Study for the Return of Ulysses, c. 1565 (pl. 65)
Ink and wash with chalk on laid paper; 7 3/4 × 13 9/16 in.
Princeton University Art Museum, Laura P. Hall
Memorial Collection *1946-155*

Christ Nailed to the Cross, early 1580s (pl. 66)
Ink and wash on antique laid paper; 8 1/4 × 11 5/8 in.
Blanton Museum of Art, The University of Texas at Austin,
The Suida-Manning Collection, 1999 *85.1999*

James Castle
United States, 1899–1977
Works from the University of California, Berkeley Art Museum
and Pacific Film Archive, Purchase: Bequest of Phoebe
Apperson Hearst, by exchange *2010.4.1-3*

Untitled, n.d. (pl. 67)
Soot on envelope and cardboard; 8 1/2 × 9 1/2 in.

Untitled, n.d. (pl. 68)
Soot on envelope and cardboard; 8 1/4 × 9 1/2 in.

Untitled, n.d. (pl. 69)
Soot on envelope and cardboard; 8 1/4 × 9 in.

Diller Scofidio + Renfro

Hand holding a model for BAMPFA, 2012 (pl. 70)
Inkjet print; 30 × 40 in.
Courtesy of Diller Scofidio + Renfro, New York

Dogon, Mali

Ritual altar ladder, late 19th–early 20th century
(pl. 71)
Wood; 29 × 12 × 2 in.
Collection of Cathryn M. Cootner, Sonoma, CA

Marcel Duchamp
France, 1887–1968

Boîte, 1966 (pl. 72)
Leather, linen, miniature replicas, photographs, color
reproductions; 16 1/4 × 15 1/8 × 3 3/4 in.
University of California, Berkeley Art Museum and Pacific
Film Archive, Purchase: Bequest of Thérèse Bonney,
Class of 1916, by exchange *1993.27*

León Ferrari
Argentina, 1920–2013

Planta, 1980/2008 (pl. 73)
Heliograph; 37 3/4 × 37 3/4 in.
University of California, Berkeley Art Museum and
Pacific Film Archive, Purchase made possible by
a gift from an anonymous donor *2015.4*

León Ferrari and Gabriel Rud
Argentina, 1920–2013; Argentina, born 1976

Planta, 2005 (pl. 74)
Single-channel video; black and white, sound; 5:28 mins;
music by Ezequiel Finger
Courtesy of Gabriel Rud and Fundación Augusto y León
Ferrari, Buenos Aires

Suzan Frecon
United States, born 1941

untitled, n.d. (pl. 75)
Watercolor on agate burnished Indian ledger paper;
5 1/2 × 25 1/2 in.
University of California, Berkeley Art Museum and Pacific
Film Archive, Purchase made in memory of Sabine LeBlanc
by her many friends *1998.32*

plan for a place (multiple red structural study), 1991
(pl. 76)
Watercolor on paper; 9 3/8 × 13 in.
University of California, Berkeley Art Museum and Pacific
Film Archive, Gift of the Peter Norton Family *1994.20.4*

long strokes, 1994 (pl. 77)
Watercolor on paper; 12 × 18 in.
University of California, Berkeley Art Museum and Pacific
Film Archive, Gift of the Peter Norton Family *1994.20.2*

untitled, 1994 (pl. 78)
Watercolor on paper; 11 5/8 × 15 1/2 in.
University of California, Berkeley Art Museum and Pacific
Film Archive, Gift of the Peter Norton Family *1994.20.6*

untitled, 1995 (pl. 79)
Watercolor on paper; 11 3/4 × 8 1/4 in.
University of California, Berkeley Art Museum and Pacific
Film Archive, Gift of the artist *1995.38*

vertical red earths, 2002 (pl. 80)
Oil on canvas; 87 1/2 × 54 1/8 in.
University of California, Berkeley Art Museum and Pacific
Film Archive, Purchase: Bequest of Phoebe Apperson
Hearst, by exchange, in honor of Lucille M. Paris *2010.7*

Buckminster Fuller
United States, 1895–1983

4D Tower: Time Interval 1 Meter, 1928 (pl. 81)
Gouache and graphite over positive Photostat on paper;
14 × 10 ⅞ in.
Avery Architectural and Fine Arts Library, Columbia
University, New York

**Proposal: A Geodesic Hangar, Plan Projection,
Geodesic Dome, Styrofoam or Tubular Aluminum,**
1951 (pl. 82)
Graphite on tracing paper; 40 ¼ × 24 ⅛ in.
Department of Special Collections, Stanford University
Libraries

**Proposal: A Geodesic Hangar, Plan Projection,
Geodesic Dome, Diamonds of Fiberglass Laminate,**
1951 (pl. 83)
Graphite on tracing paper; 39 ⅜ × 23 ⅞ in.
Department of Special Collections, Stanford University
Libraries

Gandhara, Pakistan
Works on long-term loan from a private collection to
the University of California, Berkeley Art Museum and
Pacific Film Archive

Teaching Buddha, 2nd–3rd century (pl. 84)
Gray schist with traces of gilding and red pigment;
20 ⅛ in. high

The Great Departure, 2nd–3rd century (pl. 85)
Gray schist; 18 ¼ in. high

Laeh Glenn
United States, born 1979

Untitled, 2013 (pl. 86)
Oil on panel with wood; 16 ¾ × 12 ¾ in.
University of California, Berkeley Art Museum and Pacific
Film Archive, Purchase made possible by a gift from
Barbara N. and William G. Hyland, Monterey, CA *2014.7*

Brent Green
United States, born 1978

Gravity Was Everywhere Back Then, 2010 (pl. 87)
16mm and digital photographs transferred to digital video;
color, sound; 75 mins
Courtesy of the artist and Andrew Edlin Gallery, New York

Ernst Haeckel
Germany, 1834–1919

Radiolarians
Graphite and ink on paper; 11 × 8 ½ in. each
Ernst Haeckel Haus, Jena, Germany

Thalassicolla nucleata, 1859 (pl. 88)

Thalassicolla nucleata, 1859 (pl. 89)

Stylodictya (Stylocyolia) arachnia, 1860 (pl. 90)

Heliosphaera tennussima, 1860 (pl. 91)

Haliommatidium fenestratum, c. 1860 (pl. 92)

Rhaphidococcus acufer, 1860 (pl. 93)

Thalassicolla (Thalassoplancta) cavispicula, 1860
(fig. 13)

Ganesh Haloi
India, born 1936

Untitled, 1997 (pl. 94)
Gouache on paper; 10 ½ × 13 ¾ in.
Collection of Neerja and Mukund Lath, Jaipur, India

Untitled, 1998 (pl. 97)
Gouache on paper; 10 ½ × 13 ¾ in.
Collection of Neerja and Mukund Lath, Jaipur, India

Untitled, 1998 (pl. 98)
Gouache on paper; 10 ¼ × 14 ¼ in.
Collection of Neerja and Mukund Lath, Jaipur, India

Untitled, 1999 (pl. 95)
Watercolor on paper; 10 ½ × 14 ¼ in.
Collection of Neerja and Mukund Lath, Jaipur, India

Untitled, 1999 (pl. 99)
Watercolor on paper; 11 ½ × 16 ¼ in.
Collection of Neerja and Mukund Lath, Jaipur, India

Untitled, 1999 (pl. 100)
Watercolor on paper; 11 ¼ × 15 ¾ in.
University of California, Berkeley Art Museum and
Pacific Film Archive, Gift of Must Art Private Ltd. *2015.16.1*

Untitled, 2004 (pl. 96)
Watercolor on paper; 10 ¼ × 14 ¼ in.
University of California, Berkeley Art Museum and Pacific
Film Archive, Gift of Must Art Private Ltd. *2015.16.2*

Trenton Doyle Hancock
United States, born 1974

Rememor with Membry, 2001 (pl. 101)
Acrylic on collaged canvas; 59 ⅞ × 72 ¼ in.
Whitney Museum of American Art, New York,
Purchase, with funds from the Contemporary
Painting and Sculpture Committee *2001.229*

Toyo Ito, Kumiko Inui, Sou Fujimoto, Akihisa Hirata
Japan, born Korea 1941; Japan, born 1969; Japan, born 1971;
Japan, born 1971
"Home-for-All" in Rikuzentakata, 2012

1:10 scale model, 2012 (pl. 102)
Wood, styrene board, styrol, plastic board;
40 ½ × 43 ½ × 43 ⅛ in.
Collection of "Home-for-All," Rikuzentakata, Japan

Sou Fujimoto

Study model, December 22, 2011 (pl. 103)
Wood, styrene board, flowers, styrol; 9 ½ × 13 × 9 ½ in.
Collection of Sou Fujimoto Architects, Tokyo

Study model, January 28, 2012 (pl. 105)
Wood, styrene board, plastic; 17 ¾ × 1/ ¾ × 1/ ¾ in.
Collection of Sou Fujimoto Architects, Tokyo

Akihisa Hirata

Study model, December 27, 2011 (pl. 104)
Wood, styrene board, styrol; 6 ¼ × 11 × 8 ½ in.
Collection of Akihisa Hirata Architecture Office, Tokyo

Study model, February 10, 2012 (pl. 106)
Wood, styrene board, plastic; 17 ¾ × 15 ⁷⁄₁₆ × 14 ¼ in.
Collection of Akihisa Hirata Architecture Office, Tokyo

Johannes Itten
Switzerland, 1888–1967

Encounter, 1916 (pl. 107)
Oil on canvas; 41 $\frac{5}{16}$ × 31 $\frac{1}{2}$ in.
Kunsthaus Zürich, Switzerland

Willy Jaeckel
Germany, 1888–1944

The Tower of Babel, 1920 (pl. 108)
Etching on heavy wove paper; 17 $\frac{15}{16}$ × 13 $\frac{7}{8}$ in.
Los Angeles County Museum of Art, The Robert Gore
Rifkind Center for German Expressionist Studies,
purchased with funds provided by the Ducommun and
Gross Acquisition Fund, and the Twentieth Century Art
Acquisition Fund *AC1992.238.50.4*

Chris Johanson
United States, born 1968

Cityscape with House & Gray Energy, 2003 (pl. 109)
Acrylic on wood; 99 × 97 in., 17 × 17 in., 17 × 17 in.
University of California, Berkeley Art Museum and
Pacific Film Archive, Gift of Ann Hatch *2015.19*

Stephen Kaltenbach
United States, born 1940

Portrait of My Father, 1972–79 (pl. 110)
Acrylic on canvas; 114 × 170 $\frac{3}{4}$ in.
Crocker Art Museum, Purchase made with contributions
from Gerald D. Gordon, Collectors' Guild, Anne and
Malcolm McHenry, Kim Mueller and Robert J. Slobe,
James R. Lenarz, and other donations *2001.85*

Khmer, Cambodia

Stupa, 13th century (pl. 111)
Bronze; 22 in. high
On long-term loan from a private collection to the
University of California, Berkeley Art Museum and
Pacific Film Archive

Frederick Kiesler
Austria/United States, born Ukraine, 1890–1965

Study for Endless House, "Paris Endless," 1947 (pl. 112)
India ink and gouache on watercolor paper; 12 × 18 in.
Austrian Frederick and Lillian Kiesler Private Foundation,
Vienna *SFP 497/0*

Study for Endless House, "Paris Endless," 1947 (pl. 113)
India ink and gouache on watercolor paper; 12 × 18 in.
Austrian Frederick and Lillian Kiesler Private Foundation,
Vienna *SFP 503/0*

Study for Tooth House, 1948 (pl. 114)
Pen on paper; 8 $\frac{1}{2}$ × 11 in.
Austrian Frederick and Lillian Kiesler Private Foundation,
Vienna *SFP 533/0*

Study for Endless House, 1951–52 (pl. 115)
Pen on paper; 8 $\frac{1}{2}$ × 11 in.
Austrian Frederick and Lillian Kiesler Private Foundation,
Vienna *SFP 586/0*

Study for Endless House, 1959 (pl. 116)
Pen on paper; 8 $\frac{1}{4}$ × 11 $\frac{3}{4}$ in.
Austrian Frederick and Lillian Kiesler Private Foundation,
Vienna *SFP 3650/0*

Model of Endless House, 1959 (pl. 117)
Cement and wire mesh; 27 $\frac{1}{2}$ × 25 $\frac{1}{2}$ × 51 in.
Collection of Gertraud and Dieter Bogner, Vienna

Kimsooja
United States, born Korea 1957

Thread Routes—Chapter II, 2011 (pl. 118)
16mm film transferred to HD; color, sound; 23:40 mins
Courtesy of Kukje Gallery, Seoul, and Kimsooja Studio,
New York

Paul Kos and Marlene Kos
United States, born 1942; United States, born 1942

Lightning, 1976 (pl. 119)
½" reel-to-reel transferred to ¾" U-matic transferred
to DVD; black and white, sound; 1 min
University of California, Berkeley Art Museum and
Pacific Film Archive *0230-01-16592*

Lace
Works from Lacis Museum of Lace and Textiles, Berkeley
JJH 14869, JVC 12377, JAC 12505, JKC 14565, JAB 13271, JAE 13037

Bestiary or Dream of Nebuchadnezzar
Veneto, Italy, early 16th century (pl. 120)
Linen; 67 $\frac{1}{2}$ × 53 in.

Coraline fragment
Veneto, Italy, 16th century (pl. 121)
Linen; 9 × 9 in.

Venetian Rose Point bertha
Veneto, Italy, 17th century (pl. 122)
Linen; 8 $\frac{3}{4}$ × 48 in.

Point Plat de Venise fragment
Veneto, Italy, 17th century (pl. 123)
Linen; 7 × 7 $\frac{1}{4}$ in.

Brussels lappet
Brussels, Belgium, 18th century (pl. 124)
Linen; 3 $\frac{1}{2}$ × 49 in.

Orvieto crochet
Umbria, Italy, 19th century (pl. 125)
Cotton; 6 × 13 in.

Fernand Léger
France, 1881–1955

Study for *Nude Model in the Studio*, 1912 (pl. 126)
Ink, oil, and charcoal on paper; 25 × 18 $\frac{1}{2}$ in.
University of California, Berkeley Art Museum and
Pacific Film Archive, Bequest of Marcia Simon Weisman
Foundation *1995.51.7*

Otto Lehmann

German, 1855–1922
Works from Karlsruhe Institute of Technology, KIT Archives,
Germany *27059 31-2, 27059 31-1, 27059 31-3, 27059 11-1, 2*

Microscopic view of liquid crystals, c. 1888–89
(pl. 127)
Pencil on paper; 8 ¼ × 6 ½ × in.

Microscopic view of liquid crystals, c. 1888–89
(pl. 128)
Pencil and colored pencil on paper; 8 ¼ × 6 ½ × in.

Microscopic view of liquid crystals, c. 1888–89
(pl. 129)
Ink, pencil, and colored pencil on paper; 8 ¼ × 6 ½ in.

Microscopic view of liquid crystals, c. 1907 (pl. 130)
Photomechanical prints; 16 ¾ × 9 ¼ in.,
16 ¾ × 8 ½ in.

Ed Loftus

United States, born United Kingdom 1973

Untitled, 2011 (pl. 131)
Graphite on paper; 7 ¾ × 5 ¾ in.
University of California, Berkeley Art Museum and
Pacific Film Archive, Purchase made possible by
Jan Boyce Fund for Contemporary Art *2012.6*

Mark Manders

The Netherlands, born 1968

Obtrusive Head, 2010 (pl. 132)
Wood, painted epoxy, painted canvas, iron;
31 × 11 ½ × 13 ¾ in.
Collection of Dean Valentine and Amy Adelson, Los Angeles

Girl Study, 2013 (pl. 133)
Wood, painted epoxy, painted wig, offset print on paper,
belt; 19 ¹⁄₁₆ × 6 ⅝ × 11 in.
Courtesy of the artist and Tanya Bonakdar Gallery, New York

Gordon Matta-Clark

United States, 1943–1978

Window Blow-Out, 1976 (pl. 134)
Eight gelatin silver prints; 30 ¼ × 66 ¾ in.
Courtesy of The Estate of Gordon Matta-Clark and
David Zwirner, New York/London

Mbuti, Congo

Barkcloth drawing, 1970s (pl. 135)
Charcoal, fruit juice ink, and mud on barkcloth; 33 × 15 in.
University of California, Berkeley Art Museum and Pacific
Film Archive, Gift of the Andres Moraga Gallery *1995.44.4*

Barkcloth drawing, 1970s (pl. 137)
Charcoal, fruit juice ink, and mud on barkcloth; 17 ½ × 31 in.
University of California, Berkeley Art Museum and
Pacific Film Archive, Gift of Penny Cooper and Rena
Rosenwasser *2000.49.5*

Barkcloth drawing, 1970s (pl. 138)
Charcoal, fruit juice ink, and mud on barkcloth; 33 × 14 in.
University of California, Berkeley Art Museum and
Pacific Film Archive, Gift of Penny Cooper and Rena
Rosenwasser *2000.49.6*

Barkcloth drawing, 1970s (pl. 139)
Charcoal, fruit juice ink, and mud on barkcloth; 15 × 34 in.
University of California, Berkeley Art Museum and Pacific
Film Archive, Gift of the Andres Moraga Gallery *1995.44.1*

Barkcloth drawing, c. 1975–2000 (pl. 136)
Charcoal, fruit juice ink, and mud on barkcloth; 20 × 35 in.
University of California, Berkeley Art Museum and Pacific
Film Archive, Gift of Cathryn M. Cootner *2013.71.2*

Barkcloth drawing, c. 1975–2000 (pl. 140)
Charcoal, fruit juice ink, and mud on barkcloth;
27 ½ × 23 ¾ in.
University of California, Berkeley Art Museum and Pacific
Film Archive, Gift of Cathryn M. Cootner *2014.70.7*

Julie Mehretu

United States, born Ethiopia 1970

Unclosed, 2007 (pl. 141)
Color hard ground etching with spit bite aquatint and
drypoint; 40 ¾ × 50 ¼ in.
Published by Crown Point Press, edition 5/25
University of California, Berkeley Art Museum and
Pacific Film Archive, Gift of Richard M. Buxbaum *2014.33*

Micronesia (Marshall Islands)

Works from Phoebe A. Hearst Museum of Anthropology,
University of California, Berkeley *11-42978, 11-43985*

Navigational chart, n.d. (pl. 142)
Bamboo, coral; 28 ½ × 33 in.

Navigational chart, n.d. (pl. 143)
Wood, sennit fiber, cowrie shells; 25 ¼ × 43 in.

Ludwig Mies van der Rohe

United States, born Germany, 1886–1969

**German Pavilion, International Exposition, Barcelona,
Spain, Interior Perspective,** c. 1928–29 (pl. 144)
Graphite on illustration board; 39 × 51 ¼ in.
The Museum of Modern Art, New York, Mies van der Rohe
Archive, Gift of the architect *MR14.1*

Jay Nelson

United States, born 1980

The Goodbye Ranch, 2007–9 (pl. 145)
Graphite on paper, diptych; 60 × 88 in.
University of California, Berkeley Art Museum and Pacific
Film Archive, Purchase made possible by the Acquisitions
Committee Fund *2011.10.2*

Yuji Obata

Japan, born 1962
Works from the collection of Nion McEvoy and Leslie
Berriman, San Francisco

Homage to Wilson A. Bentley No. 1, 2005–6 (pl. 147)
Pigment print, edition 2/5; 34 × 23 in.

Homage to Wilson A. Bentley No. 12, 2005–6 (pl. 146)
Pigment print, edition 1/5; 34 × 23 in.

George Ohr
United States, 1857–1918
Clay vessels, c. 1903–7
Private collection, New York

Red clay bisque vase (pl. 148)
Clay; 4 1/8 × 5 5/8 × 4 5/8 in.

Tan clay bisque pitcher (pl. 149)
Clay; 3 3/4 × 6 1/2 × 5 1/8 in.

Bisque pitcher with terra-cotta slip streaks (pl. 150)
Clay; 4 1/2 × 5 5/8 × 5 5/16 in.

Bisque vase with terra-cotta slip streaks (pl. 151)
Clay; 4 3/4 × 5 1/4 × 5 1/4 in.

Tan clay bisque pitcher with cutout handle (pl. 152)
Clay; 4 1/2 × 5 × 5 1/4 in.

Tan clay bisque pitcher (pl. 153)
Clay; 3 3/4 × 6 1/2 × 5 1/2 in.

Georgia O'Keeffe
United States, 1887–1986

Wall with Green Door, 1953 (pl. 154)
Oil on canvas; 30 × 48 in.
National Gallery of Art, Washington, DC *CGA.1977.8*

Robert Overby
United States, 1935–1993

Broken Window Maps, 1972 (pl. 155)
Eighteen canvas panels, sewing pins;
2 panels 9 × 8 in., 2 panels 13 1/2 × 8 1/2 in.,
2 panels 12 × 9 in., 12 panels 10 1/2 × 7 3/4 in.
Courtesy of The Estate of Robert Overby

Bernard Palissy
France, 1510–1589

Plate decorated with rustic figures, 1550–1600
(pl. 156)
Earthenware, glaze, polychrome enamel;
2 3/4 × 19 1/2 × 14 3/4 in.
Musée des Beaux-Arts de la Ville de Paris, Petit Palais
PP-ODUT01129

Nipam Patel
United States, born India 1962

Radiolarian confocals 1x–10x, 2015 (pl. 157)
Confocal microscope imaging
Courtesy of Nipam Patel

Giovanni Battista Piazzetta
Italy, 1682–1754

**Six Studies of Hands, with a Pair Held
Before a Boy's Face,** 18th century (pl. 158)
Chalk on paper; 10 7/8 × 15 in.
The Morgan Library & Museum, New York, Gift of
the Samuel H. Kress Foundation *1961.12:40*

Pomo, Northern California
Works from the Phoebe A. Hearst Museum of Anthropology,
University of California, Berkeley *1-163940, 1-28619, 1-434, 1-70833,*
1-28639, 1-3049, 1-409, 1-53627, 1-233496, 1-3030, 1-53622, 1-24066, 1-70918,
1-27916, 1-28441, 1-53621

Coiled basket miniature, n.d. (pl. 159)
3/16 × 3/16 × 3/16 in.

Twined burden basket, n.d. (pl. 160)
17 × 20 × 20 in.

Coiled storage basket, n.d. (pl. 161)
Willow, sedge, sedge bark; 1 3/4 × 5 × 5 in.

Coiled basket, n.d. (pl. 162)
1 3/16 × 4 5/16 × 4 5/16 in.

Coiled basket with quail crests and feathers, n.d.
(pl. 163)
4 1/2 × 8 1/2 × 8 1/2 in.

Coiled basket with feathers and shell beads, n.d.
(pl. 164)
Willow, sedge, sedge root, feathers, shell beads;
5 1/2 × 11 × 11 in.

Coiled basket with feathers and beads, n.d. (pl. 165)
Willow, sedge, sedge root, redbud, feathers, beads;
6 × 11 × 11 in.

Coiled basket with quail crests, n.d. (pl. 166)
8 × 19 1/2 × 19 1/2 in.

Twined cooking and food storage basket, n.d. (pl. 167)
Sedge root, redbud shoot, willow shoot warp; 7 1/2 × 12 × 12 in.

Twined cooking and food storage basket, n.d. (pl. 168)
Willow, sedge, redbud; 9 × 11 × 11 in.

Coiled doctor's basket, n.d. (pl. 169)
3 3/4 × 10 × 16 in.

Openwork twined food preparation basket, n.d.
(pl. 170)
6 × 18 × 18 in.

Coiled serving basket with beads, n.d. (pl. 171)
4 × 16 × 16 in.

Coiled storage basket, n.d. (pl. 172)
3 × 6 × 6 in.

Coiled storage basket, n.d. (pl. 173)
4 × 7 × 7 in.

Coiled storage basket, n.d. (pl. 174)
3 × 5 1/2 × 5 1/2 in.

Avery Preesman
The Netherlands, born 1968
Works from the University of California,
Berkeley Art Museum and Pacific Film Archive

**Untitled, Last Silver Painting, Hang II
(voor Noorden/for North),** 2006 (pl. 175)
Oil, microwax, and pigment on linen; 98 3/8 × 98 3/8 in.
Gift of the artist in honor of Susanne Ghez *2014.48.5*

Within, S.W.S., 2008–9 (pl. 176)
Sable cement and pigment on wood;
32 5/8 × 56 5/16 × 16 1/2 in.
Purchase made possible by a gift of The Buddy Taub
Foundation, Dennis Roach, Director *2009.17*

Qiu Zhijie
China, born 1969

The World Garden, 2016 (pl. 177)
Ink on wall; 24 × 63 ft.
Commissioned by the University of California,
Berkeley Art Museum and Pacific Film Archive

Rajasthan, India

Untitled (Legend: A Meditation on the
Four Directions), 1998 (pl. 178)
Paint on paper; 12 ¾ × 9 ¾ in. each
Private collection, San Francisco

Untitled (Portrait of Kali, the Goddess,
the "Black One"), 2007 (pl. 179)
Paint on paper; 13 × 10 ⅛ in.
University of California, Berkeley Art Museum and
Pacific Film Archive, Purchase: Bequest of Phoebe
Apperson Hearst, by exchange *2010.17.3*

Untitled (The Goddess, Having Journeyed Through
the Blue of Consciousness, at Her Source, Her Center),
2008 (pl. 180)
Paint on paper; 12 ¾ × 9 ¾ in.
University of California, Berkeley Art Museum and
Pacific Film Archive, Purchase: Bequest of Phoebe
Apperson Hearst, by exchange *2010.17.4*

Ad Reinhardt
United States, 1913–1967

Abstract Painting, 1960–65 (pl. 181)
Oil on canvas; 60 × 60 ¼ in.
University of California, Berkeley Art Museum and
Pacific Film Archive, Gift of the artist *1966.62*

Ben Rivers
United Kingdom, born 1972

Origin of the Species, 2008 (pl. 182)
16mm film (color, sound; 16 mins) and mixed-media
structure; 6 ½ × 8 ¼ × 8 ½ ft.
Courtesy of the artist and Kate MacGarry, London

A. G. Rizzoli
United States, 1896–1981

Mrs. Geo. Powleson Symbolically Portrayed /
The Mother Tower of Jewels, 1935 (pl. 183)
Ink on rag paper; 37 × 25 in.
University of California, Berkeley Art Museum and Pacific
Film Archive, Purchase: Bequest of Phoebe Apperson Hearst,
by exchange, a partial gift of The Ames Gallery *2014.9*

Alfredo Capobianco and Family Symbolically
Sketched / Palazzo del Capobianco, 1937 (pl. 184)
Ink on rag paper; 32 × 45 in.
Courtesy of Bonnie Grossman and The Ames Gallery,
Berkeley

Mother in Metamorphosis Idolized / The Kathredal
(A glimpse of Heaven's intermediate grandeur), 1938
(pl. 185)
Ink on rag paper; 57 × 38 in.
Courtesy of Bonnie Grossman and The Ames Gallery,
Berkeley

Margaret E. Griffin Symbolically Sketched / Palazzo
Pianissimo, 1939 (pl. 186)
Ink on rag paper; 31 ½ × 43 ¼ in.
Courtesy of Bonnie Grossman and The Ames Gallery,
Berkeley

John Robson (Gyaawhllns)
Canada, 1846–1924

Model crest pole, 1875 (pl. 187)
Wood; 30 ¼ × 4 ½ × 6 in.
Phoebe A. Hearst Museum of Anthropology, University of
California, Berkeley, Collected by Annie Moller, 1934 *2-14267*

Till Roeskens
France, born Germany 1974

Videomappings: Aida, Palestine, 2009 (pl. 188)
DVD; sound, color; 46 mins
Courtesy of the artist

Dieter Roth
Switzerland, born Germany, 1930–1998

At Home, 1970 (pl. 189)
Screenprint on gray cardboard; 25 ½ × 36 ¼ in.
University of California, Berkeley Art Museum and
Pacific Film Archive, Gift of Steven Leiber *1991.4*

Fred Sandback
United States, 1943–2003

Untitled, 1989 (pl. 190)
Acrylic yarn; dimensions variable
Estate of Fred Sandback, Courtesy of David Zwirner,
New York/London

Tomás Saraceno
Germany, born Argentina 1973
Works courtesy of the artist and Tanya Bonakdar Gallery,
New York

Hybrid solitary semi-social musical instrument
Ophiuchus: built by *Parasteatoda lunata*—two
weeks—and a *Cyrtophora citricola*—two weeks,
2015 (pl. 191)
Spider silk, carbon fiber, glass; 9 ⅞ × 6 × 6 in.

Hybrid semi-social musical instrument Arp87: built
by a couple of *Cyrtophora citricola*—one month—one
Agelena labirintica—two months—one *Cyrtophora
moluccensis*—two weeks—and one *Tegenria
domestica*—four months—(turned four times 180
degrees on Z axis), 2015 (pl. 192)
Spider silk, carbon fiber, Plexiglas; 35 ¾ × 35 ⅞ × 35 ⅞ in.

Solitary, semi-social mapping of ESO-510 613
connected with intergalactic dust by one *Nephila
clavipes*—one week— and three *Cyrtophora
citricola*—three weeks, 2015 (pl. 193)
Spider silk, glue, paper, ink; 16 ⅛ × 23 ¼ in.

Semi-social musical instrument Arp77: built by a
single *Cyrtophora moluccensis*—one week, 2015
Spider silk, carbon fiber, glass; 17 ¼ × 21 × 21 in.

Hybrid solitary semi-social musical instrument NGC
660: built by one *Nephila clavipes*—two weeks—
one *Argiope anasuja*—two weeks—and a pair of
Cyrtophora citricola—two weeks, 2015
Spider silk, carbon fiber, glass; 9 ⅜ × 13 × 13 in.

Viktor Schauberger
Austria, 1885–1958
Works from Schauberger Archive, Bad Ischl, Austria

Detail of a water turbine, late 1940s (pl. 194)
Graphite on paper; 8 ¼ × 11 ½ in.

Detail of a water turbine, late 1940s (pl. 195)
Graphite on paper; 8 ¼ × 11 ½ in.

Detail of a bio-plough and a water impeller,
late 1940s (pl. 196)
Graphite on paper; 8 ¼ × 11 ½ in.

Studies for water impellers, late 1940s (pl. 197)
Graphite and colored pencil on paper; 8 ¼ × 11 ½ in.

Studies for a suction turbine, late 1940s (pl. 198)
Graphite and colored pencil on paper; 8 ¼ in × 11 ½ in.

Study of twisted water pipes, c. 1950 (pl. 199)
Copper; 2 ½ × 5 ⅛ × 6 in.

Water impeller, c. 1950 (pl. 200)
Copper; 2 ¼ × 3 ½ × 4 in.

Jesse Schlesinger
United States, born 1979

Construct III (to forget the name), 2009 (pl. 201)
Graphite on paper; 25 ¼ × 20 ¼ in.
Private collection, Berkeley

Felix Schramm
Germany, born 1970

Untitled, 2008 (pl. 202)
Wood, plaster, drywall, paint; 78 ¾ × 69 × 76 ¾ in.
University of California, Berkeley Art Museum and Pacific
Film Archive, Gift of Robin Wright and Ian Reeves *2014.2*

June Schwarcz
United States, 1918–2015
Works on long-term loan from the estate of the artist to
the University of California, Berkeley Art Museum and
Pacific Film Archive

2485, 2009 (pl. 203)
Copper, enamel; 9 × 5 × 4 in.

2425, 2011 (pl. 204)
Copper, enamel; 7 ¼ × 8 × 6 in.

2492, 2013 (pl. 205)
Copper, enamel; 9 ½ × 4 ½ × 4 ½ in.

2493, 2013 (pl. 206)
Copper, enamel; 10 ¼ × 6 ¼ × 4 in.

Harry Smith
United States, 1923–1991

String figures, c. 1970 (pl. 207)
String on board; 7 ¾ × 20 in. each
Collection of John Cohen, New York

Hyun-Sook Song
Germany, born Korea 1952

21 Brushstrokes, 2007 (pl. 209)
Egg tempera on canvas; 63 × 94 ½ in.
Courtesy of the artist

4 Brushstrokes over Figure, 2012 (pl. 208)
Egg tempera on canvas; 66 ½ × 51 in.
University of California, Berkeley Art Museum and
Pacific Film Archive, Gift of Jochen Hiltmann *2015.7*

2 Brushstrokes, 2013 (pl. 210)
Egg tempera on canvas; 59 × 94 ½ in.
Courtesy of the artist

Hedda Sterne
United States, born Romania, 1910–2011

Untitled (November 14, 2001), 2001 (pl. 211)
Graphite and oil pastel on paper; 12 ³⁄₁₆ × 10 ¹⁄₁₆ in.
Whitney Museum of American Art, New York,
Purchase, with funds from the Contemporary
Painting and Sculpture Committee *2003.203*

Untitled (March 21, 2002), 2002 (pl. 212)
Graphite and oil pastel on paper; 12 ¼ × 9 ¹⁄₁₆ in.
Whitney Museum of American Art, New York,
Gift of the artist *2003.119*

Untitled (July 22, 2002), 2002 (pl. 213)
Graphite and oil pastel on paper; 13 ³⁄₁₆ × 9 ¹⁄₁₆ in.
Whitney Museum of American Art, New York,
Purchase, with funds from the Contemporary
Painting and Sculpture Committee *2003.202*

Untitled (August 15, 2002), 2002 (pl. 214)
Graphite and oil pastel on paper; 12 ¼ × 9 ⅛ in.
Whitney Museum of American Art, New York,
Gift of the artist *2003.121*

Untitled (August 12, 2002), 2002 (pl. 215)
Graphite and oil pastel on paper; 12 ¼ × 9 ¹⁄₁₆ in.
Whitney Museum of American Art, New York,
Gift of the artist *2003.120*

Bob Stocksdale
United States, 1913–2003

Oval bowl, mid-20th century (pl. 216)
Brazilian rosewood; 3 ½ × 8 ⅛ × 8 ¾ in.
Oakland Museum of California, The Oakland
Museum's Yvonne Greer Thiel Collection *A63.16*

Bowl, mid- to late 20th century (pl. 217)
Black acacia wood; 4 ¼ × 7 × 6 ½ in.
Oakland Museum of California,
Gift of Norman H. Anderson *A91.73.1*

Bowl, 1983 (pl. 218)
Macadamia wood; 3 ¾ × 3 ¾ × 4 ¼ in.
Oakland Museum of California,
Gift of Norman H. Anderson *A91.73.16*

Do Ho Suh
Korea, born 1962

Staircase, 2013 (pl. 219)
Thread embedded in cotton paper;
17 ½ × 15 × 1 ½ in.
Collection of Jacqueline Miller Stewart, Dallas

Al Taylor

United States, 1948–1999
Works courtesy of the Estate of Al Taylor and David Zwirner,
New York/London

Untitled, 1985 (pl. 220)
Wood and enamel mounted on plywood; 30 × 26 × 28 in.

Untitled (Latin Studies), 1985 (pl. 221)
Plywood with acrylic and wooden broomsticks with enamel
mounted on Formica laminate; 25 × 17 ½ × 15 ½ in.

Untitled (Latin Study), 1985 (pl. 222)
Wood, lacquer, and enamel mounted on particleboard;
24 ¼ × 22 ¼ × 14 ¾ in.

Pavel Tchelitchew

United States, born Russia, 1898–1957

Tree into Double-Hand (Study for "Hide and Seek"),
1939 (pl. 223)
Pen and brown ink over graphite on wove paper;
12 ¾ × 10 ¼ in.
The National Gallery of Art, Washington, DC,
Joseph F. McCrindle Collection *2009.70.233*

Interior Landscape, *c.* 1947 (pl. 224)
Oil on canvas; 46 ⅛ × 22 in.
Courtesy of Michael Rosenfeld Gallery, New York

Tibet

Scenes from the Life of Buddha Shakyamuni,
12th century (pl. 236)
Opaque pigments and gold on textile; 30 ⅛ × 23 in.
On long-term loan from a private collection to
the University of California, Berkeley Art Museum and
Pacific Film Archive

Hevajra Mandala, 14th century (pl. 233)
Opaque pigments and gold on textile; 21 ¾ × 18 in.
On long-term loan from a private collection to
the University of California, Berkeley Art Museum and
Pacific Film Archive

Seated Buddha, 14th century (pl. 235)
Gilt bronze; 56 in. high
On long-term loan from a private collection to
the University of California, Berkeley Art Museum and
Pacific Film Archive

Four Mandalas of Hevajra, 16th century (pl. 234)
Opaque pigments and gold on textile; 20 × 18 in.
On long-term loan from a private collection to
the University of California, Berkeley Art Museum and
Pacific Film Archive

Mandalas from the Theos Bernard Collection,
19th–20th century
Ink on cotton; 15 × 15 in. each
University of California, Berkeley Art Museum and
Pacific Film Archive, Bequest of G. Eleanore Murray
2004.20.17, 19, 22–28, 30, 33, 35–36, 39–41

Mandala of Buddhakapala (pl. 225)

Mandala of Krsnari (pl. 226)

Mandala of Nila Varahi (pl. 227)

Mandala of Trikayavajra (pl. 228)

Mandala of Jnana Dakini (pl. 229)

Mandala of the Cakravartin of the Six Realms
(pl. 230)

Mandala of Vajra Humkara (pl. 231)

Mandala of Mahamaya (pl. 232)

Mandala of Pita Varahi

Mandala of Shamvara Vajrasattva

Mandala of Two-Armed Shamvara

**Mandala of Shamvara and the
62 Deities of the Secret Elixir**

Mandala of Krodha Humkara

Mandala of Vajravarahi

Mandala of Vajramrita

Mandala of the Gold Shamvara

Rosie Lee Tompkins

United States, 1936–2006

Blue Medallion, 1986 (pl. 237)
Mixed media; quilted by Willia Ette Graham; 85 × 77 in.
Collection of Eli Leon, Oakland

Untitled, 1987 (pl. 238)
Mixed media, 100 ½ × 70 ½ in.
University of California, Berkeley Art Museum and
Pacific Film Archive, Purchase: Bequest of Phoebe
Apperson Hearst, by exchange *2009.18*

Carlo Urbino

Italy, c. 1510/20–after 1585
Selections from the *Codex Huygens* (Urbino codex),
16th century
The Morgan Library & Museum, New York, Purchased 1938
2006.14:6, 2006.14:7, 2006.14:21

"Primi" (fol. 6) (pl. 239)
Ink, chalk, and incised lines on laid paper; 7 ¼ × 5 ⅛ in.

**"Quinta figura et principio di moto et ultima del
primo libro" (fol. 7)** (pl. 240)
Chalk and ink on laid paper; 7 ⁷⁄₁₆ × 5 ¼ in.

"Secondo moto. Prima figura" (fol. 21) (pl. 241)
Ink and chalk on laid paper; 7 ⁷⁄₁₆ × 5 ¼ in.

Muhammad Hafiz Wan Rosli

Malaysia, born 1983

Point Cloud, 2015 (pl. 242)
Software; black and white; indefinite run time
Courtesy of the artist

James Whitney

United States, 1921–1982
Works courtesy of Whitney Editions, Los Angeles

Yantra, 1957 (pl. 243)
16mm transferred to HD; color, sound; 8 mins

Lapis, 1966 (pl. 244)
16mm transferred to HD; color, sound; 9 mins

John Whitney

United States, 1917–1995

Arabesque, 1975 (pl. 245)
16mm transferred to HD; color, sound; 7 mins
Courtesy of Whitney Editions, Los Angeles

Lebbeus Woods

United States, 1940–2012
Works from the Estate of Lebbeus Woods

Sarajevo, 1993 (pl. 246)
Graphite and colored pencil on board;
10 ⅝ × 12 ⅞ in.

SCAR Construction, 1993 (pl. 247)
Graphite and colored pencil on board; 12 × 20 in.

Bosnia Free State: The Wall, or Defense by Absorption, 1993–94 (pl. 248)
Colored pencil and pastel on electrostatic print mounted on Bristol board; 10 × 40 in.

Bosnia Free State: The Wall, or Defense by Absorption, 1993–94 (pl. 249)
Colored pencil and pastel on electrostatic print mounted on Bristol board; 10 × 40 in.

Bosnia Free State: Segment of the Wall, 1993–94 (pl. 250)
Graphite and colored pencil on board; 9 × 13 in.

Bosnia Free State: Segment of the Wall, 1993–94 (pl. 251)
Graphite and colored pencil on board; 9 × 13 in.

Wow! signal (pl. 252)
11:16 p.m. EDST, August 15, 1977
Ink on paper; 12 × 18 in.
Ohio History Connection, Columbus MSS 1151

Iannis Xenakis

Greece/France, born Romania, 1922–2001
Works courtesy of the Xenakis family, Paris

Initial studies of musical rhythm for *Metastasis*, 1953 (pl. 253)
Graphite on graph paper; 8 ¼ × 10 ¾ in.

Diastematic calculations and intervals for *Metastasis*, 1954 (pl. 254)
Ink on graph paper; 11 ¾ × 29 ½ in.

Sketch for west facade of Convent of Sainte Marie de La Tourette, "Pans de verre ondulatoire," 1954 (pl. 255)
Ink on tracing paper; 16 ½ × 23 ¼ in.

Graphic score for *Metastasis*, glissandi of chords, 1954 (pl. 256)
Graphite on graph paper; 8 ½ × 10 ¾ in.

Preparatory studies for the Philips Pavilion, 1956 (pl. 257)
Sketchbook; graphite on paper; 11 ⅞ × 15 ⅓ in.

"Sounds as lightning," sketch describing the acoustic qualities of the Philips Pavilion, 1958 (pl. 258)
Sketchbook; colored pencil on paper; 8 ⅝ × 13 ½ in.

Sketch showing the link between *Metastasis* and the Philips Pavilion, 1958 (pl. 259)
Ink on paper; 25 ½ × 45 ½ in.

Score for *Concret PH*, electronic music composed for the entrance and exit of the Philips Pavilion, 1958 (pl. 260)
Ink on graph tracing paper; 20 × 25 ¼ in. each

Will Yackulic

United States, born 1975

Trait Family A, 2013 (pl. 261)
Stoneware; 4 ⅞ × 3 ½ × 3 in.
University of California, Berkeley Art Museum and Pacific Film Archive, Purchase: Bequest of Phoebe Apperson Hearst, by exchange 2015.15

Yoruba, Nigeria

Divining tray, n.d. (pl. 262)
Wood; 15 ½ × 15 ½ in.
Phoebe A. Hearst Museum of Anthropology, University of California, Berkeley 5-1744

Photo Credits

FIGURES

1 Courtesy The Bancroft Library, University of California, Berkeley; **2** Courtesy and © Diller Scofidio + Renfro; **3** Photo: Lucien Hervé. Courtesy The Getty Research Institute, Los Angeles (2002.R.41). © J. Paul Getty Trust; **4** Courtesy Fondation Le Corbusier. © F.L.C. / ADAGP, Paris / Artists Rights Society (ARS), New York 2015; **5** Courtesy Sabrina Dalla Valle; **7** © 1953 Kenneth Anger, courtesy Brian Butler and Anger Management; **10** Digital Image © The Museum of Modern Art / Licensed by SCALA / Art Resource, New York. © 2015 Artists Rights Society (ARS), New York / VG Bild-Kunst, Bonn; **12** Courtesy Ernst Haeckel Haus; **13** Courtesy Karlsruhe Institute of Technology, KIT Archives; **14** Photo: Sibila Savage. © 2015 Artists Rights Society (ARS), New York / ADAGP, Paris; **15** Photo: Sibila Savage; **16** From *The Red Book* by C. G. Jung, edited by Sonu Shamdasani, translated by Mark Kyburz, John Peck, and Sonu Shamdassani. © 2009 by the Foundation of the Works of C. G. Jung, Translation 2009 by Mark Kyburz, John Peck, and Sonu Shamdasani. Used by permission of W. W. Norton & Company, Inc.; **17** Courtesy Anthony Ashworth; **18** Courtesy Gordon R. Ashby; **19** Originally published in *ARTnews*, May 1956. © 2015 Estate of Ad Reinhardt / Artists Rights Society (ARS), New York; **20** © 2002 Lloyd Center / Clear Cut Press.

PLATES

1–12 © 2014 David Chalmers Alesworth; **13–14** © 2015 Noriko Ambe / Artists Rights Society (ARS), New York; **15** Photo: Sibila Savage. © Phoebe A. Hearst Museum of Anthropology and the Regents of the University of California; **16–18** Courtesy Yuri Ancarani and ZERO..., Milan; **19** © 1953 Kenneth Anger, courtesy Brian Butler and Anger Management; **20, 23–24** Photo: Laurence Cuneo. © Estate of Ruth Asawa; **21–22** Photo: Sibila Savage. © Estate of Ruth Asawa; **25** Photo: Paul Hassel. © Estate of Ruth Asawa; **26–28** Courtesy Gordon R. Ashby; **29** Courtesy Joslyn Art Museum, Omaha; **43** Image © The Metropolitan Museum of Art; **44–49** Minneapolis Institute of Arts. © 2015 Karl Blossfeldt Archiv / Ann u. Jürgen Wilde, Köln / Artists Rights Society (ARS), New York; **50** Photo: Paul Hester. Courtesy The Menil Collection, Houston. © 2015 Lee Bontecou; **51–53** © 2015 Lee Bontecou; **54–56** Art © The Easton Foundation / Licensed by VAGA, New York, NY; **57–59** Courtesy National Gallery of Art, Washington, DC; **60** © Rheinisches Bildarchiv Köln, Michael Albers; **61–64** Courtesy Cajal Legacy, Instituto Cajal (CSIC), Madrid; **65** Princeton University Art Museum / Art Resource, NY; **66** Photo: Rick Hall. Blanton Museum of Art, The University of Texas at Austin, The Suida-Manning Collection, 1999; **67–69** © 2008 James Castle Collection and Archive LP. All rights reserved; **70** Courtesy and © Diller Scofidio + Renfro; **71** Photo: Sibila Savage; **72** © Succession Marcel Duchamp / ADAGP, Paris / Artists Rights Society (ARS), New York 2015; **73** Courtesy Fundación Augusto y León Ferrari and Sicardi Gallery; **74** Courtesy Gabriel Rud; **75–79** Photo: Sibila Savage. © 2015 Suzan Frecon / Artists Rights Society (ARS), New York; **80** © 2015 Suzan Frecon / Artists Rights Society (ARS), New York; **82–83** Courtesy The Estate of R. Buckminster Fuller; **84–85** © 2015 Christie's Images Limited; **86** Courtesy Laeh Glenn and Altman Siegel, San Francisco; **87** © Brent Green; **88–93** Courtesy Ernst Haeckel Haus; **94–100** © Ganesh Haloi, photo courtesy of Akar Prakar; **101** Digital Image © Whitney Museum of American Art. © Trenton Doyle Hancock; **102–6** © Toyo Ito, Kumiko Inui, Sou Fujimoto, Akihisa Hirata, Naoya Hatakeyama, Architecture. "Home-for-All", 2013, TOTO Publishing (TOTO LTD.); **102–4** Photo: Nacasa & Partners Inc.; **105** Photo: Sou Fujimoto Architects; **106** Photo: Akihisa Hirata Architecture Office; **107** © 2015 Artists Rights Society (ARS), New York / ProLitteris, Zürich; **108** Digital Image © 2015 Museum Associates / LACMA, Licensed by Art Resource, NY. © 2015 Artists Rights Society (ARS), New York; **109** © Chris Johanson; **110** Courtesy Crocker Art Museum, Purchase with contributions from Gerald D. Gordon, Collector's Guild, Anne and Malcolm McHenry, Kim Mueller and Robert J. Slobe, James R. Lenarz, and other donations; **111** © 2015 Christie's Images Limited; **112–16** © Austrian Frederick and Lilian Kiesler Private Foundation, Vienna; **117** Photo: Lena Deinhardstein. © Austrian Frederick and Lilian Kiesler Private Foundation, Vienna; **118** Courtesy of Kukje Gallery, Seoul, and Kimsooja Studio; **119** © 1977 Paul Kos; **120–25** Photo: Sibila Savage; **126** Photo: Sibila Savage. © 2015 Artists Rights Society (ARS), New York / ADAGP, Paris; **127–30** Karlsruhe Institute of Technology, KIT Archives; **131** Photo: John White. © Ed Loftus, courtesy of Gregory Lind Gallery, San Francisco; **132–33** Courtesy Mark Manders and Tanya Bonakdar Gallery, New York; **134** Courtesy The Estate of Gordon Matta-Clark and David Zwirner, New York / London. © 2015 Estate of Gordon Matta-Clark / Artists Rights Society (ARS), New York; **135–40** Photo: Sibila Savage; **141** Courtesy of Julie Mehretu and Crown Point Press, San Francisco; **142–43** © Phoebe A. Hearst Museum of Anthropology and the Regents of the University of California; **144** Digital Image © The Museum of Modern Art / Licensed by SCALA / Art Resource, New York. © 2015 Artists Rights Society (ARS), New York / VG Bild-Kunst, Bonn; **145** Jay Nelson; **146–47** © Yuji Obata, courtesy of Danziger Gallery, New York; **148–53** Photo: Phillip Ennis; **154** Photo: Steven Sloman © 1989. Courtesy National Gallery of Art, Washington, DC. © Georgia O'Keeffe Museum / Artists Rights Society (ARS), New York; **155** Photo: Andy Stagg. Image courtesy Estate of Robert Overby; **156** Courtesy Musée des Beaux-Arts de la Ville de Paris, Petit Palais. © Petit Palais / Roger-Viollet; **157** Courtesy and © Nipam H. Patel; **158** Courtesy of The Morgan Library & Museum; **159–74** Photo: Sibila Savage. © Phoebe A. Hearst Museum of Anthropology and the Regents of the University of California; **175** © Avery Preesman; **176** Photo: Sibila Savage. © Avery Preesman; **177** Courtesy and © Qiu Zhijie; **178–80** Photo: Sibila Savage; **181** © 2015 Estate of Ad Reinhardt / Artists Rights Society (ARS), New York; **182** Courtesy Ben Rivers and Kate MacGarry, London; **183–86** © The Ames Gallery, Berkeley, CA; **187** Photo: Sibila Savage. © Phoebe A. Hearst Museum of Anthropology and the Regents of the University of California; **189** © Dieter Roth Estate, courtesy of Hauser & Wirth; **190** Photo: Vicente de Mello, courtesy of Fred Sandback Estate. All work by Fred Sandback © 2016 Fred Sandback Archive; **191–93** Courtesy Tomás Saraceno and Tanya Bonakdar Gallery, New York. © Tomás Saraceno; **194–200** © E. Schauberger / Schauberger Archives; **201** Courtesy Jesse Schlesinger; **202** Photo: Ian Reeves; **203–6** Photo: Sibila Savage; **207** Collection of John Cohen, courtesy of Harry Smith Archive; **208–10** Photo: Michael Pfisterer; **211–15** Digital Image © Whitney Museum of American Art. © 2015 The Hedda Sterne Foundation / Artists Rights Society (ARS), New York; **219** © Do Ho Suh, courtesy the artist and Lehmann Maupin, New York and Hong Kong; **220–22** © 2015 The Estate of Al Taylor, courtesy David Zwirner, New York/London. Reproduced by permission; **223** Courtesy National Gallery of Art, Washington, DC; **225–32** Photo: Sibila Savage; **233–36** © 2015 Christie's Images Limited; **237–38** © the heirs of Rosie Lee Tompkins, courtesy Eli Leon; **239–41** Courtesy of The Morgan Library & Museum; **242** © Muhammad Hafiz Wan Rosli; **243–44** Photo courtesy of Whitney Editions™, Los Angeles. All rights reserved; **245** Photo © 1975 John Whitney, © renewal 2015 by Whitney Editions™, Los Angeles. All rights reserved; **246–51** Courtesy Estate of Lebbeus Woods; **252** Courtesy the Ohio History Connection; **253–60** Courtesy Xenakis Family, Paris. All rights reserved; **261** Photo: Phillip Maisel. © Will Yackulic, courtesy of Gregory Lind Gallery, San Francisco; **262** Photo: Sibila Savage. © Phoebe A. Hearst Museum of Anthropology and the Regents of the University of California.

Lenders to the Exhibition

Akihisa Hirata Architecture Office, Tokyo

David Chalmers Alesworth, London

Yuri Ancarani, Milan

Andrew Edlin Gallery, New York

Association des Amis du Petit Palais, Geneva

Austrian Frederick and Lillian Kiesler Private
 Foundation, Vienna

Avery Architectural and Fine Arts Library,
 Columbia University, New York

Blanton Museum of Art,
 The University of Texas at Austin

Gertraud and Dieter Bogner, Vienna

Louise Bourgeois Trust, New York

Cajal Legacy, Insituto Cajal (CSIC), Madrid

Cheim & Read, Los Angeles

John Cohen, New York

Cathryn M. Cootner, Sonoma, California

Crocker Art Museum, Sacramento

David Zwirner, New York/London

Department of Special Collections, Stanford
 University Libraries, Stanford, California

Diller Scofidio + Renfro, New York

Ernst Haeckel Haus, Jena, Germany

Fundación Augusto y León Ferrari,
 Buenos Aires

Brent Green, Cressona, Pennsylvania

Bonnie Grossman and The Ames Gallery,
 Berkeley

Halley K. Harrisburg, New York

Hauser & Wirth, New York

Joslyn Art Museum, Omaha, Nebraska

Karlsruhe Institute of Techonology, KIT
 Archives, Karlsruhe, Germany

Kate MacGarry, London

Kimsooja, New York

Kunsthaus Zürich, Switzerland

Lacis Museum of Lace and Textiles, Berkeley

Neerja and Mukund Lath, Jaipur, India

Eli Leon, Oakland

Los Angeles County Museum of Art,
 Los Angeles

The Estate of Gordon Matta-Clark

Nion McEvoy and Leslie Berriman,
 San Francisco

The Menil Collection, Houston

The Metropolitan Museum of Art,
 New York

Michael Rosenfeld Gallery, New York

Stephen Mills and Brent Hasty, Austin

Minneapolis Institute of Arts

The Morgan Library & Museum, New York

Musée des Beaux-Arts de la Ville de Paris,
 Petit Palais, Paris

The Museum of Modern Art, New York

National Gallery of Art, Washington, DC

Oakland Museum of California

Ohio History Connection, Columbus

The Estate of Robert Overby,
 Glendale, California

Nipam Patel, Berkeley

Phoebe A. Hearst Museum of Anthropology,
 University of California, Berkeley

Princeton University Art Museum,
 New Jersey

Private collection, Albany, California

Private collection, Berkeley

Private collection, New York (2)

Private collection, Oakland

Private collection, Richmond, California

Private collection, San Francisco (3)

Deborah and Andy Rappaport,
 San Francisco

Ben Rivers, London

Till Roeskens, Marseille, France

Gabriel Rud, Buenos Aires

Estate of Fred Sandback, New York

Santa Barbara Museum of Art,
 Santa Barbara

Studio Tomás Saraceno, Berlin

Schauberger Archive, Bad Ischl, Austria

Snyder Family Living Trust, Santa Barbara

Hyun-Sook Song, Hamburg

Sou Fujimoto Architects, Tokyo

Jacqueline Miller Stewart, Dallas

Tanya Bonakdar Gallery, New York

Estate of Al Taylor

Dean Valentine and Amy Adelson,
 Los Angeles

Muhammad Hafiz Wan Rosli,
 Santa Barbara

Lea Weingarten, Houston

Whitney Editions, Los Angeles

Whitney Museum of American Art,
 New York

Estate of Lebbeus Woods, New York

Xenakis family, Paris

ZERO..., Milan

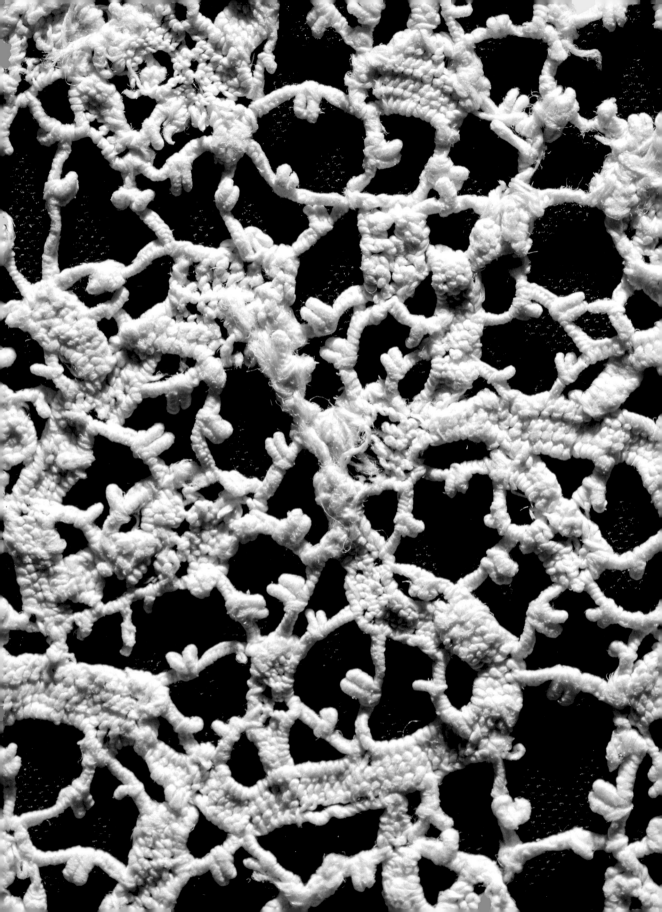

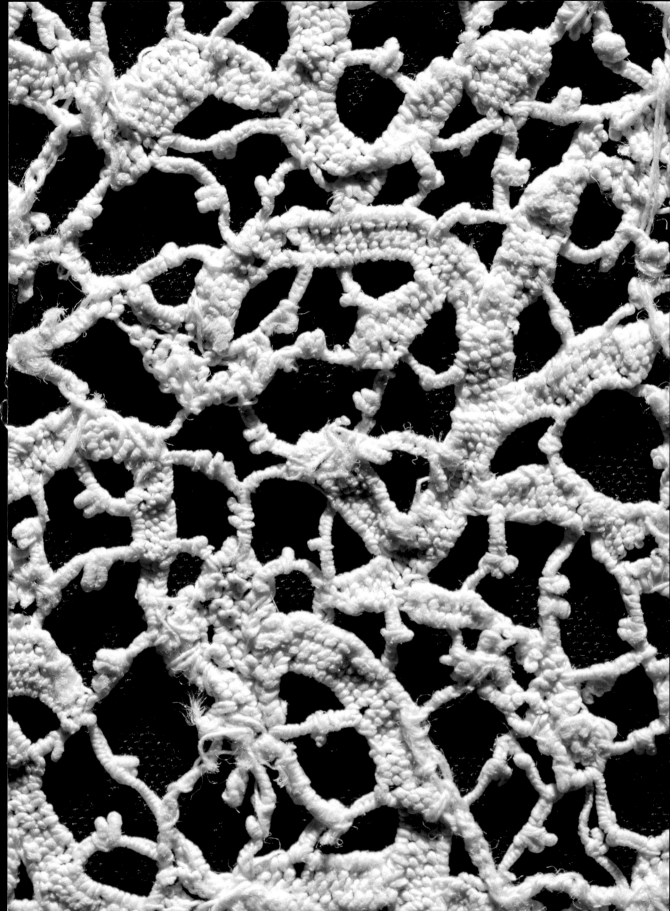

7.

quinta figura
o di moto, et ultima
primo libro

Testa VIII alt...
Piede VI alta...

Cubito IIII alta sa figu...
H. è centro del minor ce...
et s'angulo del triangolo
li angoli. da basso.

sono. l'anguli del esagono
sono. l'anguli del quadrato
sono. l'anguli del pentagono
sono. l'anguli del ottogono
...angolo. del Triangolo. b.b. a sopra
...contra. disopra.